ART OF IMMERSIVE

edited by Pauline Minevich and Ellen Waterman

with a DVD edited by James Harley

SOUNDSCAPES

University of Regina Press

Printed and bound in Canada at Friesens. The text of this book is printed on 100% post-consumer recycled paper with earth-friendly vegetable-based inks.

Cover and text design: Duncan Campbell, University of Regina Press.
Editor for the Press: Donna Grant, University of Regina Press.
Copy editor: Dallas Harrison.
Indexer: Patricia Furdek.

Cover photo: "Person's Ear," by Barnaby Hall, Photonica Collection, Getty Images, and "Blue Smooth Waves on White Background" by Vector Graphics, used under a Creative Commons Attribution 3.0 license (see http://creativecommons.org/licenses/by/3.0/).

LIBRARY AND ARCHIVES CANADA CATALOGUING IN PUBLICATION

Available on line at *www.collectionscanada.gc.ca/cip/*
and at *www.uofrpress.ca/publications/Art-of-Immersive-Soundscapes*

10 9 8 7 6 5 4 3 2 1

University of Regina Press, University of Regina
Regina, Saskatchewan, Canada, s4s 0a2
TEL: (306) 585-4758 FAX: (306) 585-4699
U OF R PRESS WEB: www.uofrpress.ca

This book has been published with the help of:
- a grant from the University of Regina President's Fund
- a grant from the Federation for the Humanities and Social Sciences, through the Awards to Scholarly Publications Program, using funds provided by the Social Sciences and Humanities Research Council of Canada
- a research grant from the Social Sciences and Humanities Research Council of Canada.

The University of Regina Press acknowledges the support of the Creative Industries Growth and Sustainability program, made possible through funding provided to the Saskatchewan Arts Board by the Government of Saskatchewan through the Ministry of Parks, Culture, and Sport.

We also acknowledge the financial support of the Government of Canada through the Canada Book Fund for our publishing activities.

 Canadian Patrimoine
Heritage canadien

 Government of Saskatchewan

University of Regina

CONTENTS

RELATIONSHIPS

POSSIBILITIES

Acknowledgements

Many people and institutions contributed to the two Art of Immersive Soundscapes workshops (2004 and 2007) and the 2007 international conference Intersections: Music and Sound, Music and Identity that were the basis for this book. We received generous funding from the Social Sciences and Humanities Research Council (SSHRC) under the Sound, Image, and Technology program and the Awards for Scholarly Publishing Program. We would like to thank the University of Regina President's Fund, the Faculty of Fine Arts, the Department of Music and the Department of Media Production and Studies for their generous and enthusiastic support of our work. Charlie Fox was the originator of the idea for the workshops, and neither would have been possible without his vision. We were fortunate to have many wonderful artists-in-residence, from across Canada, who shared their work and stimulated experimentation and discussion. They were Darren Copeland, James Harley, Peter Hatch, Christos Hatzis, Steve Heimbecker, Ellen Moffat, Gordon Monahan, Barry Truax, Ellen Waterman, and Hildegard Westerkamp.

Like many another project, this book has had a long genesis. We are particularly grateful to the authors both for their scholarly and creative contributions and for their patience. Thanks, finally, to James Harley for producing the accompanying DVD in 5.1 surround sound that, we hope, will make your reading experience an immersive one.

PROLOGUE
Wildurban

Charlie Fox

Editors' note: Charlie Fox was an integral partner in organizing the Art of Immersive Soundscapes workshops that inspired this book. The insightful comments he offers here about his eight-channel electroacoustic composition Wildurban *capture the essence of our themes of immersiveness and soundscapes.*

In 2007, artist/curator Ellen Moffat commissioned seven artists to create six contemporary public media artworks for the City of Saskatoon. The project, titled Aneco, was a suite of artworks that utilized contemporary artistic methods and ideas not normally made available in public art. Furthermore, the artworks in Aneco specifically responded to concerns about ecology and social dynamics, with the intention of creating awareness and dialogue about the interactions between natural and constructed environments.

My commission became an eight-channel immersive soundscape, titled *Wildurban*, created for playback in the block-long outdoor Saskatoon City Transit bus mall. The soundscape composition remained in continuous playback mode for three years (2007–10). Presenting a repeating, publicly received, two-hour soundscape composition to be heard within the extreme range of noise generated by the coming and going of buses was an engaging

See DVD — Charlie Fox — for the complete audio recording of Wildurban.

logistical, compositional, and technical challenge. After the Aneco commission, *Wildurban* has had several other venues in public spaces: continuously cycled for one year in an indoor, high-traffic, pedestrian walkway of the EPCOR Centre, Calgary (beginning in August 2010), and in the rotunda of City Hall in Kitchener for the Open Ears Festival 2009, as in the twenty-minute version on the DVD accompanying this book.

The background to *Wildurban* started in the early 1990s, when I began to develop practical field recording methods that enabled the capture of immersive soundscapes for artistic expression, the desired outcome being the creation of new, immersive audio experiences for audiences. The sounds in *Wildurban* were selected from a series of multichannel "surround sound" field recordings that I made from 1999 to 2006 in various remote, "wild" locations around Saskatchewan. The bus mall in Saskatoon, site of the Aneco commission, had an eight-channel sound system, intended to present muzak in the outdoor mall. So the fit seemed obvious: the soundscape composed for *Wildurban* would bring the sounds of the Saskatchewan wilderness into the centre of urban Saskatoon.

The recorded samples reflected a diversity of ecological communities fast disappearing from Saskatchewan: these recordings included large groupings of waterfowl, songbirds, insects, and mammals. Composition considerations of the soundscape were informed by several main aspects: activity cycles in the various wildlife populations, the large-scale to intimate interactivity of these wild communities revealed by the spatial recording methods, and the many unique properties of vocalizations in their original form or pitched downward to a speed that more closely resembled human metabolisms.

The resulting mix of these various elements was intended to allow the complexity of the wildlife vocalizations to truly *speak* to the audience in the bus mall. Between the coming and going of the scheduled buses, there would be enough quiet in the mall environs that the wildlife sounds would, almost like magic, emerge. For many people in the mall, hearing the soundscape could be a return to the wilderness areas that they had known before coming to live in the city. For others, the soundscape was a welcome respite from the daily noise of the city. *Wildurban* invited all those who encountered the installation to listen in on the recordings and perhaps consider the origins and possibilities of human behaviour when exploring these wild forms of communication and urbanization.

CHAPTER ONE

Introduction: The Art of Immersive Soundscapes

Pauline Minevich

Since childhood, I have always loved listening to radio, especially radio drama. As much as I enjoyed the narrative flow, I was fascinated by the sound effects, from busy street noises to muffled footsteps that put the listener in suspense. My imagination was liberated from the definitive visual images of television and cinema. Gradually, I discovered the world of soundscapes, in which sounds are enjoyed for their own sake and for their associative and imaginative properties. As a result of my passion for soundscapes, I teamed up with Professor Charlie Fox, a colleague at the University of Regina who is a renowned audio artist, and we embarked on two summer workshops, The Art of Immersive Soundscapes (AIS) 1 and 2, presented at the University of Regina in 2004 and 2007. In each workshop, artists-in-residence worked alongside each other and with emerging artists to explore innovations in digital audio interfaces, sound diffusion, and soundscape composition. A relatively unstructured format made for a free and stimulating mix of technology and creative ideas, in which artists were challenged to interrogate their own artistic practices and theories. The 2007 workshop also included an international conference, Intersections: Soundscapes and Music; Soundscapes and Identity, from which many of the chapters in this book originated.

The term "immersive soundscape" is likely unfamiliar to many readers. The following is a brief history and explanation of the terms "soundscape" and "immersive."

WHAT IS A SOUNDSCAPE?

Canadian composer R. Murray Schafer is acknowledged to be the father of soundscape studies, and indeed Canadians continue to be at the forefront of the field. The soundscape movement began in the late 1960s when Schafer, with a group of graduate students, created the World Soundscape Project (WSP) at Simon Fraser University in Burnaby, British Columbia. The WSP was intended to be an educational and research project that would address a critical lack of attention to our sound environment, and its effects on our well-being, by fostering public awareness of soundscapes and noise pollution. Initially, Schafer and his students collected sounds from various urban locations, first in Vancouver and its suburbs, then across Canada, and finally, in 1975, from five villages in Europe (the Five Village Soundscape project). From these environmental or "found" sounds, they created aural images of the various locations. Schafer outlined his goals for soundscape studies in his 1977 book *The Tuning of the World*:

> The home territory of soundscape studies will be the middle ground between science, society, and the arts. From acoustics and psycho-acoustics we will learn about the physical properties of sound and the way sound is interpreted by the human brain. From society we will learn how man behaves with sounds and how sounds affect and change his behavior. From the arts, particularly music, we will learn how man creates ideal soundscapes for that other life, the life of the imagination and psychic reflection.[1]

Here Schafer articulated several important qualities of soundscapes. First, he envisioned the field as inherently interdisciplinary, with practitioners and theorists from a variety of backgrounds. This has indeed proven true, and the contributors to this book, who come from backgrounds in science, communication, music, and the visual arts, represent a range of disciplines involved in contemporary soundscapes.

Second, Schafer spoke to the importance of sound in society and in relation to the individual. This has been perhaps his most important contribution, and has engendered the field of acoustic ecology, which resonates strongly with many of the artists featured in this book. For Schafer, the term "soundscape" has come to trace a lamentable history that begins with harmonious sounds in an unspecified and likely rural utopia (a "hi-fi" environment) and deteriorates into the confusing "noise" of modern life (a "lo-fi" environment). A hi-fi environment has low ambient noise, and because of this discrete sounds are clearly audible. In contrast, a lo-fi environment is full of indiscriminate noise. Schafer laments the loss of hi-fi soundscapes and seeks ways to restore them. He has been accused of having a prejudice

against urban environments, and his work is replete with prescriptive ideological and ecological messages about which sounds "matter" and which do not. Although his groundbreaking work has influenced almost all of the work that has since come to create the field of sound studies, the term "soundscape" has come to have a much broader meaning and at the same time more nuanced implications.[2]

Third, Schafer cited the imaginative aspect of soundscapes and emphasized how, like musical works, they can enrich the inner lives of the creator and listener. More than any other characteristic of the genre, this fascinates all of our contributors, who demonstrate the myriad possibilities inherent in soundscape creation.

Several of the students involved in the original WSP went on to become noted composers in their own right. One example is Barry Truax, whose work is featured in this book and on the accompanying DVD. A member of the WSP from its start, he has worked for over forty years at Simon Fraser University in the acoustic research and communication program. He is a prolific soundscape composer and plays an active role in environmental protection; in 1996, he served on the City of Vancouver's Urban Noise Taskforce and contributed to the educational recommendations of its final report, *Urban Noise*. About twenty years after Schafer's manifesto, he offered a definition of soundscapes that speaks both to composition and to studies:

> An environment of sound (or sonic environment) with emphasis on the way it is perceived and understood by the individual, or by a society. It thus depends on the relationship between the individual and any such environment. The term may refer to actual environments, or to abstract constructions such as musical compositions and tape montages, particularly when considered as an artificial environment.
>
> The study of the systematic relationships between humans and sonic environments is called soundscape ecology, whereas the creation, improvement or modelling of any such environment is a matter of soundscape design.[3]

Truax has also defined the principles that he believes should govern soundscape composition:

- Listener recognizability of the source material is maintained.
- Listener's knowledge of the environmental and psychological context is invoked.
- Composer's knowledge of the environmental and psychological context influences the shape of the composition at every level.

- The work enhances our understanding of the world and its influence carries over into everyday perceptual habits.[4]

As we will see, "listener recognizability of the source material" has become an elastic concept, for some composers sonify data collected from unusual sources, such as satellites far away from the Earth. However, the last clause articulates the element of environmental activism that has traditionally been a part of the mission of soundscape composers, beginning with the World Soundscape Project. It has its roots in the concept of "acoustic ecology," which Schafer defined as follows: "Ecology is the study of the relationship between living organisms and their environment. Acoustic ecology is therefore the study of sounds in relationship to life and society."[5] Hildegard Westerkamp, another composer associated with the early days of the WSP (and featured in this book), goes further in an article on her website:

> Conscious listening and conscious awareness of our role as sound-makers is an inseparable part of acoustic ecology, as it deepens our understanding of relationships between living beings and the soundscape. The question is, how can soundscape composition enhance such environmental listening awareness? What is its role in inspiring ideas about balanced soundscapes and acoustic ecology?… What is the ecological stance that we take through our compositions both as listener and composer?[6]

In 1993, Truax and Westerkamp became two of the founding members of the World Forum for Acoustic Ecology (WFAE), an organization devoted to studying the world's soundscapes.[7] It has since grown to include organizations from around the world. Through numbers of conferences and symposia, the WFAE has increasingly identified an activist role for soundscape composers. In the fall of 2007, the editors of *Soundscape: The Journal of Acoustic Ecology* issued a call for action:

> Soundscape art has always had a couple of key themes near its centre: to make explicit the patterns and changes to our sounding world, and to raise awareness about the state of the world, as revealed through sound. These two impulses are related to, but clearly distinct from, the roles of science and of environmental activism. In this issue of *Soundscape*, we are challenging the acoustic ecology community to dig a little deeper in these two directions, to consider ways that our work might contribute in more practical — and influential — ways to the work of scientists and activists.… Where is the sound art that communicates and helps ground scientists, or that speaks directly to

the crises that call for widespread changes in our society's relationships with the natural world? How can sound art help both scientists and activists to grapple with these times? Beyond that, how can artists work in tandem with scientists and activists, or perform those roles themselves?[8]

So, in the forty-plus years since the founding of the World Soundscape Project, Schafer's original concerns continue to resonate, and many soundscape composers have taken on a greater responsibility as proponents of change. Having elucidated the concept of "soundscape," we should now explore the meaning of "immersion."

IMMERSION

What is an immersive soundscape? It can be as simple as a recording made in a forest: leaves crunching underfoot, birds chirping, a squirrel chattering. Or it can be as complex as an interactive new media work that uses generative sound and video software to create a virtual immersion in a fantastical environment. The concept of immersion itself can have several meanings. The *Oxford English Dictionary* defines it in two senses: "Absorption in some condition, action, interest.... Dipping or plunging into water or other liquid, and *transf.* [transferred sense] into other things." The role of the listener is important and demands concentration. Pauline Oliveros, one of the early pioneers of electronic music, developed her philosophy of Deep Listening during the 1970s: she encourages us to listen to all sounds everywhere all the time in order to become intentionally empathetic. Soundscape artists and composers are acutely aware of their audio environments and expect the same attention from their audiences.

The term "immersive soundscapes" examines the semiotic systems created by sound or in which sound is a participant. Essentially, "immersive sound" suggests a social life of sounds that situates them in relationships created around a particular sound, the material of its media, and the physicality of its surroundings. The immersive effect can be achieved in several ways, for instance by positioning sound sources variously throughout a performance space or presenting them separately in each ear through headphones with considerations of the ways in which sounds travel through space and the anatomical structure of the ear. At the AIS workshops, octophonic[9] sound was the norm, immersing listeners in a 360-degree sonic experience. Although the number of sounds to which we can devote simultaneous awareness is relatively small, true soundscapes achieve the immersive effect of landscapes by including all of these sounds and their myriad reflections, refractions, and reverberations that depend on the configuration of a particular performing space. In terms of technology, this can mean dividing sounds into signals

dependent on a speaker's location or treating many sounds as if they are a single sound operating from multiple positions. The social element, then, is a matter of each sound's responses and adjustments relative to the responses of other sounds. There is also a phenomenological aspect to the making of meaning presented in soundscapes in that they invite us to consider how sounds "feel" when they are abstracted from their sources or processed in ways that reshape their relationships with reality. Examples include John Bullitt's *Earth Sound*[10] (a 3-D immersion in which the listener is meant to be "inside the Earth" hearing tectonic shifts, earthquakes, and other resonating activities) and Barry Truax's *Temple* (on the DVD accompanying this book), in which the effects of both the embodied voice and the disembodied reverberations across time are achieved through mixing and remastering such that listeners sense the sounds moving around them.

But what emerged strongly at the workshops and conference was another sense of immersion: that of being plunged into the interior world of the artist. One of the most seductive aspects of sound art is that it gives free rein to the imagination of both the creator and the listener. Barry Truax invites the audience to become immersed in the illusory world that he creates in his multichannel soundscape composition *Spirit Journies*, while Gabriele Proy's soundscape composition of a rural area in Austria entices us into a loving re-creation of an idyllic past. Viv Corringham's re-created memory walks with improvised singing take the audience into the personal worlds of those who told her their stories, while John Wynne's recordings, made in an intensive care unit devoted to heart transplant patients, transport us into a frightening world where the *lack* of sound can signal death. Soundscapes defy categorization, and artists using this medium describe their work in many different ways: as sound installations, audio art, radio art, and music. The flexibility and temporality of soundscapes enable infinite interpretations and iterations. On the accompanying DVD, you will find wonderful and varied examples of how the artists featured in this book use sound to stimulate and engage the listener's imagination. To contextualize them, it is useful here to look at the history of sonic art in general.

BUT IS IT ART (OR MUSIC)?
HISTORICAL AND THEORETICAL PERSPECTIVES[11]

Since the time of Luigi Russolo and his *The Art of Noises: Futurist Manifesto* (1913), artists and musicians have debated the relationships among sound, the environment, art, and society.[12] Russolo was one of the earliest artists to work both in sound and in visual art; for example, he created large mechanical noise instruments, *intonarumori*, that effectively were sound sculptures. As early as the mid-1920s, the Futurist F.T. Marinetti was making *radio sintesi*, audio collages of sounds, and in 1929 Walter Ruttman created *Weekend*, a

collection of sounds recorded during one weekend in Berlin. Composers such as Edgard Varèse, Henry Cowell,[13] and John Cage theorized the role of sound in or as music. Varèse in particular preferred the term "organized sound" to "music" in discussing his work, and he pioneered the use of electronic sounds. Examples are his work *Déserts* (1954), which incorporates found sounds in tape-recorded sections, and *Poème électronique*, a composition for tape alone that was designed for Le Corbusier's pavilion for the Philips firm at the Brussels Exposition Universelle of 1958. Utilizing hundreds of loudspeakers, this was an early example of spatialization, a technique that is integral to the works discussed in our book.

As early as 1948, Cage was thinking about the role of silence in the range of sounds that can be interpreted as music, as evidenced by the text of a lecture that he gave that year at Vassar College.[14] In 1952, he problematized these concepts in *4' 33"*, an entirely silent piece that provoked new attention to environmental sound as music. The connection between visual art and musical art appears here again, for Cage stated that he was influenced by Robert Rauschenberg's white paintings, in which the absence of content draws the viewer to notice minute details of texture: "When I saw those, I said, 'Oh yes, I must; otherwise I'm lagging, otherwise music is lagging.'"[15] The fields of visual art and music continued in tandem in the 1960s in the work of the international collective Fluxus, which was strongly influenced by Cage, among others.[16] One of their most well-known and influential (if somewhat reluctant) members, Yoko Ono, created conceptual works that questioned whether music even requires sound.[17] Another member, Nam June Paik, worked in experimental sound and sculpture, video and music, and set the stage for others who were similarly interested in the interactions between visual and sonic arts.[18] To this day, sonic art is as much the province of visual artists as of musicians; indeed, it is often presented in that classic setting for visual art, the gallery. Some influential examples of Canadian work in this venue include David Rokeby's *Very Nervous System* (1986–90), Janet Cardiff's *Forty Part Motet* (2001), and Gordon Monahan's *Theremin Pendulum* (2008).[19] The differences between those who come to soundscapes from a background in the visual arts and those who view themselves as primarily musicians–composers have led to some disagreements over terminology.

TERMINOLOGY

So far, I have used the term "sonic art" instead of "sound art." This has been a deliberate choice, because "sound art" is a highly contested term. Some theorists associate it with visual art and sound installations in particular. Alan Licht devotes a chapter of *Sound Art* to a lengthy discussion on how one might define "sound art." He attributes the origin of the term to William Hellermann's SoundArt Foundation, which dates from the late 1970s,

and an exhibition that it produced in 1983, entitled *Sound/Art*. Licht decries "a tendency to apply the term 'sound art' to any experimental music of the second half of the twentieth century, particularly to John Cage and his descendents [sic]."[20] For him, a crucial distinction between music and sound art is that music has a fixed narrative quality — in other words, a beginning, a middle, and an end — whereas sound art has no fixed duration, without a beginning or an end. It follows that sound art is usually experienced as an installation, either in a gallery or in some other public space rather than in a concert setting. In this context, Claudia Tittel notes that sound installations allow the audience to enter an artwork at will and experience it individually. The concept of an artwork as a fixed object is exploded: "The use of sound as artistic material opens fine art up to a temporal dimension, changing the once-distant relationship between work and recipient and making it transitory."[21] Leigh Landy notes that

> This term ["sound art"] has been used inconsistently throughout the years. Currently it is typically used to designate sound installations (associated with art galleries, museums, and public spaces), sound sculptures, public sonic artifacts, and site-specific sonic art events.... Sound art has traditionally been largely associated with fine and new media artists, but has also been associated with some musicians' works.[22]

However, Landy also points out that "people involved in sonic art (and sound art as well) not only call themselves composers, but also sonic artists, sound artists, sound designers, and audio artists."[23] As editors, we have intentionally taken a broad approach to sound, and the works discussed in our book include pieces intended for concert performance, site-specific events, and installations. Therefore, it seems appropriate to use "sonic art" as an umbrella term for many diverse practices using sound, including, but not limited to, immersive soundscapes.

AIMS OF THIS BOOK

It is obvious that sonic art, and soundscapes, are wide-ranging areas of creative and critical exploration, so it would be impossible to create a collection of works and articles that would be comprehensive. Our guiding principles for this book have been informed by two of the precepts outlined by R. Murray Schafer: interdisciplinarity and a focus on the relationship of humans with their acoustic environments. At the same time, we wanted to create a collection that would be a snapshot of a particular event in time, when scholars and artists from eight countries gathered at the University of Regina. Included in this book are perspectives from soundscape composition and

performance, site-specific sound installation, recording, and programming in addition to ethnographic research and critical analysis. Importantly, we recognize the pioneering place of Canadian sound artists within this international field. The papers were selected from a strong group of submissions for their particular contributions to the field. Co-editor Ellen Waterman and I also solicited special content from three of the most important Canadian soundscape composers: Darren Copeland, Hildegard Westerkamp, and Barry Truax. The book includes on DVD sonic and visual examples from some of the works discussed. In this way, we have endeavoured to preserve a sense of the richness and diversity of the event.

Histories

The first two chapters in the book are historical profiles, one of visual artists working with sound and one of a composer, Luigi Nono. In Chapter 2, María Andueza Olmedo cites the influence of Russolo, in particular his 1913 composition *Risveglio di una citta* (Awakening of a City), in her discussion of sound installations by Max Neuhaus, Bernhard Leitner, Bill Fontana, and Bruce Nauman. Located in places as diverse as New York's Times Square, London, and the city of Buchberg, Austria, all of these works continue the tradition, dating back to Russolo, of problematizing the individual's relationship to urban noise. Andueza Olmedo argues that their sonic artworks subtly alter the auditor's perception of the city by immersing him or her in sound, even though that sound might barely be perceptible. This brings to mind Gabor Csepregi's discussion of the almost indefinable quality of "atmosphere" that we encounter in any space.[24] Sound is a vital factor in how we experience a physical location; as Csepregi writes, "The acoustic sphere entails an element of possessiveness; we are seized by sounds and delivered to their influence."[25] For example, the sound source for Neuhaus' *Times Square* installation is unseen; it is hidden in the subway vents below ground, and the work itself is located on a pedestrian island, so that most people walk through it unaware. Even so, Andueza Olmedo argues that it has an undeniable influence on passersby because, whether they want to or not, they must somehow integrate these pervasive sounds into their own experiences of the space.

David Ogborn inverts this relationship in Chapter 3 by examining the influence of the indigenous sounds of Venice on the composer Luigi Nono. Immersed most of his life in the uniquely Venetian sound environment of bells over water, and of water itself, Nono intended his last major work, *Prometeo* (1984), for performance in a huge structure resembling the keel of a boat, installed in the church of San Lorenzo in Venice. Drawing on a documentary containing interviews with Nono in his later years, Ogborn argues that many factors in the composer's environment can be found in his late

works. Ogborn frames his argument in the contexts of Nono's involvement in politics (in particular the Italian Communist Party) and his adoption of live electronics in the late 1970s. He posits not only that the sounds of bells and water are important but also that the many complicated resonances and echoes that inflect these sounds in the unique Venetian soundscape contribute to "the element of continual change and motion in his [Nono's] work." Again, an atmosphere created by a specific urban environment has a subtle yet profound influence on a citizen.

Environments

The term "soundscape" (a sonic analogy to "landscape") originated in the late 1960s with Schafer's World Soundscape Project, with its focus on acoustic ecology, as discussed above. Understanding "sounds in relationship to life and society … can only be accomplished by considering on location the effects of the acoustic environment on the creatures living in it."[26] Schafer envisioned an important role for sound artists in creating awareness of the sound environment and its social and cultural effects. Sound can be considered a problem, as in noise pollution, or an important cultural artifact, as in the preservation of "sound marks" such as ancient cathedral bells. By lifting sounds out of their quotidian contexts, by framing digital data in novel ways, sound artists help us to understand the relationships between identity and space/place, whether using satellite data or recordings made in quiet country settings. In recent years, the field has burgeoned, due partly to the proliferation of digital technologies and partly because the environment (social, cultural, and ecological) has become an overriding concern in our society.

The four chapters in this section are by artists who work with different kinds of environmental sound. All show kinship with the Schaferian concepts of acoustic ecology outlined above. Chapters 4 and 5 describe interdisciplinary projects between scientists and sound artists, perhaps best understood as data art. This exciting new field melds scientific data with sound art in works that challenge audiences to rethink concepts of place, environment, and identity.

In Chapter 4, Andrea Polli takes the broadest possible view of environmental change with her innovative work on the sonification of satellite data. It has much in common with Schafer's ideology, though using twenty-first-century technology. She describes her work as "ecomedia," defined as "media made with the emerging technologies, tools, and information structures that describe and model environmental systems." Although we might not pay much attention to graphs and tables of data, Polli believes strongly that audiences can be sensitized to the ecological issues facing the world through art based on the "sonic interpretation of real-time, recorded, and

simulated data describing global weather and climate as image, animation, and sound." Polli's argument positions ecomedia in the history of locative media (e.g., global positioning satellites) and examines the ever-shifting boundaries between art and science. Her *Heat and the Heartbeat of the City* (excerpted on the accompanying DVD) uses real and projected data about summer temperatures in New York's Central Park to create a work in which uncomfortably loud sounds mirror uncomfortably high heat levels. Another project, *N*, used sonifications of data collected at the North Pole to create a soundscape of the weather patterns found there. In each work, Polli collaborated with other artists, programmers, and scientists.[27]

A collaborative approach is also found in Chapter 5, about the work of Albertans Craig Coburn, a geographer, and William Smith, a new media designer. They are working on a project to create place-specific musical works based on satellite data maps of over twenty Canadian cities. Their work is a high-tech variation on the more conventional idea of songs written about place, from Stompin' Tom Connors' odes such as "Sudbury Saturday Night" to the Canadian Broadcasting Corporation's 2009 song contest in which listeners were invited to propose a place in their province that should be immortalized in song.

Coburn notes that landscapes have always inspired composers but explains that "we wanted to explore the ways that landscapes, through satellite data and sonification tools, could create their own sounds." The use of raw data from space to create art is similar to Polli's method, but Coburn and Smith use it not to arouse concern over global ecological issues but to give the audience a new sense of identification with place. Their piece *Recording Regina from Eta Carinae* proposes a two-way dialogue stretching across space, reaching out to communities that are impossibly far away: "Imagine seeing Regina as if in a satellite image, from another galaxy or nebula, such as Eta Carinae." Indeed, the artists creatively invert the trope of humans' obsessive collection of data from "outer space" to imagine that the Canadian prairie might provide fascinating data to an imagined culture in a remote star system.

Coburn and Smith use raw data taken from a satellite image of Regina without alteration but combine them with algorithms derived from the words *Regina, Saskatchewan*, that add more depth and definition to the musical texture. This work is immersive in many ways: in locating Regina in space, in using satellite data from the larger environment, and in how it is ideally presented, in a multiscreen audiovisual format. Like Polli, Coburn and Smith are in the vanguard of innovation and collaboration between science and art.

Composers Gabriele Proy and James Harley are both deeply immersed in the natural environment. Their works are based on sounds recorded in rural surroundings but developed in very different ways. In addition to her

work as a composer, Gabriele Proy (at the time of writing) is president of the Forum Klanglandschaft (FKL), or Soundscape Forum, an organization inspired by the World Forum for Acoustic Ecology, founded in 1993. It is based on Schafer's ideals of "widening sensitivity for the sonic environment and improving its quality."[28] Her work *Waldviertel*, which she discusses in Chapter 6, is an intriguing construct of recorded sounds from the rural landscape of the Waldviertel, an area in Lower Austria, manipulated to produce an idealized soundscape. The project was commissioned by the Austrian government to present a sound portrait of the country for the EU-Japan-Year-2005. Proy recorded sounds in the area over an entire year and then manipulated them in the studio to re-create her memories of the area from holidays spent there as a child. She relentlessly hunted her sounds, often lying in wait for hours to capture the iteration that precisely matched her sonic imagination. In *Waldviertel*, Proy collapses and layers time in order to represent both the changing seasons and the passage from dawn to dusk. The result is a beautiful soundscape that immediately immerses the listener in its pastoral setting.

The influence of landscapes and environmental sounds on James Harley's work resonates with Coburn's reflections on how landscapes have always inspired composers. Chapter 7 outlines Harley's compositional evolution, moving through jazz, improvisation, and modernist composition into electroacoustic and soundscape compositions that incorporate environmental sounds, texts, images, and interactive improvisation. Harley gives us an intensely personal insight into his *Wild Fruits* series of soundscape compositions as a kind of spiritual exploration of his relationship with nature. Like Smith, once he started working with electronic media, Harley experimented with using algorithms in his compositions, though for a different reason: "The connection to nature remained, but it took the form of 'chaotics,' adapting into music mathematical algorithms that model the often chaotic or non-linear behaviour of natural phenomena." Inspired by the meditations of Annie Dillard[29] and the journals of Henry David Thoreau, *Wild Fruits 2: Like a Ragged Flock, Like Pulverized Jade* (included on the DVD) is a feral soundscape of birds and water sounds combined with live improvisations on alto flute. The flutist provides a focal point for the audience, and for Harley this helps to bridge the gap between embodied performance and non-visual electroacoustic presentation.[30] As Harley says, "For the performer, as for the audience, the experience is elemental, akin to immersion in a chaotic natural environment of wind and water."[31]

Relationships
Many of the chapters and artists' statements in this book are concerned with the environment, and that is equally true of the contributors to this section.

The writers and artists presented here also explore intricate and intermeshed personal environments and relationships. In addition, all of them ponder the relationship between the body and the sounds in and around it, real or imaginary. In the process, they delve deeply into both the imaginative possibilities and the social implications of soundscapes.

Ellen Waterman's analysis of the work of two creative duos, Ian Birse and Laura Kavanaugh and Skoltz_Kolgen in Chapter 8 interrogates the relationship between creator/performer and audience and positions it as a social one. Since 2003, Birse and Kavanaugh have been working on an extended project entitled *Instant Places*, which they describe as a "series of researches into place as a field of possibilities." The installation that Waterman focuses on is called *Removable Room* and has been presented in cities across Canada. The duo begin their work by walking the streets of the city, gathering detritus, making sound recordings, and taking photos. With these materials, they construct a "room" that reflects their personal experiences of the city. The audience is invited into the space while Birse and Kavanaugh perform on laptops and in other ways. Waterman points out the essentially social nature of the installation and performance, in which the audience can wander through the space, sit down, or even take their own videos. An open room is, after all, an invitation to enter and explore. But at the same time, Waterman notes that Birse and Kavanaugh follow the laptop performance tradition of self-effacement during the show; the performers want the audience to focus on the sounds and visuals of the installation rather than on the artists as their source. Birse and Kavanaugh create a relationship with their audience that is a dual experience of presence (through the intimate quality of the room) and non-presence (through their deliberate attempt to distance themselves from the audience).

Skoltz_Kolgen (Dominique Skoltz and Herman Kolgen in effect between 1996 and 2008) were a Montreal team of visual artists who originally worked in advertising and who now work with many different media. Waterman investigates their work *Silent Room*, which they describe as a "film-poem." The work, a sophisticated marriage of generative audio and video software capturing and manipulating scripted and improvised performance, consists of many brief and surreal vignettes of individuals inhabiting imaginary rooms. *Silent Room* has been presented in several formats, including live performance, multisite installation, and DVD. In the DVD version, the viewer can choose the sequence of rooms that she looks in on and explore extensive additional material on the making of *Silent Room*. Indeed, the work is arguably interactive and therefore social, even when it is presented on the relatively static medium of DVD.

Waterman reflects that, though we often conceive of modern technology as distancing, new media have a fluidity and immediacy because of the

inherent mutability of digital data. This is particularly true of interactive formats. Indeed, Kavanaugh comments on the "warm" feel of computer technologies, a perception that, for these artists, is reminiscent of human-to-human contact. Indeed, Skoltz_Kolgen would observe their audiences at screenings of their work to get feedback, in much the same way that Birse and Kavanaugh can watch their audiences by being as self-effacing as possible. This is an interesting inversion of the usual interaction between creator/performer and audience. Many social relationships are revealed in Waterman's chapter: between audience and performers; between audience and works (because they can be experienced in so many different ways); and, not least, between the two duos, whose works resulted from relationships that were both personal and professional. In each case, digital technology only contributes to the intimacy and interactivity of the works of these artists.

In Chapter 9, John Wynne's account of his time spent as artist-in-residence along with photographer Tim Wainwright at Harefield Hospital near London, England, probes the relationships between sound and noise, healing and trauma. Here "environment" means the Intensive Treatment Unit (ITU), where patients await heart or lung transplants. Being restricted to bed means that patients' sensory experiences are very limited and that their awareness of sounds becomes acute. Since these patients are connected to machines (or, in the case of those awaiting heart transplants, have machines implanted in them), intimate sounds signal the continued functioning of the body. They are also subjected to a lot of exterior noise; as Wynne (quoting Tom Rice) states, the hospital ward is "a potentially overwhelming sound-scape in which 'the boundary between bodily interiority and exteriority is challenged in sometimes disturbing ways.'" This sound environment is often remarkably loud, and Wynne takes its various components as his point of departure for both a theoretical discussion and his creative work.

Wynne describes *ITU*, his audio-video collaboration with Wainwright (included on the DVD), as "acousmatic" because the listener cannot readily perceive the source of the sound or image. This term dates back to Pythagoras, who is said to have delivered lectures from behind a curtain so that his students could listen without visual distraction. Pierre Schaeffer, the pioneer of *musique concrète*, originally applied "acousmatic" to music by following the Pythagorean ideal of an audience concentrating on sounds without reference to their sources.[32] As he wrote,

> It is the listening itself that becomes the origin of the phenomenon to be studied. The concealment of the causes does not result from a technical imperfection, nor is it an occasional process of variation: it becomes a precondition, a deliberate placing-in-condition of the subject. It is *toward it*, then, that the question turns around: "What

am I hearing?… What exactly are you hearing" in the sense that one asks the subject to describe not the external references of the sound it perceives but the perception itself.[33]

ITU subverts this idea in at least two senses. Because photographer Tim Wainwright shot the video through a curtain, the audience inadvertently shares the perspective of a patient who might be lying in the next bed trying to interpret the sounds she hears, which can indicate life or death. Of course, we also want to know what is going on behind the curtain. So the result, though literally acousmatic, actually stimulates the audience's imagination about the sound sources — the exact opposite of Schaeffer's aesthetic.

Embodiment through immersion in a particular environment is a long-established theme in the work of Hildegard Westerkamp, presented in Chapter 10. She is well known for her many soundscape compositions that speak to a particular place or space[34] and has described her compositional process as "an ongoing conversation with the sonic environment." In *MotherVoiceTalk*, however, she immerses herself and the listener in a dialogue with another artist, the Japanese Canadian Roy Kiyooka (1926–94). Kiyooka began his career as a painter but moved into other fields, including video and music improvisation. Westerkamp's work was commissioned by Vancouver New Music Festival as part of a collective show on Kiyooka's life and work, in a call for works that would "become an organic stimulus for an inner dialogue between Kiyooka, his displayed works, the composers, the performing musicians, and the audience." Although she never met Kiyooka, Wester-kamp grew to know him through intensive research and expresses a sense of kinship with him through their experiences as outsiders. Westerkamp immigrated to Canada from Germany, and, though Kiyooka was born in Canada, his family was interned during World War II, effectively isolating him as a foreigner in his own country.[35] After completing her research on Kiyooka, Westerkamp felt a need to find common ground on which she could "meet" with him for an inner dialogue. This was realized in a stay on Saltspring Island because, as West Coast artists, she thought that this environment would be "a place of inner resonance" for both of them. The resulting work embodies Kiyooka in a sound portrait that, because of the equal presence that Westerkamp affords herself, also gives us considerable insight into the composer.

Like Westerkamp, Viv Corringham poses questions about the artist's relationship to her subject. *Shadow-walks*, discussed in Chapter 11, combines an awareness of the environment with a unique creative response. For Corringham, an environment is much more than a defined physical space and/or place; it is also made up of the sedimented histories, both public and private, with which it resonates. In this sense, we return to Csepregi's

concept of "atmosphere." Corringham enlists the participation of someone who is willing to take her on a "special" walk. The walk could be across town, to a particular building, anywhere; the only requirement is that it has some particular significance for that person. Corringham accompanies the walker, who tells her the story of the route. Then she returns to the walk, sometimes gathering detritus along the way (a practice that recalls Birse and Kavanaugh's work), and improvises vocally in a way that responds to the underlying narrative. In her own words, "through my improvisations and compositions, I am trying to convey people's special relationship with familiar places and how that links to the interior landscape of personal history, memory, and association." Corringham is very aware of the physicality and embodiment of her work: "The motion of walking allows a certain mental freedom that translates a place to a person kinaesthetically, and intimately connected to the body's movement is the voice...." By allowing herself to become immersed in another's experience, Corringham creates a kind of dialogue with the physical environment and her participant reminiscent of Westerkamp's approach to articulating the life of Roy Kiyooka. The reader can compare the results of both composers on the accompanying DVD.

Possibilities

The final section of this book looks to the future of the art of immersive soundscapes in terms of both composition and programming. All three authors consider that the venues and contexts for presenting immersive soundscapes are crucial factors in their accessibility and impact.

Peter Hatch and Darren Copeland, besides being composers, are both presenters of major Canadian festivals and series. Hatch was founding artistic director of the Open Ears Festival of Music and Sound in Kitchener, and Copeland is the artistic director of New Adventures in Sound Art in Toronto (NAISA). Both Hatch and Copeland are deeply conscious of the role of the presentation spaces used in their festivals. For both, "environment" has multiple implications for performance and the creation of a positive reception for sound art, which extend from utilizing the complex infrastructure of a city to exploiting the intimate atmosphere of a house concert. As Copeland says, "One could argue that NAISA has created an "immersive environment" for sound art out of a city, Toronto, which up to now has not offered much institutional support for electroacoustic music."

In Chapter 12, Hatch speaks movingly about his sense of dialogue with a concert space and of being aware of all the things that have happened there before. On entering a new performance venue, performers often make sounds such as clapping hands or clicking fingers in order to test the acoustics of the space. Hatch extends this practice: "I clap my idea into the social environment and listen for its cultural resonance." This sentiment is echoed

by Copeland in his discussion of the role of the venue in providing a social context for sound art. Indeed, Hatch envisions the entire city of Kitchener (where he employs dozens of venues) as the performance arena, which was traditionally signalled by sounding all the church bells in the city on the opening day of the festival.[36] Hatch believes that the performance venue adds extra layers of meaning to a work for its audience. For example, seeing the powerful and transgressive performance artist Diamanda Galás perform her extreme vocalizations in a church might seem daringly sacrilegious to some audience members.[37] Similarly, having the group Negativland,[38] which has a twenty-year history of creating "collage and appropriation-based works," perform in Kitchener's City Council Chamber (and sitting in the councillors' chairs no less) invites us to question the nature of authority. Hatch and Copeland have also instigated "guerrilla" art events in the streets during their festivals, such as a work by Hatch for opera singers using cell phones that was performed at Open Ears in 2005.

There are some valid concerns about such events; if you pass a piece of public visual art that you do not like, you can always ignore it, but a piece of sound art is by definition more intrusive because it is indeed immersive and inescapable until you are out of hearing range. I had an interesting experience when participating in one of Hatch's guerrilla pieces, the *Sonata for Five Car Horns*, in Regina at AIS1. Hatch auditioned several types of car to ensure that the horn sounds were distinctive (my favourite was a vintage TR6), and we rehearsed carefully in a large parking lot at the University of Regina, reading small scores pasted to the dashboard while listening to instructions on a walkie-talkie. At the evening performance, we drove around a circular driveway outside the Riddell Centre, which was our main performance venue. It so happened that the driveway was full of students, most dressed in black with heavy makeup, waiting to get into a goth concert that was about to start at the student pub. To our amazement, these rebellious-looking teens were outraged by our performance and protested vigorously at the noise! They seemed to think that middle-aged people should not be doing such an outlandish thing. For me, it was a high point of the concert series and a vivid illustration of the power of guerrilla sound art.

As a soundscape composer, Darren Copeland has made it his personal mission to develop audiences for, and educate young artists in, electroacoustic music and sound art.[39] Chapter 13 places his extensive promotion of sound arts in Toronto in the context of his own development as a soundscape composer. Copeland's organization, New Adventures in Sound Art, programs a variety of festivals, concerts, workshops, and symposia that cover the whole range of sound arts, from interactive performances and installations to radio art and soundscape compositions, with a special passion for multichannel electroacoustic music. Copeland's compositional philosophy is influenced

by R. Murray Schafer's emphasis on the environment, but Copeland is also adamant that soundscape works should have strong associative properties, with a deliberate appeal to the imagination of the listener. Barry Truax agrees that "the original sound must stay recognisable and the listener's contextual and symbolic associations should be invoked for a piece to be a soundscape composition."[40]

Because of his strong belief that electroacoustic music should communicate with people, Copeland's article stresses his interest in, and sensitivity to, audiences' reactions to his work. This awareness extends to his project of capitalizing on young people's familiarity and ease with consumer technologies. By teaching youth how to build basic electronic devices that are compatible with home computers, Copeland encourages them to experiment with sound from an early age, a strategy that he sees as essential to the continued evolution of sound art.

Truax's contribution in Chapter 14, with which we conclude our explorations of immersive sound art, is an account of his series of four works collectively called *Spirit Journeys*. The inspiration for these works comes from contrasting cultural contexts that Truax describes variously as spiritual, secular, Aboriginal, and Asian. Although they sound like recordings made in real environments, Truax employs granular synthesis to create virtual acoustic spaces that are entirely convincing, although they are also entirely manufactured.[41] A striking example is *Temple*, which gives the impression that it was recorded in a very large and reverberant space. In fact, Truax duplicated the acoustic dimensions of the cathedral of San Bartolomeo, in Busetto, Italy, when remixing and processing recorded voices. The effect is remarkable, particularly in octophonic sound. The other pieces in the set are similarly designed to evoke a spiritual environment as well as to create a virtual acoustic one.

Truax has since issued this work on CD (and an excerpt is provided on the DVD that accompanies this book); however, he was delighted with the opportunity afforded by AIS2 to present his cycle as a whole, in a rich aural format, to an enthusiastic and knowledgeable audience. He was able to introduce each piece and take questions from the audience, in a process in which immersion was understood to be time-based, intellectual, and aesthetic as much as acoustic. In an interesting sidebar to Hatch's discussion on the intimacy of house concerts in Kitchener, Truax muses that "the entire atmosphere was informal, intimate, and felt more like a family get-together than an impersonal public concert." Again, the venue, the means of presentation, and the quality of audience reception emerge as crucial issues in programming the art of immersive soundscapes. In a world where the staggering quantity and variety of available music are counterbalanced by the wide public acceptance of increasingly degraded sound quality (e.g.,

mp3 compression), Truax, Hatch, and Copeland are all strong advocates for the transformative potential of high-integrity sound environments.

For me, AIS1 and 2 have been eye-opening, or more accurately ear-opening, events. As a classical clarinetist, albeit one who works extensively in new music, I was dazzled and energized by the multiple possibilities that I discovered in sound art. There are so many ways today for performers and composers to express themselves, not only in an abstract sense, but also in art that engages with social, cultural, and environmental issues. Our book reflects this diversity and encompasses a broad range of works and ideas about sound. The majority of the contributors to this volume are from Canada, which clearly demonstrates the continuing importance of Canadian artistry and scholarship to the field. By including a DVD of the work of some of the most distinguished national and international contemporary soundscape composers and audio artists, along with their artist statements, we provide rich documentation of the field.

Dividing the book into sections was a difficult task since most of the contributors bring overlapping perspectives. In my opinion, this is an accurate reflection of the liveliness and interdisciplinarity of contemporary immersive soundscape studies and practice. Each writer investigates our categories of histories, environments, relationships, and possibilities in different ways and with different emphases, thus illustrating both common concerns and common questions. Above all, immersive soundscapes highlight the importance of communication, the practice of actively sounding and listening that has the potential to forge meaningful relationships and enhance our appreciation of, and concern for, each other and the environment, however we conceive that term. The "art" of immersive soundscapes is meant to encourage attentiveness by creating imaginative worlds that envelop, engage, and entrance us.

NOTES

1 R. Murray Schafer, *Our Sonic Environment and the Soundscape: The Tuning of the World* (Rochester, VT: Destiny Books, 1994), 4. Originally published as *The Tuning of the World* (New York: Knopf, 1977).

2 For a comprehensive discussion of Schafer's use of the term "soundscape," see Ari Kelman, "Rethinking the Soundscape: A Critical Genealogy of a Key Term in Soundscape Studies," *The Senses and Society* 5 (2010): 212–34.

3 Barry Truax, *Handbook for Acoustic Ecology*, CD-ROM edition, v. 1.1 (Vancouver: Cambridge Street Publishing, 1999).

4 See http://www.sfu.ca/~truax/scomp.html.

5 Schafer, *Our Sonic Environment*, 205.

6 Hildegard Westerkamp, "Linking Soundscape Compositions and Acoustic Ecology," http://www.sfu.ca/~westerka/writings%20page/articles%20=pages/ linking.html. Originally published in *Organised Sound* 7, 1 (2002): 51–56.

7 See http://wfae.proscenia.net/about/index.html.

8 Jim Cummings and Steven M. Miller, editorial in *Soundscape: The Journal of Acoustic Ecology* 7, 1 (2007): 1.

9 An octophonic sound system comprises eight speakers, positioned equidistantly around the performance space.

10 See http://www.jtbullitt.com/.

11 For a comprehensive discussion on the interaction between visual artists and musicians in the twentieth century, see "Sound and the Art World," in Alan Licht, *Sound Art: Beyond Music, between Categories* (New York: Rizzoli International Publications, 2007), 134–251.

12 Luigi Rossolo, *L'arte dei rumori* (Milan: Edizioni futuriste di "poesia," 1916).

13 Henry Cowell, "The Joys of Noise," *New Republic*, 31 July 1929.

14 Douglas Kahn, *Noise, Water, Meat: A History of Sound in the Arts* (Cambridge, MA: MIT Press, 2001), 168.

15 Quoted in ibid.

16 For more information on Fluxus, see http://www.fluxus.com. The movement remains active today.

17 For example, anticipating her activism for feminism and peace, *Wall Piece for Orchestra* (1962) had Ono kneeling on a stage and repeatedly banging her head on the floor. See http://www.a-i-u.net/onolife4.html.

18 See http://paikstudios.com.

19 For Cardiff, see http://www.cardiffmiller.com/artworks/inst/motet.html; for Rokeby, see http://homepage.mac.com/davidrokeby/vns.html; and for Monahan, see http://www.gordonmonahan.com/pages/Theremin_Pendulum.html.

20 Licht, *Sound Art*, 12.

21 Claudia Tittel, "Sound Art as Sonification, and the Artistic Treatment of Features in Our Surroundings," *Organised Sound* 14, 1 (2009): 58.

22 Leigh Landy, *Understanding the Art of Sound Organization* (Cambridge, MA: MIT Press, 2007), 11.

23 Ibid.

24 Gabor Csepregi, "On Sound Atmospheres," in *Aural Cultures*, ed. Jim Drobnick (Toronto: YYZ Books/Walter Phillips Gallery Editions, 2004), 170.

25 Ibid., 172.

26 Schafer, *Our Sonic Environment*, 205.

27 For more information on Polli's work, see her website at http://www.andreapolli.com.

28 See http://www.klanglandschaft.org/content/view/12/38/lang,en.

29 In particular, Annie Dillard, *Pilgrim at Tinker Creek* (New York: Harper's Magazine Press, 1974). For more information, see Dillard's website at http://www.anniedillard.com.

30 This is a concern shared by many soundscape composers; we will see it in Ian Birse and Laura Kavanaugh's live (though self-effacing) performances

in their installation *Removable Room* discussed in Chapter 8 and in Darren Copeland's discussion of curating electroacoustic music in Chapter 13. Polli has incorporated on occasion vocal improvisation in her *Heat and the Heartbeat of the City*.

31 Having been present at a performance of *Wild Fruits 2* by James Harley and Ellen Waterman at AIS2, I can attest to the freshness and intensity of the work as Harley electronically manipulated the sounds of the amplified flute in unpredictable patterns through the octophonic diffusion system.

32 Schaeffer's primary text is *Traite des objets musicaux* (Paris: Éditions du Seuil, 1966). The chapter entitled "Acousmatics" has been translated by Daniel W. Smith and reproduced in Christoph Cox and Daniel Warner, eds., *Audio Cultures: Readings in Modern Music* (New York: Continuum International Publishing Group, 2005), 76–81.

33 Ibid., 77.

34 Instances of Westerkamp's environmental pieces are *A Walk in the City* (1981), *Beneath the Forest Floor* (1992), and *On the Edge of Wilderness* (2000). For details of these and other works, see her website at http://www.sfu.ca/~westerka/index.html.

35 For more information on the politics of being Japanese Canadian, see Greg Robinson, *A Tragedy of Democracy: Japanese Confinement in North America* (New York: Columbia University Press, 2009).

36 Bells seem to hold special meaning for many of our contributors: Ogborn talked of the importance of the bells of Venice in Luigi Nono's work; Proy chose them as one of the iconic sounds in *Waldviertel*; Hatch used them as a soundmark in the Open Ears Festival.

37 See Mark N. Grant, "Diamanda Galás: The Extended Voice as Singing Id," http://diamandagalas.com/about/diamandas-bio/. Originally published as a blog in *The New Musicbox: The Web Magazine from the American Music Centre*, 27 August 2007. "Part exorcist, part Pentecostal channeler, part Antonin Artaud, part Tibetan monk chanting 'om' sound-processed to glass-shattering decibels, the regal, Goth-like Galás in *Imitation of Life* is the incarnation of the mythological Lilith, the she-demon as singing shaman."

38 From Negativland's website: "Over the years Negativland's 'illegal' collage and appropriation based audio and visual works have touched on many things — pranks, media hoaxes, advertising, media literacy, the evolving art of collage, the bizarre banality of suburban existence, creative anti-corporate activism in a media saturated multi-national world, file sharing, intellectual property issues, wacky surrealism, evolving notions of art and ownership and law in a digital age, and artistic and humorous observations of mass media and mass culture." http://www.myspace.com/officialnegativland.

39 In Canada, electroacoustic music and soundscape composition have been developed most actively in Montreal and Vancouver. But Copeland is in the vanguard of attempts to bridge the gap between university programs in electroacoustic music and the plethora of popular music genres that is indebted to electronic music. See also http://www.sonicpostcards.org/ for details

of a project of the Sonic Arts Network (since renamed Sound and Music) in England to encourage elementary school students to be aware of their sound environments and to experiment with information and communication technology. The project has since expanded to several other countries.

40 Barry Truax, "Soundscape Composition as Global Music: Electroacoustic Music as Soundscape," *Organised Sound* 13, 2 (2008): 105.

41 For a comprehensive discussion of the role of historical and technological developments in creating virtual acoustic environments, see "Inventing Virtual Spaces for Music," in Barry Blesser and Linda-Ruth Salter, *Spaces Speak, Are You Listening?* (Cambridge, MA: MIT Press, 2007), 163–214.

Histories

CHAPTER TWO

Beyond Sound and Listening: Urban Sound Installations and Perception[1]

María Andueza Olmedo

INTRODUCTION

In different ways, works of art conceived for specific places lead us to consider the audience's presence or, in a wider sense, the presence of the individual within the space of the work. Here I analyze sound installations in urban environments using a historical and multidisciplinary approach and focus on their reception by the "city-citizen" (a term that recognizes the reciprocal influence of the dynamic space of the city and its inhabitants). When site-specific artworks include sound as a material, they also incorporate or reinforce ideas of temporality, simultaneity, and dynamism, and these qualities are inherent to the modern city. I draw on 1960s research by urban planner Kevin Lynch to discuss the impact of urban sound installations by Max Neuhaus, Bernhard Leitner, Bill Fontana, and Bruce Nauman. These artists create works that, by immersing the citizen in sound, change and enrich his or her perception of the city.

SITE-SPECIFIC SOUND INSTALLATIONS
BEYOND SOUND AND LISTENING

Artists' fascination with sound in the urban environment can be traced to the technological innovations made possible with the Industrial Revolution and the gradual shift from primarily agrarian to primarily urban Western societies during the nineteenth century. The Industrial Revolution (with

its factories and machines) altered the quotidian rhythms of citizens and inaugurated major transformations of cities, which became complex sets of sensitive and dynamic stimuli that artists used as new materials.[2] Technology particularly occupied various modernist art movements of the early twentieth century, from Italian Futurist painting to Russian avant-garde film. For example, the well-known Futurist manifesto made this enthusiastic cry in favour of the machine age: "Let's go! Friends, away! Let's go! Mythology and the Mystic Ideal are defeated at last. We're about to see the Centaur's birth and, soon after, the first flight of the Angels!..."[3] Futurist Luigi Russolo (author of the 1913 manifesto *Art of Noises*) composed works such as *Risveglio di una citta* (Awakening of a City) on his *intonarumori*, or noise machines, in homage to the tumult, speed, and noise of the modern city.[4]

It was not until the middle of the twentieth century, however, that serious investigations of the modern city proliferated.[5] On the one hand, these investigations took into consideration the dynamic presence of the individual citizen; on the other hand, they evaluated all the relationships happening in the city in line with their social and spatial structures. Thus, in the 1960s, a series of explorations from different disciplines converged on the city. The "city-citizen" became the hub of activity for urban planning, sociology, art, and even philosophy. This binomial acquires its meaning when the concept of "city" (architectonic, urban, social, political, and economical) merges with the concept of "citizen" (the individual who inhabits and animates the city). Specialists from different disciplines, such as sociologist Henri Lefebvre and urban planner Kevin Lynch, suggest that individual citizens actively constitute what we understand as "the city"; at the same time, the city configures what we understand as "the citizen." City and citizen modify one another reciprocally.

In the artistic realm, we tend at times to separate "sound art" from other artistic practices, often lumping works together simply because they share a basis in sound. For example, both visual artist Janet Cardiff's *The Forty Part Motet* (2001) and composer Alvin Lucier's *I Am Sitting in a Room* (1969) are experiments in layering sounds within a specific environment, but they stem from very different disciplinary and aesthetic perspectives.[6] Sound art arose as the result of a series of experiments originating in different fields, such as sculpture, painting, music, dance, poetry, and theatre. I consider it essential to remember that the "sound" in sound art is related to discourses and sensations beyond sound alone.

This chapter is concerned specifically with artists who experiment with sound in public spaces. Thus, the site-specific sound installation in the urban context, far from being understood solely according to its formal qualities from the architectural or acoustical point of view, is discussed from the point of view of the immersion of the individual in the particular experience of

time and space created by a sound art installation in relation to his or her environment. This approach permits me to address sound art in everyday life from an anthropological perspective. Over time, direct sound experiences have evolved in such a way that the sound installation today is perceived "affectively." As Gilles Deleuze and Felix Guattari explain,

> The work of art is *a block of sensations, that is to say, a compound of percepts and affects.* Percepts are no longer perceptions; they are independent of a state of those who experience them. Affects are no longer feelings or affections, they go beyond the strength of those who undergo them. Sensations, percepts, and affects are beings whose validity lies in themselves and exceeds any lived.[7]

I continue Deleuze and Guattari's statement by referring to the artwork as a block of phenomena waiting to be perceived by an individual. For this reason, in the case of sound installations that intervene in public spaces, I refer to the individual or citizen who perceives the artwork rather than to the purely visual "spectator." Sounds introduced in site-specific urban artworks usually do not have representational meanings. They are abstract sounds immersed in the contextual spaces of the city that might be heard simply as integral to the urban soundscape. They need to be reactivated by the citizen in order to have a personal meaning in the context in which they are installed. Thanks to these sounds, art and life are connected in the city.

URBAN DESIGN AND SOUND INSTALLATIONS: RELATIONSHIPS AND INTERSECTIONS

Kevin Lynch, the controversial yet praised American urban planner, conducted a field study in which citizens' perceptions of the city had relevance. His exploration of the individual in the city linked his work to urban planning issues that had more to do with sociology and even art. Lynch paid attention to art as a source of structural richness for the city. In his book *What Time Is This Place?* he discusses the artistic interventions produced in the city during the end of the 1950s and early 1960s.[8] He even refers to early urban sound art experiments, although he does not mention any particular examples.[9]

Lynch began his career with a study that was intended to analyze the importance of the external appearances of the city's façades. To do so, he considered the behaviours and reactions of citizens in the urban environment. His conclusions were published in 1960 in *The Image of the City*,[10] a text that proved to be an introduction to what would be his subsequent career as an urban planner. The initial paragraphs of Lynch's book mention some of his most important ideas and advance his proposals for city planning that took effect in the following years. Two are especially relevant to my argument.

First, Lynch refers to the city as a construction or creation in space and time, which we as individuals already inhabit. Second, he writes about city design as a "temporal art," being simultaneously aware of the differences that separate it from other temporal arts.

Looking at cities can give us a special pleasure, however common the sight might be. Like a piece of architecture, the city is a construction in space, but on a vast scale, a thing perceived only over long spans of time. City design is therefore a temporal art, but it can rarely use the controlled and limited sequences of other temporal arts, such as music. On different occasions and for different people, the sequences are reversed, interrupted, abandoned, cut across. The city is seen in all lights and all weathers. At every instant, there is more than the eye can see, more than the ear can hear, a setting or view waiting to be explored. Nothing is experienced by itself but always in relation to its surrounding, the sequence of events leading up to it, the memory of past experiences.[11]

That Lynch considered relevant the perception of the individual in relation to the visual and functional features of the city brought his ideas close to the aesthetic conceptions of diverse artists working in the city.[12] His urban studies have much in common with, and can be read through, art, architecture, anthropology, or sociology, making them particularly attractive for my multidisciplinary approach. Through the analysis of some site-specific sound installations, I show how they introduce "temporal arts" through sound and listening, as parts of the particular spatial and temporal conditions of the city and citizen.

Let us consider as a first case Times Square in New York City, which is possibly one of the busiest places in the world. Since 1977, one element in the sound texture of Times Square has been the installation of the same name — *Times Square* — a constant humming sound installed by the pioneering sound artist Max Neuhaus,[13] who coined the terms "sound work" and "sound installation."[14] This hum is the result of the disturbance that air currents provoke in the sound frequency (emitted from a large speaker) that Neuhaus incorporated into the subway's ventilation path located at the north end of a triangular traffic island on Broadway between 45th and 46th Streets. The sound rises through a grate to combine with the other sounds of the Times Square environment. For decades, millions of people who have visited this tourist crossroads in the centre of New York have experienced the relentlessly resonating frequency of Neuhaus' installation. Nevertheless, how many of those who pass through Times Square perceive this vibrating sound amid the constant ebb and flow of mechanical and human movements? As Neuhaus explained, "within the nature of the sound itself lies an immense zone of meaning. Its expressions are transcultural; they are neither literal nor codified.... I have been interested in going further, letting it be the sole carrier of meaning in a sound work."[15]

Neuhaus rejected the hegemony and exceptionality of the work of art by not informing pedestrians about what they would find. He wanted to work with that part of the sound that lacked any particular meaning, as a fragment that is endowed with a sonic character. Possibly, because sound forms a part of unconscious learning, we understand and accept the sound work without any explanation. The citizen in this work is simply immersed in circumstances that cannot be differentiated from the rest of those that occur continuously in his or her environment. By its very nature, sound is integrated into the rest of the mise-en-scène, which emphasizes the context in which sound occurs, not by startling citizens but by adjusting itself to their manner of perception. Neuhaus did not set limits for *Times Square*. The intention behind this expanding sound is not to construct an object but to alter and emphasize our perception of space. Thus, the work inevitably creates a subjective sensation because it depends on each participant in the chaotic environment of Times Square.

Discovering Neuhaus' work in situ is a puzzling experience because of how indiscernible it is within the context of the city. However, in the conceptual and emotional areas, this subtle intervention unleashes an interior response. Individuals are immersed unconsciously in the work since they are not the recipients but the producers of the experience. Neuhaus introduced a sound into the space, but individual listeners complete the work when they appropriate the sound in connection to the rest of the events happening at that moment. They complete the proposal of the work with the internalization and elaboration of their own meaning. As Neuhaus stated, "For those who find and accept the sound's impossibility, though, the [traffic] island becomes a different place, separate, but including its surroundings."[16]

In order to reach this degree of creative participation, we have to presume, as Lynch proved in his study, that individuals in the space have a fragmentary perception that selects and organizes the multitude of stimuli that they receive.[17] The work of art in this context is no more than a proposal with which the pedestrian can connect at a certain moment and for whom, when confronted with the work, different factors such as temporality and movement take on importance, in addition to others, such as the surrounding visual stimuli, strongly associated with acoustics. As Neuhaus said, "Our eye and ear are constantly working together as a closely linked team to form our perception of the world."[18] But recall Lynch's words: "At every instant, there is more than the eye can see, more than the ear can hear."[19] Through their awareness of the body in the space, individuals relate to the events and the discernible phenomena in their surroundings, which lead them to adopt an active role within a concrete space. This is determined, as Lynch explained, by reference points that citizens locate in the surrounding space and that link them to the urban environment.[20] The references can be

any visual aspect that causes an individual to recognize a space. They can also be, as I argue below, a sequence of sounds that provides citizens with guidelines for reinterpreting their environment.

From my point of view, urban planning in Lynch's theory is conceptualized as creating a site-specific city for any citizen (considering the activity and the potential creativity of any person). The fieldwork that Lynch conducted for *The Image of the City* served to show that the city is not a static construction but a constantly changing process. Lynch analyzed its constituent parts to speak of the relationships that are generated between the diverse elements of the city, which he structured according to five categories,[21] and the citizens. These relationships configure in the citizens what he called the mental image of the city: that is, the image that any individual has of the city depending on his or her experience of it: "The perception of the city is a transaction between the person and the place."[22] We can refer in these terms to site-specific sound installation in the urban context. These works presume a new articulation of the space from the point of view of individual perception. Sound, for Lynch, seems to be particularly appropriate for developing our spatial awareness of the city. He even referred to the temporal organization of the elements of the city as series structured in time and thus melodic in nature.[23] These series, as he explained, are a great asset for the contemporary metropolis: the city is primarily dynamic and temporary; the structure of the city, according to melodic organization of the elements in the urban context, will take into account the movement of the citizen in the space-time of the city.

Sound Space Buchberg (1991), by Bernhard Leitner,[24] an artist trained as an architect, perfectly illustrates this idea. *Sound Space Buchberg*, installed in one of the castle courtyards in the Austrian city of Buchberg, consisted of the emission and circulation of sound signals by four loudspeakers that were distributed along the upper parts of its walls and one more sunk in the ground in the middle of the courtyard. The sound sequence proposed by the artist was presented as a succession of reference points in the space. As Dieter Bogner describes the work, "Fluttering, percussive sounds, and subtle, splintering elements are perceived by the visitor as an invisible, only acoustically perceptible roofing of the upper courtyard of Buchberg Castle. Like finely woven vellum, a delicate sound tapestry stretches out between the courtyard and the sky."[25] The sound created the illusion of a dome. The emission of sound simulated a movement in the upper courtyard and an acoustic in the space that incited individuals to create a spatial image that would correspond to this movement and have a meaning in the place.

Beyond the spatial vision that permits us to understand the tridimensional world, the spatial image projects the subjective imagination of a listener into the space. For this reason, I assert that this concept of spatial image, produced in this case by the concrete movement of sound, refers to a

visual field based on a conceptual organization that obtains its validity and meaning from the fictitious construction of the senses and the sensations. This fact, though implying an effort of abstraction, nevertheless encourages individuals to understand and place themselves within the actual plane of events. As Lynch suggested, "most often, our perception of the city is not sustained, but rather is partial, fragmentary, mixed with other concerns. Nearly every sense is in operation, and the image is the composite of them all."[26]

If we thought of a courtyard and its simplest structure, four walls that create an empty space in the middle, we would be properly situated to imagine the courtyard that Leitner utilized. The sound sequence was emitted in this courtyard from the speakers placed high up on the walls, as mentioned above. If individuals were immersed in this ambience, could they dissociate themselves from the space and time of this sequence of sound? Thanks to the capacity of sound to provoke a strong image, listeners were encouraged to produce the spatial image while the sound moved around the heights above the courtyard. A spatial image: the image of a dome. Lynch called this property of physical objects (in this case, sound) to connect the space and the individual "imageability": "this quality gives physical objects a high probability of evoking a strong image in any given observer."[27] When giving meaning to these sounds (e.g., a dome over the courtyard), listeners simultaneously recognize and rediscover the space in which they find themselves. Through their creative participation, they can project a new spatial distribution for the site. They can articulate a new manner of spatial perception, thanks to the intersection of sound and space at the moment in which they are present.

THE INDIVIDUAL PROJECTED IN SPACE DUE TO SOUND WORKS

With these reflections, I want to suggest that we conceive of a subject who is somehow projected in space through his or her perception of a sound installation. These works have traces of 1960s minimalism in how their makers rethink the space and provide it with a character that exceeds the bounds of its dimensionality. The apparent simplicity of the works, though they hide within themselves a technical complexity, is similar to the majority of minimalist works that seek to eliminate all representative functions in such a way that they become suggestive for spectators' imaginations.

The American minimalist artist Carl André, for example, cracked the exhibition space in different shows by scratching it with a steel strip.[28] The room remained empty except for the modules that made up the strip; the material, however, stopped being the centre of the work and became a detail of the space in which the object was situated. "In art, the medium is not often the message," Neuhaus would say.[29] André's work is a starting point that triggers a process of relating ourselves to the environment. Something

similar happened with the *Metaphysical Boxes* that the Spanish sculptor Jorge Oteiza made around the 1950s.[30] These sculptures, empty metal cubes with open forms, permit the spectator to see at the same time both the inside and the outside of the sculpture, which established a permanent play between the inner and the outer spaces of the sculptures. As a consequence, Oteiza's *Metaphysical Boxes* urge spectators to conceptually traverse the space *through* the sculpture. In short, André's and Oteiza's works are mentioned here because they explore, in other ways, the same proposition as Leitner's: how to achieve a more complex understanding of the body in space.

For decades, sound artist Bill Fontana has been producing works using "sound as a sculptural medium to interact with and transform our perceptions of visual and architectural settings."[31] *Harmonic Bridge* (2006) was produced amid a controversy over the strong vibrations in the structure of the London Millennium Footbridge at its inaugural ceremony. As analysts explained, "The bridge's movements were caused by a 'positive biofeedback' phenomenon, known as synchronous lateral excitation. The natural sway motion of people walking caused small sideways oscillations in the bridge, which in turn caused people on the bridge to sway in step, increasing the amplitude of the bridge oscillations and continually reinforcing the effect."[32]

After this problem was addressed, Fontana's proposal revealed the imperceptible vibrations, translated into sound, that continued to exist in the structure of the bridge: those coming from the vertical loads exercised on the bridge — the presence of people — and the lateral ones caused by the wind. Fontana recorded these vibrations and their changes in order to process them later as sound sequences continuously transformed by the structure of the bridge. He amplified them in real time in the interior of two spaces near the bridge: the Turbine Hall of the Tate Modern (London) and the subway stop closest to the London Millennium Footbridge. Although the information recorded was processed before being listened to in these spaces, I should emphasize the link established by capturing small details between the actual space and its simulation in these other sites. Through this sonic rereading of the space, the individual arrives at another conceptualization of the bridge, which responds to the movement of humans over it. As Lynch maintained, "The specific character of a site is now perhaps as much the result of human action and desires as of the original geological structure."[33] The work reveals on the bridge, which spans the Thames from Bankside to the City, the strong connection between city elements and human presence there. The sounds of the bridge together with its image, functionality, and history construct its "spatial and temporal image"; they project the individual onto the consciousness of the space itself.

The works that I am studying here not only make it easier to appreciate the sensitive dimension of space but also stimulate the projection of indi-

viduals onto the social space. The French sociologist and philosopher Henri Lefebvre, who expressed his ideas in these terms, developed the study of the social space of the city:

> (Social) space is not a thing among other things, nor a product among other products: rather, it subsumes things produced, and encompasses their interrelationships in their coexistence and simultaneity — their (relative) order and/or (relative) disorder. It is the outcome of a sequence and set of operations, and thus cannot be reduced to the rank of a simple object.... [S]ocial space is what permits fresh actions to occur, while suggesting others and prohibiting yet others. Among these actions, some serve production, others consumption (i.e. the enjoyment of the fruits of production).[34]

The work *Raw Materials*,[35] which American artist Bruce Nauman produced in 2004 for the Turbine Hall of the Tate Modern (London), connected individuals' experiences in the exhibition place with those of citizens in the city. Although his work was not installed in an outdoor location, it reconstructed a situation that is characteristic of the city: the moment at the crossroads when it is possible to hear segments of other people's conversations. While crossing the space of the Turbine Hall, visitors[36] could hear different fragments of speaking voices coming from the two longitudinal walls of the space. The work doubled a typical situation in the urban context: anyone who has walked down a crowded city street is familiar with the sensation of fragmented voices coming from different directions.

The text fragments used in *Raw Materials*,[37] each one emitted from a loudspeaker in the exhibition hall, also produced interesting reactions in visitors who entered into relationships with the space, which was completely empty except for the loudspeakers, equidistantly distributed along the hall. The video documentation[38] of the piece reveals the movements of visitors in the space. Visitors respond directly to the sonic stimuli, performing graphically Lynch's idea of spatial organization as "melodic structure." While some of the visitors seem more closely related to the sounds, moving closer to the sources of their emission, others simply cross the space in a straight line. In this case, recognition of a sequence of sounds defines a vigorous trajectory through the space along which the majority of visitors choose to walk: the longitudinal axis of the hall. Interestingly, visitors repeat this behaviour even though there are no visual guidelines. Some movements of the body in space have no functional meaning but simply reflect its reaction to various external stimuli; these movements express our relationship to our environment.

CONCLUSION

As an integrated element in the city, the site-specific sound installation contributes to our knowledge of and experimentation with the city. These works go beyond the sculptural or monumental in order to make sound a material with which to converse within the space: "the sound is not the work; the sound is the material that I make place out of, that I transform the space into a place with," as Neuhaus said.[39] Neuhaus, Leitner, Fontana, and Nauman make sound the medium that connects the individual to a space conceived for livability but often lacking it. Conceived as organizations of sounds in space, these works are transformed into subjective projections of the individual presence in the city. Works with these properties do not require a specific time of contemplation, and for that reason they adapt perfectly to the individual's impermanence in the city. In these kinds of works, movement combines with the kinesthetic appreciation of the city; they are not dissociated from the space in which they are found. On the contrary, these artistic interventions are combined with the rest of the movements that coexist in the city. As citizens become aware, through sound art installations, of the sonorous richness of the city, their skill in actively perceiving the urban system increases, while their deeper understandings of the context enrich the city itself.

NOTES

1 This chapter stems from my PhD research on "Urban Site-Specific Sound Installations" that I carried out at the Universidad Complutense of Madrid under the supervision of Mercedes Replinger and with the support of KREA Expresión Contemporánea and the Fundación Residencia de Estudiantes. The chapter has undoubtedly been enriched by the collaboration of Pauline Minevich and Ellen Waterman, to whom I am very grateful, as well as Abelardo Gil-Fournier, who contributes to the development of my research with his opinions and support.

2 See R. Murray Schafer, *The Soundscape: Our Sonic Environment and the Tuning of the World* (Rochester, VT: Destiny Books, 1994), for a fascinating history of urban sound culled from nineteenth-century literature and painting.

3 Filippo Tomaso Marinetti, "Fundación y Manifiesto del Futurismo," *Le Figaro*, 20 February 1909, in *La mirada nerviosa: Manifiestos y textos futuristas*, ed. San Martín, Diputación Foral de Guipúzcoa (Guipúzcoa: Arteleku, 1992), 93–102.

4 Luigi Russolo, *The Art of Noises* (1913), trans. and with an introduction by Barclay Brown (Pennington: Pendragon Press, 1986; reprinted 2005). Russolo's 1914 piece *Risveglio di una citta* can be heard at http://www.medienkunstnetz.de/works/intonarumori/audio/1/.

5 See, for example, Kevin Lynch, *The Image of the City* (Cambridge, MA: MIT Press, 1960); and Henri Lefebvre, *Critique of Everyday Life*, 3 vols. (London: Verso, 2002).

6 For Cardiff, see http://www.cardiffmiller.com/artworks/inst/motet.html; for Lucier, see http://alucier.web.wesleyan.edu/.

7 Gilles Deleuze and Felix Guattari, *What Is Philosophy?*, trans. Graham Burchell and Hugh Tomlinson (London: Verso, 1994), quoted in Simon O'Sullivan, "The Aesthetics of Affect: Thinking Art beyond Representation," *Angelaki: Journal of the Theoretical Humanities* 6, 3 (2001): 132.

8 Kevin Lynch, *What Time Is This Place?* (Cambridge, MA: MIT Press, 2001), 86–87.

9 It seems likely that Lynch is referring here to the "Happenings" of Allan Kaprow and Wolf Vostell.

10 Kevin Lynch, *The Image of the City* (Cambridge, MA: Technology Press, 1960).

11 Ibid., 1.

12 See the Happening movement (specifically the artworks of Allan Kaprow and Wolf Vostell) and the activity carried out by the Situationist International in France. For more information, see Mariellen R. Sandford, *Happenings and Other Acts* (New York: Routledge, 1995); and Simon Sadler, *The Situationist City* (Cambridge, MA: MIT Press, 1998).

13 For further information, see Neuhaus' website at http://www.max-neuhaus. info. *Times Square* was installed from 1977 to 1992 but was reinstalled in 2002 by the Dia Art Foundation.

14 Max Neuhaus, "Interview with William Duckworth," in *Sound Works Volume I: Inscription*, ed. Gregory Desjardins (Ostfildern: Cantz Verlag, 1994), 42–49.

15 Max Neuhaus, "Sound as a Medium," in *Three to One: Max Neuhaus* (Brussels: La Lettre Volée, 1997), n. pag., available at http://www.max-neuhaus. info/soundworks/soundasamedium.

16 Max Neuhaus, *Sound Works Volume III: Place* (Ostfildern: Cantz Verlag, 1994), 20.

17 Lynch, *The Image of the City*, 2.

18 Neuhaus, "Sound as a Medium," n. pag.

19 Lynch, *The Image of the City*, 1.

20 Ibid., 4.

21 Lynch distinguished five elements of the city: paths, edges, districts, nodes, and landmarks. See Chapter 3, "The City Image and Its Elements," in ibid., 46–90.

22 Kevin Lynch, *City Sense and City Design: Writings and Projects of Kevin Lynch* (Cambridge, MA: MIT Press, 1995), 251.

23 Lynch, *The Image of the City*, 99.

24 For further information, see Leitner's website at http://www.bernhardleitner.at/en/; and Bernhard Leitner, *Sound: Space*, ed. Christine Traber (New York: Cantz Verlag, 1998).

25 Dieter Bogner, in Bernhard Leitner, *Sound: Space*, ed. Christine Traber (New York: Cantz Verlag, 1998), 239.

26 Lynch, *The Image of the City*, 2.

27 Ibid., 9.

28 See http://www.carlandre.net; and Nick Serota, ed., *Carl Andre, Sculpture, 1959–78*, exhibition catalogue (London: Whitechapel Art Gallery, 1978).

29 Max Neuhaus, *Sound Art?*, first published as an introduction to the exhibition Volume: Bed of Sound, P.S.1 Contemporary Art Center, New York, July 2000.

30 See http://www.museooteiza.org/; and *Escultura de Oteiza: Catálogo IV Bienal de São Paulo, 1957 (facsímil)* (Alzuza [Navarra]: Fundación Museo Jorge Oteiza, 2007).

31 Artist's statement for the exhibition at the Tate Modern, London, 16 June–28 August 2006, http://www.tate.org.uk/modern/exhibitions/fontana/biography.shtm. For further information, see Fontana's website at http://www.resoundings.org.

32 Steven H. Strogatz, Daniel M. Abrams, Allan McRobie, Bruno Eckhardt, and Edward Ott, "Theoretical Mechanics: Crowd Synchrony on the Millennium Bridge," *Nature* 438, 7065 (2005): 43–44.

33 Lynch, *The Image of the City*, 110.

34 Henri Lefebvre, *The Production of Space*, trans. Donald Nicholson-Smith (Oxford: Blackwell, 2000), 73.

35 See http://www.tate.org.uk/modern/exhibitions/nauman.

36 In this case, I use the word *visitors* rather than *citizens* since Nauman was working in an indoor space devoted to art.

37 "For Raw Materials, he has selected 22 spoken texts taken from existing works to create an aural collage in the Turbine Hall. Removed from their original context, the individual texts and voices become almost abstract elements, taking on new meanings as they are rearranged as part of a single work." Emma Dexter, curator, Tate Modern, http://www.tate.org.uk/modern/exhibitions/nauman/.

38 See http://www.tate.org.uk/modern/exhibitions/nauman/about_timelapse.shtm.

39 Neuhaus, "Sound as a Medium," n. pag.

CHAPTER THREE
Listening to Venice: Remarks on the Late Nono

David Ogborn

Ascolta,
non vibra qui ancora un soffio dell'aria
che respirava il passato?
Non resiste nell'eco la voce
di quelle ammutolite?
Come nel volto dell'amata
quello di spose mai consciute?
(Massimo Cacciari, Prologue to *Prometeo*, by Luigi Nono)

Listen
does not a trace yet move, here, of the air
breathed by the past?
In the echo, does not the voice linger
of those who have fallen?
As in the face of a lover
that of wives unknown?[1]

See DVD — David Ogborn — Field Recording: Bells of Venice.

enned by Massimo Cacciari, these words stand at the beginning of Luigi Nono's magnum opus of the 1980s, *Prometeo* (1981–84, revised 1985). Cacciari's evocative libretto text references Walter Benjamin's "On the Concept of History"[2] and relates the preoccupations of Nono's late work to the political poetics for which the Italian composer had been known since the early 1950s (when he joined the Italian Communist Party, or PCI, never to leave). The audience is commanded to listen, which command one can readily connect to the extreme concern for the conditions and limits of aural perception in Nono's late work. Yet a subtle but important elision takes place in the libretto — the audience is to listen to a physical, acoustic space, a here (*qui*) and now, but this "here" is also supposed to be a relatively direct trace of history. History is folded into landscape — or, rather, into soundscape.

My remarks here focus on Nono's affinity for the specific soundscape of Venice, the city that was his life-long home, and on the profound effect that this soundscape had on his conception and articulation of sonic space. This concern for the Venetian soundscape became most evident in the 1980s, both the last decade of his life and a postlude to the terminal crisis of the PCI. At this juncture, the history of human figures in revolutionary situations that had featured so prominently in the first three decades of Nono's work ceded place to synchronic themes, though without disappearing entirely.

Between 1976's … *sofferte onde serene* … and 1979's *Con Luigi Dallapiccola* (composed on the occasion of that venerable Italian composer's death), Nono completed no other works. These three years of compositional silence correspond closely to the period of the crisis and failure of the PCI's strategy of the *compromesso storico* or "Historic Compromise." At the heart of the *compromesso storico* was the idea that the PCI would orient itself toward collaboration with the Democrazia Cristiana (Christian Democrats), the big-business party that formed Italian governments throughout the Cold War period. When first advanced by the PCI's new leader, Enrico Berlinguer, in late 1973, the strategy was presented as a response to the recent events in Chile, where a CIA-backed coup had ousted the elected government of Salvador Allende, disappeared and incarcerated thousands, and established a military dictatorship. An accord with the Christian Democrats was necessary to avoid a similar outcome in Italy as the communist vote continued to climb, or at least so the argument went. Later, as historian Paul Ginsborg notes, the Historic Compromise was presented as a wider "strategy in which Communists and Catholics would have been able to find a common moral and ethical code on which to base the social and political salvation of Italy."[3]

The strategy was put into practice following substantial gains by the PCI in the 1975 regional elections and then the 1976 national elections. From August 1976 to January 1979, the PCI sustained the Christian Democrats

in power by not voting against them — a period in Italian parliamentary history alternately referred to as the "no no-confidence governments" or the "governments of national unity."[4] The Christian Democrats (under Giulio Andreotti) had little difficulty ensuring that this arrangement did not translate into any meaningful constraints on their activities, and the strategy was finally abandoned in 1979. In the elections of that year, the PCI's support fell precipitously.[5] It would continue to fall throughout the 1980s, a process accompanied by the formation of diverse factions within the party and ultimately leading to the party's demise as a unified body.[6]

Throughout the prolonged death agony of the Italian Communist Party, Nono never publicly broke with the political formation in which he had spent most of his adult life (he had joined the party in 1952). Indeed, Nono served on the central committee of the party in the latter half of the 1970s and penned a glowing obituary of Berlinguer in 1984.[7] Nonetheless, the shifting political ground pushed forward a complex set of new or previously latent themes in the composer's work, including a special emphasis on listening. In an oft-cited 1983 lecture, later published under the title of "Error as Necessity," Nono explicitly amalgamates "listening" as the perception of acoustic phenomena with "listening" as a concept of political behaviour wherein the absence of certainty is championed:

> Silence. It is very difficult to listen. Very difficult to listen, in silence, to others. Other thoughts, other noises, other sonorities, other ideas. When one listens, too often one seeks to find oneself again in others. To find again one's own mechanisms, systems, one's own rationality in the other. This is an entirely conservative violence.[8]

The changed political context and the explicit championing of aural perception as such were both roughly coincident with Nono's adoption of the medium of live electronics. From *Con Luigi Dallapiccola* (1979) to the end of his life (1990), the overwhelming majority of his completed compositions employed live electronic means. This was not a technical rupture for Nono, for his previous work in the tape studio (the Studio di fonologia of RAI, the Italian public radio) involved a performance practice in which every configuration of loudspeakers, every diffusion of a tape, every performance of a piece of *musica mista* (literally, "mixed music": i.e., music for tape and live performers) was always approached anew and subjected to continual change and experimentation.

Such precedents notwithstanding, the intersection of Nono's interest in live electronics with the environment, expertise, and apparatus of the Experimentalstudio Freiburg, from 1979 to 1990, remains one of the most significant transformational moments in the musical history of the twentieth

century. From the late 1960s onward, Hans Peter Haller and others at the Experimentalstudio (a project of the public radio of southwest Germany, the SWF) had developed innovative devices for real-time sound control and transformation together with a well-documented composition and performance practice around those devices.[9] Working with Haller, and later André Richard, Nono centred his compositional activity at the Experimentalstudio on a process of interaction with virtuosic, individual performers on the one hand and with the spaces of performance on the other.[10]

The necessity of working closely with the performers arose from two principal considerations. In the first place, just as with composition in the tape studio, sound transformations needed to be evaluated in close connection with the precise sounds to be transformed. As Nono wrote in a 1986 tribute to his long-time collaborator in the tape studio of the RAI, Marino Zuccheri, "The first lesson: the electronic studio requires not preconceptions worked out on the desk but rather study, experimentation, always listening in real time to each moment, with a passionate patience, beyond 'time,' with a continual deepening of utopian thinking and knowing, both possible and impossible … including the use of space."[11]

In the second place, to the impossibility of a priori work with sound transformations (as well as Nono's established tendency to collaborate closely with performers in developing compositions), the live electronics medium adds another consideration: the performers in a live electronics context need to change the way that they play, above all to accommodate and incorporate their interactions with the microphones.[12] Nono worked closely with performers not only to unearth new sounds for his own activity but also to help them unearth or acquire new sounds and modalities for their own activity. Flautist Roberto Fabbriciani, who worked with Nono in the Experimentalstudio from the earliest days of the composer's time there, testifies to this mutual process of exploration:

> Nono would ask me to realise extraordinary sounds on the very edge of the audible/inaudible. Within these sonorities he would then look for stimuli to new ways of thinking and listening. I used to experiment on the basis of his requests and often I created systems for realising futuristic sound worlds by means of the flute. *We* began long experimental sessions which lasted up to two weeks, recording, cataloguing and refining the products of *our* experimentation, with a view to using them organically in the drawing up of a piece. The executant proposed and the composer chose, and though conscious of the beginning, *we* were never certain of the end. Sometimes, after days spent in the studio in Freiburg, *we* abandoned all the work done and set off again in the direction of an extraordinary and beautiful

universe, with the desire to explore the amazing undercurrents of sound. With humility, *we* were spurred on by the desire to experiment to the utmost limits with *our* instruments, and with *ourselves* and the instruments, in playful and *reciprocated provocation*.[13]

In this sense, there was an intermingling of the creation, rehearsal, and performance contexts wherein the creation context gave new possibilities not only to the composer but also to the performers. Other performers who worked closely with Nono at this time included Susanne Otto (alto voice), Ciro Scarponi (clarinets), Giancarlo Schiaffini (tuba), Stefano Scodanibbio (double bass), among others. Fortunately, many of them remain active as interpreters of Nono's music and as teachers of the performance practice integral to faithfully representing Nono's work after the passage of two or more decades.

Alongside the intense performer-composer collaborations, the other critical pole of Nono's creative process with live electronics was the cardinal importance given to the spatial aspect of sound. In this connection, Haller draws an important distinction between *geometrische Raum* (geometric space) and *Klangraum* (sound-space). Geometric (or mathematical) space is defined by three-dimensional Cartesian coordinates and thus consists merely of positions and/or extents within a system of numerical coordinates. Sound-space, on the other hand, consists of "controlled or uncontrolled acoustic information within a geometric space,"[14] and is fundamentally a psychoacoustic rather than a physical phenomenon. According to Haller, Nono's work at the Experimentalstudio progressed quickly from an initial orientation to geometric space toward a wider orientation to sound-space, which "can correspond to geometric space but which does not necessarily correspond to geometric space."[15] Live electronic means enabled the composer to "play a not-exactly-definable game with sound."[16]

In other words, there are spatial possibilities for live electronic sound that are not necessarily described or perceived primarily in terms of position (i.e., geometric space) or that might in fact be perceptually ambiguous in terms of positional information. Such positional complexity is a recurrent and important feature of the late Nono oeuvre that requires particularly careful attention during performance. For instance, in the 1985 work *A Pierre dell'azzurro silenzio*, dedicated to Pierre Boulez and scored for contrabass flute, contrabass clarinet, and electronics, the first gesture of the piece consists of a gradual introduction of amplification of the two instruments in the left (front) and right (front) speakers. Because the contrabass clarinet sits to the right but is amplified in the left speaker, while the contrabass flute sits to the left but is amplified in the right speaker, the function of the electronics is to introduce confusion about the locations of the sound sources.

The specific role of the live electronics performer is to ensure, by listening and moving the faders sensitively, that this confusion takes place.[17] The generation of electronic sounds *ex nihilo*, whether from sampled recordings or by synthesis from first principles, is foreign to Nono's late work, and the function of the electronics is instead to exaggerate, amplify, and redeploy acoustic phenomena, so as to enable heightened forms of listening.

In the first composition that Nono completed in the Experimentalstudio (1981's *Das atmende Klarsein* for choir, bass flute, and live electronics), the electronics are simply several prepared "tapes" (based on recordings of flute improvisations by Roberto Fabbriciani) as well as live amplification/spatialization of the flute using the Halaphon, the Experimentalstudio's main device for spatialization and a fixture of many of Nono's works in the 1980s. In essence, the Halaphon provides a form of amplitude panning between sets of loudspeakers within arrays of loudspeakers, with the ability to describe "idiosyncratic" and complicated trajectories.[18] In live performance, the electronics performer typically has control over, and responsibility for, the rate at which the device progresses through a given complex trajectory.

Although Nono would continue to develop and differentiate the spatial aspect of his compositions throughout his decade of live electronics work at the Experimentalstudio, the concept of a more complicated, dynamic, and potentially ambiguous sound-space was manifest early and in an emphatic way. For Nono, this was no doubt a development and an extension of an alternative twentieth-century avant-garde theatre tradition. In writings as early as the beginning of the 1960s, he criticized the traditional theatre for its frontal visual focus, its separation of audience and performers, and the way that sound (i.e., speech) and sight exist as a unified layer rather than as media that can be developed independently.[19] Nono's early criticisms of the theatre have a spatial focus.

The spatial emphasis in his late work is not, however, merely a *negation* of traditional theatre practices. It is also a *positive* reflection and representation of his sound environment and the soundscape of his life-long home, Venice, in particular. Nono repeatedly went on record regarding his relationship to the Venetian soundscape. This is especially apparent in a 1998 interview for French television. While floating in a boat off the shore of the Giudecca, Nono's long-time home and an island immediately south of Venice proper, he tells the interviewer:

> That has been my house on the Giudecca since the beginning of my marriage with Nuria in 1955. Silvia and Bastiana came into the world here, many years ago. And now I hear these things too. What does silence mean to me? It is not emptiness but rather all the tiny sounds, all the tiny noises, the tiny voices in motion that have greatly

influenced my thinking about sound. In this silence, one hears tones of diverse origin, reflected in the water. Here sounds and voices arrive indirectly. I also hear many voices, those of Silvia, of Bastiana, of friends, of the year 1968 when the students came from Nanterre, from Berlin, Rudi Dutschke, Marcuse. The voice also of Karlheinz Stockhausen, of Hartmann, Bruno Maderna, the voices of Ljubimov, of Claudio Abbado, before *Al gran sole carico d'amore*....[20]

Starting from a historical reflection on the contemporary state of the island that has been his home for so long, Nono proceeds to reflections on the acoustic characteristics of the Venetian lagoon, where "sounds and voices arrive indirectly" "reflected in the water," and as if to underline this he says that he "hear[s] many voices." Only in the next phrase do we realize that he has changed the topic; now he is speaking not about the tiny voices reflected in the water but about the voices of people who were close to him at one or another time. Or are they the same thing for him? Does one suggest the other? Either way, it is a wonderful transition or amalgamation, and it underlines the pride of place occupied by the Venetian soundscape in Nono's perceptions. We can discern three broad elements of this sound world in his late compositional thought and practice: waves, bells, and an orientation toward general spatial and dynamic complexity.

In 1976, immediately before the period of relative compositional silence preceding his late work, Nono completed a beautiful piece for piano and tape, ... *sofferte onde serene* ... (... suffered sweet waves ...), in which the two intricate parts swell, decay, and break against each other like waves in the lagoon. The relationship of the piece to the Venetian soundscape is explicitly signalled in the work's title. The shape of waves then recurred in the ensuing decade in a number of pieces in which the function of the electronics is to allow sounds to crash through the hall repeatedly. For instance, in *A Pierre dell'azzurro silenzio*, discussed above in connection with the quest for ambiguous spatialization, a principal element of the electronics is the interplay among two front loudspeakers, two rear loudspeakers, and a set of delay lines. The dynamic form of the composition in the space is that of a mass of fluid rolling gently back and forth within the concert hall.[21]

The distinct spatial separation of the various church bells around Venice provides a major historical and contemporary soundmark of the city. A sample of the complicated combination of multiple sets of church bells can be heard on the DVD accompanying this book; I made this field recording (both for use in my own creative practice and to support research on Nono) at 5 p.m. on 3 November 2007 from the northernmost corner of the island of San Giorgio Maggiore, roughly twenty metres east of the San Giorgio *vaporetto* terminal and only several hundred metres east of the Giudecca. It

is difficult to capture in a stereo recording the full spatial complexity of large bells ringing in different parts of this small city at the same time. Nonetheless, multiple distances and directions are apparent. Most notably, a more distant bell tower appears near the three-minute mark as the closer bells from the beginning of the recording cease ringing. It is especially striking how, in Venice, the heavy low-frequency components from passing boats (not at all attenuated by high-pass filters in the recording) do not obliterate all the tiny sounds of water, docks, footsteps, and so on.

Nono also explicitly discusses the bells in the 1988 television interview:

> How can one perceive the various tone qualities? For me, the quality of a tone is important, far more important than its substance. The type of tone, where it comes from, where it goes…. When there is a fog, the bells warning of the island, DONG, DONG, DONG, unswervingly constituting sound fields of ceaseless magical power. This compels one to develop one's capacity for listening. It enables one to perceive these sounds. It really is a sound, not only water…. All of this leads to a certain type of musical thinking that stands opposed to academic music. Music becomes an element of life, an element of listening, of the soul, of the heartbeat, of emotion, of emotional experience, containing — one cannot call it anything different — Magic. *The true mystery, Venetian space.* Everything comes without forewarning, like the beginning of Mahler's First Symphony. One is completely immersed in it. Here it is exactly the same. I have always been immersed in this music.[22]

Interestingly, Nono mentions "sound fields" in connection with the bells, using vocabulary that entered the lexicon in the 1950s in the context of serialism and the Darmstadt school. In fact, from the middle of the 1950s onward, Nono heavily used a technique of intuitively overlapping multiple voices of serially differentiated rhythmic patterns[23] — precisely the rhythmic technique rejected by Karlheinz Stockhausen in his well-known essay on "…How Time Passes…" as not rising to a supposed state of the art of serial composition:[24]

> To compose separate parts as *polyrhythm* is a stylistic error; and this criticism led to a result which is certainly the most relevant for further developments. One said to oneself: when, in an initial phase of the structure, three such subharmonic time-series overlap, and in a second one, five, etc., there results an overall impression of varying density, and the average speeds are a complex result of serial density-relationships. It is also possible, in the process, to take the parts so far

from their original function as "voices" — i.e., their "register" — that they become merely inextricable threads in a network, and this network must be audible only as such, and not as a superposition of parts. If in the end one carries such polyrhythmic complexes so far that the "pointillist" hearing of the individual duration-relationships turns into structural hearing, then serial method will be concerned, above all, with such *statistical form-criteria*, with average relationships.[25]

Admittedly, Stockhausen's insight regarding the parts becoming audible primarily as part of the whole is valid in relation to the serial rhythmic textures deployed by Nono in a work such as *Il canto sospeso* (1956) — even though Nono did not use the basic "subharmonic"[26] series of numbers 1 through 12 that is the main object of Stockhausen's concern. Nonetheless, Nono adopted the "polyrhythmic" technique — which resembles the polyphony of Venetian bells so closely — more or less precisely at the moment when it was declared out of step with a mathematically or numerologically inspired "state of the art" of serial composition. A basic orientation toward concrete materials and experiences (as opposed to mathematical and numerological abstractions) was manifest even at this early juncture.

The "bell-compatible" serial rhythms of the 1950s play a role up to the end of Nono's oeuvre, albeit subject to new processes of transformation. In Nono's works of the 1980s, long rhythms are often generated by fragmenting and selecting from sketches of serially generated rhythms (often referred to in multiple places in the complex web of reused, varied materials that characterizes his late work) and then overlapping such rhythms with other similarly derived voices. In places, sounds are even employed that directly suggest the sonic phenomena of Venetian bells. In the middle section of the 1982 live electronics piece *Diario Polacco n. 2: Quando stanno morendo ...*, for instance, a deep bell-like sound is obtained from the cello and live electronics by a combination of gentle pizzicati with downward pitch shifting and reverberation. In a less specific and more intuitive way, one can hear bells in the dynamics of many of the choral voice parts of the late Nono, in a certain preponderance of collectively articulated *forte-piano*s, as well as in the counterpoint of rhythmic values.

Venice is a complex soundscape not only on account of the sound "makers" that it contains but also by how the physical features of the city project and modify sound. Nono was attuned to the idea of tiny sounds that arrive "indirectly": that is, reflected off the numerous surfaces of stone and water, transmitted through the numerous tunnels, and bent around the many blind corners of the city. In addition to the evocation of specifically Venetian sounds such as waves and bells, one finds in the late Nono a general orientation toward spatial and dynamic complexity. For instance, the existing

literature emphasizes the element of continual change and motion in his work,[27] and in the 1988 interview Nono relates this specifically to characteristics of his environment:

> The south side of Venice here is quite extraordinary. This wide open space, this endlessness, the silence, the changing colours and weather conditions. Often I remain standing here, motionless, and watch, listen to, all that takes place. The colours are constantly transforming, the seasons, the wind, the calls, the sounds.... That over there we Venetians call *gibigiana* — the play of light from the water dynamically transformed by the stones and the wall. There is nothing static. Not only the water but also the earth is active....[28]

The various threads of Nono's live electronic composition (the mobility of sound in space, polyrhythmic textures, reference to Venetian soundmarks, etc.) all flow into *Prometeo*, his magnum opus of the first half of the 1980s, as musical materials and sketches for many pieces are reused in the sketches and realization of this giant "tragedy of listening." Essentially an "opera" for the ear alone, *Prometeo*'s labyrinthine multimovement structure is conceived of as a set of *isole*, or islands, like those of the Venetian lagoon. Mounting the work required the construction of a large, dedicated wooden space, designed by architect Renzo Piano, inspired by the inside of a violin, and installed within another acoustic space, the church of San Lorenzo in Venice. Haller's account mentions Nono's reading about historical instances in which musicians performed in San Lorenzo on specially constructed physical structures, which the composer took as a sign that *Prometeo* needed to happen there.[29] The space was constructed and manipulated according to musical and acoustic rather than visual considerations and was shared by the audience and musicians (a large "mixed consort" that included choirs, strings, and many of the virtuoso soloists with whom Nono had developed his live electronics performance practice). The stark silences and the overall enormous dimensions of the work encourage the kind of detailed listening demanded explicitly by the work's text — to listen for history's victims and tragedies, unknown possibilities, and alternative routes — but they are just as easily heard as programmatic evocations of the scale and mystery of the Venetian lagoon.

Friedemann Sallis has argued convincingly against those who, perhaps all too eager to discard the complicated legacy of the avant-garde, would exaggerate the element of rupture between Nono's late work and that which preceded it.[30] Indeed, it is striking how much the general structure, process, and intention of Nono's work remained unchanged in the new period that emerged following the Historic Compromise. The differentiation of materi-

als (i.e., the avoidance of obvious repetition) is still emphasized, the works are the result of a multistage process of generating and selecting materials, and the mounting of any given work is still just as likely to involve both performance/rehearsal challenges and challenges to the prevailing social organization of music making. Yet the surface character of Nono's work is undeniably very different from that of his earlier work. How is this stylistic shift to be understood then? What I am suggesting here is that *conscious and specific* attention to the soundscape of Venice was a key ingredient in the shift and that Nono was "well equipped" to make that shift because he had been employing techniques derived from that sonic environment throughout his life. His special contribution to the postwar avant-garde thus lies not only in what his political commitments might expose about the relationship between art and politics in the Cold War context but also in the way that his acute awareness of, and attention to, a particular social and sonic environment was sublimated into concertized music making.

NOTES

1 English translation mine.

2 Walter Benjamin, "On the Concept of History," 2nd thesis, in *Selected Writings: Volume 4, 1938–1940*, trans. Edmund Jephcott et al., ed. Howard Eiland and Michael W. Jennings (Cambridge, MA: Harvard University Press, 2003), 390.

3 Paul Ginsborg, *Storia d'Italia dal dopoguerra a oggi: Società e politica 1943–1988* (Milan: Einaudi, 1989), 480.

4 James Ruscoe, *On the Threshold of Government: The Italian Communist Party, 1976–81* (New York: St. Martin's Press, 1982), 90–96. The Italian term for "no no-confidence" is the considerably less alliterative *non sfiducia*.

5 Simon Serfaty and Lawrence Gray, *The Italian Communist Party: Yesterday, Today, and Tomorrow* (Westport, CT: Greenwood Publishing Group, 1980), 75.

6 One contemporaneous account of the final years of the PCI is provided by Stephen Hellman, *Italian Communism in Transition: The Rise and Fall of the Historic Compromise in Turin, 1975–1980* (Oxford: Oxford University Press, 1988), 218–20.

7 Luigi Nono, "Le sue parole e le sue grandi drammatiche solitudini," *L'Unità*, 16 June 1984. Reprinted in Luigi Nono, *Scritti e colloqui*, 2 vols., ed. Angela Ida De Benedictis and Veniero Rizzardi (Milan: Ricordi, 2001), 1: 397–99.

8 Remarks by Nono on 17 March 1983 at a concert in Geneva ("Contrechamps"). First published as "L'erreur comme necessité," *Révolution* 169 (1983): 50–51. Reprinted in Nono, *Scritti e colloqui*, 1: 522. English translation mine.

9 See both volumes of Hans Peter Haller, *Das Experimentalstudio der Heinrich-Strobel-Stiftung des Südwestfunks Freiburg 1971–1989: Die Erforschung der Elektronischen Klangformung und ihre Geschichte* (Baden-Baden: Nomos, 1995).

10 See Hans Peter Haller, "Nono in the Studio — Nono in Concert — Nono and the Interpreters," *Contemporary Music Review* 18, 2 (1999): 11–18.

11 Luigi Nono, "Per Marino Zuccheri (1986)," manuscript in the possession of Alvise Vidolin. Reprinted in Nono, *Scritti e colloqui*, 1: 406–13. English translation mine. This tribute to Zuccheri was also a protest against the dismantling of the tape studio by the RAI administration.

12 See Veniero Rizzardi, "Notation, Oral Tradition, and Performance Practice in the Works with Tape and Live Electronics by Luigi Nono," *Contemporary Music Review* 18, 1 (1999): 47–56.

13 Roberto Fabbriciani, "Walking with Gigi," *Contemporary Music Review* 18, 1 (1999): 7–15, at 9; emphasis added.

14 Haller, *Das Experimentalstudio der Heinrich-Strobel-Stiftung des Südwestfunks Freiburg 1971–1989*, 2: 149. English translation mine. Haller also introduces the concept of *Zeitraum* (time-space), which refers to phenomena in which a direct interdependency of time and physical extent is established, such as reverberation and echoes. An expansion of the possibilities of sound-space involves an awareness of this space also.

15 Ibid., 2: 150. English translation mine.

16 Ibid. English translation mine.

17 I am grateful to André Richard and the rest of the team from the Experimentalstudio Freiburg who mounted a workshop, in November 2007, at the Archivio Luigi Nono and the Fondazione Giorgi Cini (Venice), on the performance of Nono's work for live electronics. My participation in this workshop was much assisted by a grant from the Forberg-Schneider Stiftung. During the workshop, we performed *A Pierre dell'azzurro silenzio* and discussed this moment in the piece. The live electronics performer has to aim at creating this spatial confusion — it does not happen mechanically or automatically!

18 The music publisher Ricordi, in close association with the Archivio Luigi Nono, now releases the score to *Das atmende Klarsein* together with an instructional DVD demonstrating the extended flute techniques integral to the work and including interviews discussing aspects of the live electronics (Ricordi 50485990).

19 Luigi Nono, "Possibilità e necessità di un nuovo teatro musicale," *Il filo rosso* 1 (1962): 86–89. Reprinted in Nono, *Scritti e colloqui*, 1: 118–31.

20 Luigi Nono, *Archipel Luigi Nono*, film/television interview by Olivier Mille, SW3/Artline Production, September 1988. English translation mine.

21 For this insight also, I am indebted to the instruction of André Richard at the November 2007 workshop on the performance of Nono's works with live electronics.

22 Nono, *Archipel Luigi Nono*. English translation mine; emphasis added.

23 The basic technique is to choose a basis unit (e.g., sixteenth notes) for a given voice and then generate a rhythm by multiplying that basis unit by some set of multipliers (e.g., numbers drawn from the set 2 3 5 8 12 17 in *Il canto sospeso*). For a more detailed discussion, see Carola Nielinger, "'The Song Unsung': Luigi Nono's *Il canto sospeso*," *Journal of the Royal Musical Association* 131, 1 (2006): 83–150.

24　Serialism refers to an ensemble of post-World War II compositional techniques in which many or all musical elements (pitches, durations, dynamic markings, etc., as well as combined structures of these elements) were organized via systematic techniques of permutation, whether or not these orderings were later subject to more "intuitive" variation and selection activities by the composer.

25　Karlheinz Stockhausen, "…wie die Zeit vergeht…," *Die Reihe* 3 (1959): 13–42. Translated by Cornelius Cardew as "…How Time Passes…" in the English edition of *Die Reihe* 3 (1959): 10–40, at 15.

26　By a "subharmonic" series, Stockhausen was referring to the fact that, if one constructs a system of durations based on twelve *multiplications* (from 1 through 12) of a given small duration, this is the opposite of the operation that produces the harmonic series (which grows upward by *divisions* of the period of a given function).

27　For instance, Manuel Cecchinato, "Il suono mobile. La mobilità interna ed esterna dei suoni," in *La nuova ricerca sull'opera di Luigi Nono*, ed. Gianmario Borio, Giovanni Morelli, Veniero Rizzardi (Firenze: Leo S. Olschki, 1999), 135–53.

28　Nono, *Archipel Luigi Nono*. English translation mine.

29　Haller, *Das Experimentalstudio der Heinrich-Strobel-Stiftung des Südwestfunks Freiburg 1971–1989*, 2: 158.

30　Friedemann Sallis, "Le paradoxe postmoderne et l'oeuvre tardive de Luigi Nono," *Circuit* 11, 1 (2000): 68–84.

Environments

CHAPTER FOUR

Ice + Air + Water + Dust: Sonifications of Global Environmental Phenomena[1]

Andrea Polli

INTRODUCTION

How is the artistic process of transforming data different from the process of transforming physical material? Like a photograph, a data set is a representation; unlike a photograph, this representation can be entered, explored, and transformed. A data set can be experienced, but unlike a physical world experience it can be replayed from various points of view and under different conditions. Simulations are tested against the real world, and results either confirm the model's accuracy or force scientists to reconsider and redesign the model. In some cases, the simulation precedes and can even cause events in reality. Scholar and artist Brett Stalbaum defines one of the most important roles of a contemporary database artist as the projection of meaning onto meaningless data streams.[2] This process mirrors the interpretation of data in the sciences, which is also a search for meaning.

Toward the end of the nineteenth century, a technology that created an almost complete dissolution of the boundaries of art and science was photography. This imaging technology created a representation of the "real" never before seen. The chemical accuracy of a photograph proved to be scientifically measurable, and the magic and power of photographs,

See DVD — Andrea Polli — for an audio excerpt from Heat and the Heartbeat of the City.

though not immediately accepted as a fine art, served as "art" for millions of viewers. Early in the development of photographic technology, it became clear that photographic images could be used to reveal truths unseen by the naked eye. In particular, photographs could fix motion and reveal patterns of movement. In the early 1880s, Etienne-Jules Marey experimented with the portrayal of motion using photographic technology. He pioneered a method of moving unexposed film called "chronophotography" and used this technology to study the mechanics of motion.

Marey's work helped to bring about motion picture technology, but some of his more interesting works are still images that attempt to isolate the "purity" of motion by dressing models in all black with white stripes, dots, and electric lights placed lengthwise along the limbs and at axis points. This work might have inspired other artists such as Marcel Duchamp and art movements such as Futurism to explore new ways of portraying the complex movements of figures and objects in space. Marey's interest in human and animal motion, however, went far beyond his photography studio. Marey was a physician and inventor whose first invention, the "sphygmograph," recorded human pulse beats. He also invented the "kymograph" to measure the wing movements of bees, the "chronograph" to measure time intervals, and "Marey's tambour" to measure subtle human and animal movements.[3]

The work of Marey, particularly that which used photographic technology, was not clearly identified as art or science because the work so clearly integrated the imaging (or "art") medium of photography with the scientific study of human and animal motion. Perhaps part of the reason for this comfortable fusion was because, at the time, photography had not yet been accepted widely as an art medium.

In 1996, I began exploring the use of a custom-designed instrument for sound performance with eye movements. I performed with various versions of this instrument for over five years, in a project called *Active Vision*, producing several recordings, including the audio CD *Retina Burn*, in which the eye movements manipulate helioseismology, the sun's sound waves. In retrospect, I think that I created this work to relate metaphorical connections in my mind between the computer screen and the retinal image: that is, the screen is made of a flat grid of pixels, and the retinal image is a flat projection of colour and pattern and the idea of a crossing over of the senses. The retinal image itself lacks the depth and meaning of the real world; it is only through the process of interpretation that an understanding of the world is formed. In a similar way, information stored in a computer has no real meaning until it is interpreted, and it must be interpreted not only by the computer program but also by a human interacting with the machine. In this work, the image of the eye, usually the receiver rather than the transmitter of an image, is received by the computer via its video

capture card. The computer then takes this material information (the bits and bytes that make up the image) in real time and translates it into sound, which is then perceived by the ears of the viewer. In some sense, this metaphorical synesthesia has turned the computer itself into the metaphorical synesthetic along with the viewer/listener. My interest in this synesthetic effect continued in my later work with the environment.

LOCATION-BASED MEDIA

Like photography at the end of the nineteenth century, contemporary technological developments in networked, global media, for example Global Positioning System (GPS), have not been accepted as mainstream artistic media. Like Marey, people working in these areas do not always identify themselves with a distinct category of art, science, or technology. In an online think tank in 2004 called location_focus created by Naomi Spellman and Brett Stalbaum to investigate issues of mobile and other location-based media, Drew Hemment defined locative media as media that use "portable, networked, location aware computing devices for user-led mapping and artistic interventions in which geographical space becomes the canvas."[4] Locative media practice draws on various disciplines and techniques that blur the boundaries of art and science: locative media projects fix movement information in time, as Marey's early photographic experiments did, but they also transform movement information in real time through direct interaction with the environment.

In addition to developing an extensive bibliography of locative media works, location_focus aimed to identify some major themes in the field. One major issue identified was access to development tools. Development in mobile and locative media has been slow because, until recently, access to this developing technology has been limited. During the discussion, artist Lize Mogel summed up both the promise of and the problem with the technology:

> I'm interested in location-based work (or cartographic/geographic/ site-based practice) because it can be populist, offers a methodology or product/artwork that can have a far-reaching social and political effect, and has the potential to have an extremely wide distribution within a geographic or social body.... The reason that GPS-enabled devices etcetera haven't tempted me yet is that much of this technology is not readily available/affordable to the general public, and within art practice, necessitates a familiar or more wired/elite audience.[5]

Many people developing work in this area have had to work around restrictions built into commercial products, which can require a fair amount

of hacking both the hardware and the software. Many companies create huge barriers to independent creative test projects. However, the need for advanced technological skills does not necessarily result in projects that cannot easily be identified as art or scientific research. Working in early digital video required a high level of technical expertise, but the works created easily fit into the category of video art. During the location_focus discussion, Ewan Branda approached the question of why locative media projects might not easily fit into the category of art:

> I'm interested in the challenges of writing histories of what the art critic Jack Burham called in the 1960s the "unobject," whose properties deny its own objecthood and in which processes of change are integral to its historicity — in short, environments. In my view, landscape is the quintessential unobject. Its history (more often told by cultural geographers than by architectural historians) runs in parallel to that of modern informatics and suggest[s] reciprocities between paradigms of information technology and ways in which we interpret and make use of landscape.[6]

Branda raises two important ideas here. One is Burnham's idea of the "unobject" that places locative media in the realm of performance or conceptual art. The unobject defies the traditional gallery and museum system by refusing to be bought and sold like a conventional art object. This lack of a physical object requires the artist and audience to focus on the process, which can be compared with the scientific process of experimentation and discovery. Branda relates the unobject to landscape, addressing the issue of scale in locative media. Although locative media map information to the landscape, typically the scale of the mapping is actual size; in other words, the "map" and the landscape are one and the same. Branda's second point relates to the study of the history of landscape and positions it primarily in the purview of cultural geographers rather than architectural (art) historians. Branda then maps the history of modern landscape to the history of informatics, making the observation that the landscape metaphor is the primary means by which we make sense of the vast "landscape" of data.

Siva Vaidhyanathan explores the social and political dimensions of mobile and locative media in his book *The Anarchist in the Library*, illustrating tensions between a tendency toward anarchy that he sees as inherent to distributed systems and an opposite tendency toward control or oligarchy.[7] Locative media and other networked media are not limited by political or geographic borders. Peer-to-peer systems allow remote collaboration, resource sharing, and political organization among individuals and groups at great distances from one another. The ability to access satellite commu-

nications gives individuals a vast amount of power, such as using satellite jamming to disrupt television broadcasts.

Geography takes on a new meaning when applied to these systems, making physical borders completely porous but, as Mogel observes, creating new, difficult-to-surmount borders formed by restrictions to access and protocols. To Vaidhyanathan, the technologically mandated tendency toward anarchy is matched by a strong trend of social control, with governments using the same technology for widespread surveillance and monitoring. In the area of location-based media, there have been trends recently toward restricting access to location-based information: for example, Google Maps blurs certain government buildings, and there has been political action toward restricting public access to geographic data, used widely by students and teachers, amateur geographers and meteorologists, and people concerned about air quality or simply curious about the weather.[8]

Vaidhyanathan does not try to make an argument for total cultural or information anarchy; in practice, he points out that "some anarchistic information systems allow bad people to do bad things,"[9] but the populism that Mogel talks about and the tendency toward information anarchy that Vaidhyanathan describes open possibilities for a reconsideration of disciplinary boundaries, particularly in the cultures of art and science. By aesthetically interpreting geographical data, artists are reconsidering disciplinary boundaries and creating new pathways for understanding location-based information.

ECOMEDIA AND DATA ART

Sean Cubitt used the term "ecomedia" to describe popular film and television works that address environmental concerns, and the term has been used in marketing environmentally conscious videos and websites by various production houses internationally.[10] Although the use of existing media, including the web, for dissemination of environmental information is extremely important, I would like to create a narrower definition of ecomedia as media made with the emerging technologies, tools, and information structures that describe and model environmental systems. This is because ecomedia is a place where a transformation is taking place, and new forms are emerging in my own work and the work of other media artists.

My definition of ecomedia encompasses locative media projects that use environmental data. These can be data such as geography, weather conditions, and air quality but can also be information about the human ecosystem such as census data, urban development, and even social interaction. Ecomedia can also include work using environmental data that is not tied to a static location, for example the patterns of various global systems. Because the data sets for geographic systems can be very large, ecomedia projects often

involve some kind of data mapping, translation, or interpretation. In his 1977 work *The Aesthetic Dimension*, Herbert Marcuse writes that, under the law of aesthetic form, reality is necessarily sublimated, content is stylized, and "the 'data' are reshaped and reordered in accordance with the demands of the art form, which requires that even the representation of death and destruction invoke[s] the need for hope."[11] When Marcuse uses the term "data," he is not referring to digital data; instead, he is talking about the raw material of experience. However, I believe that digital data are part of the landscape of raw material, and when these data describe the disappearing natural world their interpretation, both scientifically and aesthetically, is crucial to human survival.

The process of translating data into an unfamiliar form for an aesthetic purpose can also be compared with the "negation" process, one of the primary aesthetic goals of the Situationists. In defining the term "negation," Guy Debord states that "the operating pattern of the dominant society … reconstitutes itself within the forces of negation."[12] In other words, if traditional ways of interpreting information — spreadsheet, visual graph, text document, et cetera — are the "dominant" forces, in our digital society, in the manner of the Situationists, data benders negate this dominance through brute force and therefore negate meaning in order to rebuild it.

Lev Manovich's influential article "The Anti-Sublime Ideal in Data in Data Art" analyzes data mapping by artists, specifically visualization, from political and aesthetic perspectives. Manovich defines the "anti-sublime," much like traditional mapping, as the process of taking a vast expanse of the data landscape and transforming it down to the scale of human perception and cognition. The "sublime" of the Romantic artists, in contrast, is defined as the idea that some phenomenon is unrepresentable, going beyond the limits of the senses. Although Manovich states that he often finds works that he defines as anti-sublime emotionally moving, at the end of his article he challenges artists in our increasingly data-saturated environment to "represent the personal subjective experience of a person living in a data society."[13] In a similar vein, Mitchell Whitelaw, an Australian art historian who writes about database art, encourages database artists to work to find other meanings, to transcend the day to day, and to "evoke the sublime."[14]

In writing about database art, both Stalbaum and Whitelaw reference the Romantic sublime. George P. Landow defines the Romantic sublime as the immersion of the viewer in a subjective dynamic landscape, using as an example the early-nineteenth-century paintings of J.M.W. Turner portraying storms. He states that, "In other words, in place of the static composition, rational and controlled, that implies a conception of the scene-as-object, Turner created a dynamic composition that involved the spectator in a subjective relation to the storm."[15] A kind of subjective immersion using new

technologies is part of Stalbaum's and Whitelaw's interest in database art. Like the paintings of Turner, the experience of database works can evoke an emotional reaction, such as pleasure or terror, in the observer.

Can an emotional connection to data emphasize the importance of the data and aid in the understanding of that information? Certainly, there is a great need for understanding large data sets, because, as we now know, the interpretation of these data can have a profound effect on human lives. Just one example is detection of the hole in the ozone layer. The chemical compound ozone absorbs harmful ultraviolet radiation from the sun. Anything that damages the ozone layer can seriously affect life on Earth. During the past thirty years, this important compound has been threatened by human-made pollution. A dramatic loss of ozone over Antarctica was first noticed in the 1970s by a research group from the British Antarctic Survey, but confirmation took over ten years. One story to explain this ten-year delay is that the satellite taking data did not show the dramatic loss because the software written to process the data was designed to treat very low values as mistakes and ignore them! Finally, in the 1980s, painstaking human analysis of the raw data confirmed the early results.[16]

I believe that through ecomedia projects artists have opportunities to create works that have emotional impacts, and by engaging the emotions of an audience a work can affect environmental understanding and therefore behaviour. This is critically important now as we face the problem of global climate change, a much more difficult and complex problem than even the hole in the ozone layer. In my own work, I have tried to use ecomedia, including the sonification of climate and weather data and the visual impact of natural imagery, to create an emotional impact and raise awareness of climate issues.

PROJECTS IN WEATHER AND CLIMATE DATA SONIFICATION

In the arts, the direct creation of music from natural processes has a long history. There are a number of bells and harps in world cultures whose compositions have been created by the wind. The sounds of Aeolian harps and wind chimes depend on the direction and amount of wind in the natural environment. In Japan, stringed instruments called *unari* are played by wind currents, and the Besisi people on the Malay peninsula use wind to play long bamboos lashed vertically to the tops of trees. In Bali, a bamboo organ played by the wind is called a *sunari* and is still used by Hindu people for religious music together with sounding bamboo propellers in the Panegtegan or Ngalinggihang ceremony for the blessing of rice. Also in Bali are the *pinchakan*, a bamboo rattle operated by the wind, and the tradition of placing bamboo tubes along irrigation channels of terraced rice paddies so that they tip over when full and create percussive sounds, each tube tuned

to a different pitch of a scale. This tradition also had a practical purpose and could be called one of the first sonification applications for natural systems since the sound allowed farmers to immediately locate a blocked irrigation channel by noticing an absent pitch in the scale.[17] In China, very light whistles have been attached to the tails of young pigeons soon after birth with a fine copper wire so that when the birds fly the wind blowing through the whistles produces an open air concert.[18]

The idea of "music of the spheres," or music created by the movements of the heavenly bodies to represent the harmony of the universe, dates back to Pythagoras, and Johannes Kepler created a music of the spheres in 1619 by transposing the known planetary orbits into new melodies. In more modern times, the computer has inspired many artists to experiment with musical composition using electronic and algorithmic processes.[19] In 1874, communications expert Elisha Gray invented a musical telegraph that produced music by transforming electricity into sound based on Morse code letter representations during telegraph communications. In the twentieth century, many composers worked with chance compositions and automated processes. Here are a few examples of far too many to list in full: John Cage, Steve Reich, Pauline Oliveros, George Lewis, Gordon Mumma, Iannis Xenakis, Laurie Spiegel, and Curtis Roads.[20]

In 1971, Charles Dodge produced *Earth's Magnetic Field*, one of the first examples of representing complex data values in sound. In this composition, the sounds correspond to the magnetic activity for the Earth in 1961.[21] More recently, in the tradition of Elisha Gray's musical telegraph, Ben Rubin and Mark Hansen created a sonic installation called *The Listening Post* that monitors and sonifies thousands of online exchanges in real time to reveal patterns and rhythms of people on the Internet.[22]

In the sciences, work in the sonification of meteorological data is part of a growing movement in data sonification research. In 1997, a sonification report was prepared for the National Science Foundation by the International Community for Auditory Display. This report provided an overview of the current status of sonification research and a proposed research agenda. Most significantly, the report stressed the need for interdisciplinary research and interaction.[23]

I have been creating artworks about environmental science issues since 1999, when I first began collaborating with atmospheric scientists on sound and sonification projects. Since then, I have created several major media projects in collaboration with scientists, including work about climate change in New York City with the NASA/Goddard Institute Climate Research Group and work using real-time air-quality data with scientists and engineers at the National Center for Atmospheric Research and the national AirNow agency.

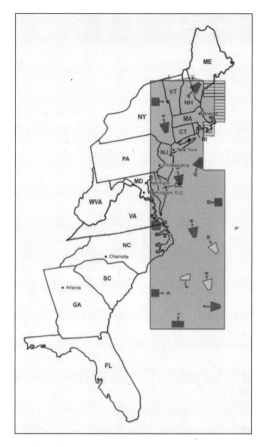

Figure 4.1 The Engine 27 floor plan superimposed over a map of the east coast of the United States.

In 2003, I collaborated with Dr. Glenn Van Knowe, a senior research scientist at MESO, a commercial atmospheric modelling firm. Van Knowe and his colleagues create highly detailed simulations of the weather based on terrain, initial conditions, and other factors for forecasting and other commercial applications. The data sets produced by MESO are extremely large and complex, and although there are various visualization tools in use to interpret the data much of the data represented is not visual (e.g., temperature and atmospheric pressure). The data represented also often portray complex changes over time, an aspect of data particularly suited for sonification.

In a multichannel series of sonifications called *Atmospherics/Weather Works*, we explored detailed models of two historical storms that occurred in the area of New York City. Historical storms were our choice because they could be modelled in great detail by combining actual recorded data from the National Weather Service with physical models, and they could trigger the memories of listeners who had experienced them. We selected the 1979 President's Day Snowstorm and Hurricane Bob from 1991. Specific geographical points were mapped to each speaker in the space, as shown in Figure 4.1. This multichannel design allowed for a detailed examination of the movement of the storm and its structure. On a website commissioned by the Whitney Museum of American Art (screenshot shown in Figure 4.2), users can listen to the sonification of each geographical point or compose various combinations of points (see http://artport.whitney.org/gatepages/may04.shtml).

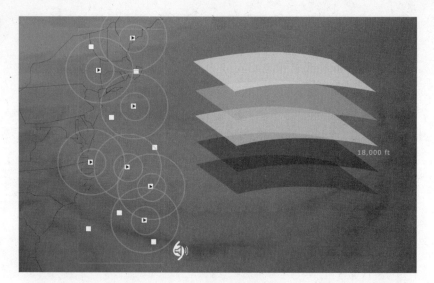

Figure 4.2 Interactive Web-based application featured by the Whitney Museum of American Art.

I was particularly interested in working with a scientist on this project because I wanted to interpret the data in the most effective way. Through conversations with my scientific collaborator, I could pinpoint relevant aspects of the data, such as how variables are coupled and which geographic and time steps are relevant, and use this information in the design of the sonification. This mode of information exchange has continued throughout my collaborations with scientists.

HEAT AND THE HEARTBEAT OF THE CITY

Storms are influenced by climate. The Earth's atmosphere is becoming warmer, and a rise in global temperatures is already causing sea levels to rise around the world. The Earth might already be experiencing an increase in hurricanes and tsunamis. In 2004, I worked with climate change data for the New York City region in collaboration with Dr. Cynthia Rosenzweig, Dr. David Rind, and Richard Goldberg at the NASA Goddard Institute for Space Studies and the Columbia University Climate Research Group. These scientists created an atmospheric model of the city that is one of the most detailed models of any urban area. The model allows them to predict how climate change will affect New York and the surrounding suburbs. They provided me with actual data for several locations from summers in the 1990s along with projected data for the summers of New York in the 2020s, 2050s, and 2080s, formatted especially for the creation of sonifications. I created a series of sonifications attempting to convey the physical experience of the increasing temperatures (excerpted on the DVD included with this book).

According to a 1999 report published by the Environmental Defense Fund, New York City will be dramatically impacted by global warming in the near future. Average temperatures in New York could increase from one to four degrees Fahrenheit by 2030 and up to ten degrees by 2100. According to the Metropolitan East Coast Assessment, the impacts of these changes on this major metropolitan area will be great.[24]

Heat and the Heartbeat of the City is a website (see http://turbulence.org/works/heat/) that presents sonifications (musical compositions created by directly translating data into sound) that illustrate these dramatic changes, focusing on the heart of New York City and one of its first locations for climate monitoring, Central Park. As you listen to the compositions, you travel forward in time at an accelerated pace and experience an intensification of heat in sound.

The *Heat and the Heartbeat of the City* site also includes excerpts from interviews with scientific collaborator Dr. Cynthia Rosenzweig of the NASA Goddard Institute for Space Studies and Columbia University. She speaks of her research on the causes and effects of warming trends on urban areas:

> In urban areas, climate change effects will be integrated across all the different sectors and groups of people. Mostly when climate change effects have been studied before, they have been studied sector by sector in a very isolated way. So, for example the effects on agriculture, the effects of climate change on world food supply, have been studied separately from the effects on water resources, and both of those had been separated from the effects on forests. In the city, we don't have the luxury of looking at the sectors individually because we're all so close together and everything is happening simultaneously, we have to look at our sectors, the impacts on our sectors, in an integrated way.[25]

In the summers, warming trends will impact human life. As Rosenzweig explains,

> one very important sector that we looked at is human health. To the 21.5 million people here in the city, clearly health is a big issue. There are two main effects that climate change will have on health. One is heat stress ... especially for elderly people and the very young because their physiological systems aren't as good at maintaining the proper body temperature, but it's also an issue for the lower socio-economic groups who don't have as much access to air conditioning.... The other main health effects are the health effects related to air pollution because higher temperatures increase the number of ozone days that

we have because the chemical reaction to create ozone is catalyzed by warmer temperatures. When there is more ozone there are more visits to hospitals related to asthma.[26]

In particular, the *Heat and the Heartbeat of the City* sonifications focused on expressing the effects of consecutive days over ninety degrees Fahrenheit during the summer months. If the number of consecutive days averaging over ninety degrees increases, then it will increase the intensity of the sound. The sonifications were designed to emphasize the days over ninety degrees, an uncomfortable temperature. I used a subtractive approach, starting with a noisy sound signal and reducing the noise for more comfortable temperatures. The noise was designed to be somewhat uncomfortable to make people feel the difficulty and discomfort but more than that to consider the actual problems that will result from global warming: maybe they will be convinced to think more seriously about the issue.

As a scientist collaborating with an artist, Rosenzweig is interested in how people can experience data in new ways:

> [W]e are so limited in the ways that we use our data. Basically we have a number of ways that are very statistical, certainly very mathematical and very useful, and then we represent the results of those statistics in graphs and tables. That's one way, and then we do have visualizations, for example an animation of how the warming [occurs], using colors from yellow to red to deep brown over the decades. But that's it, it's really quite limited. So working on the sonification project you realize that when you hear something, you're able to understand the data in a new way, and that's what [has] been very fascinating.[27]

In addition to the website, the project has been presented as a multichannel sound installation presenting climate change throughout the New York City region in the summers from 1990 to 2060 and a stereo headphone or speaker installation.

N.

Climate change in the Arctic is an important indicator of global climate change. In 2005, English artist and programmer Joe Gilmore and I collaborated to create *N.*, a real-time online sonification and visualization of the Arctic. For this project, we worked with daily data gathered and formatted by our scientist-collaborator, meteorologist, and convective snow and ice specialist Dr. Pat Market of the University of Missouri and online data from the National Oceanic and Atmospheric Administration's Arctic Research Program. The data were in the format of a sounding every twelve hours: that

Figure 4.3 *N.* installation, Beall Center for Art and Technology, 2007.

is, information about the weather from sea level to the top of the atmosphere as if one was taking a trip on a weather balloon.

To undertake more effectively the complex real-time data interpretation in the *N.* installation, and to help others involved in art and science collaborations, computer programmer and video artist Kurt Ralske and I developed a custom piece of software for use in conjunction with Max/MSP. We have also made this software and its source code freely available to other artists.[28]

Aesthetically, the sonifications combined my subtractive approach with an additive approach by Joe in which simple sine waves and other signals were combined and transformed based on the data. The combination created a rich soundscape to represent the complexity of weather at the North Pole. Figure 4.3 illustrates the installation created from this project and others as part of my exhibition Atmospherics/Weather Works, presented at the Beall Center for Art and Technology, 5 January–17 March 2007.

CONCLUSION

In each of the sonifications presented, I used all the data that the scientists provided for each parameter directly in order without adding or subtracting data, except when necessary using a linear interpolation algorithm to obtain a smoother transition between data points. I am not a complete purist and have done performances using live vocal sounds altered by the data. In that

case, the data are again used directly, but the resulting soundscape is altered by the vocal sound. The data themselves, even in their raw state, are not "reality" any more than the sonifications are, and I think that the scientists with whom I have worked will agree. For example, in the case of the storm sonifications, the data were obtained through a weather model. This model, although it was cross-referenced with actual data from the storms, which makes it much more accurate than a model created without historical data, is still a model. In other words, it is an approximation of reality. In addition, data from the model were generated every three minutes of a twenty-four-hour period, an arbitrary time frame and an interval that were unavoidable; any time frame and interval would have been arbitrary.

In the case of the Central Park climate sonifications, the data were again modelled, and there were actually several possible models at which the scientists were looking. They chose the most conservative model for the sonifications — in other words, the model that showed the least amount of warming — but having conservative results does not automatically make the model any more accurate than other models used.

Finally, even real-time data like those used in *N*. are not seen by the scientists as accurate until there is a chance to view and verify them. Automatic data capture is subject to error, so scientists have to review the data before their "official" publication. I was interested in real-time data, warts and all, so I accepted the possibility of error as part of the piece. An analogy that might describe how I have come to think of the sonification of data is the eye-witness. An eye-witness has experienced an event and has a much more accurate idea of what has happened than someone who has not witnessed the event, but an eye-witness also has limitations. An accurate picture of an event is formed by a combination of the eye-witness and physical evidence, other witnesses, and so on. This is the same process that happens with the data; the scientists spend a lot of time comparing and contrasting the data with various model results, satellite images, and other information to try to get an accurate picture. Sonification is just another piece of that puzzle. Can an artistic sonification be beneficial to science? An analogy might be an artistic crime scene photograph or sketch. Although it is an artwork with a point of view, it is still likely to contain useful information.

One of my personal interests in working with complex data is in the artistic creation of new languages for data interpretation. As individuals and groups are faced with the task of interpreting more and more information, a language or series of languages for communicating this mass of data needs to evolve. Through an effective sonification, data interpreted as sound can communicate emotional content or feeling, and I believe that an emotional connection with data can increase human understanding of the forces at

work behind the data, encourage cross-cultural communication, and serve as an aid to memory.

In a 1970 position statement on technology and composition to UNES-CO, Herbert Brun presented one of the more interesting discussions of the importance of process in art as a means to develop new languages of communication. Echoing the Situationists, Brun called the process of new language development "anticommunication."[29] However, he used the prefix "anti" as in "antithesis," not to mean "against," but to mean "juxtaposed" or "from the other side." He saw anticommunication as the offspring of communication, an attempt to say something through new modes rather than a refusal to say something, as might be defined as non-communication. One uses anticommunication as an active way of redefining or re-creating the language. Brun called this "teaching the language." In the best case, anti-communication goes through a transition from being learned and accepted to becoming communication, but this process can take any amount of time, from minutes to decades. Anyone who has ever looked at a work of art or listened to a concert and said "What does it mean?" has experienced what Brun calls anticommunication.

I believe that an active engagement with data models and databases is an important aspect of working in this medium, and through my collaborations with scientists I have tried to learn as much as possible about the data in order to translate them more effectively. I have also combined sonifications with interviews with scientists, articles, and other textual information in order to add context and meaning to the work. Stalbaum sees the database not as a static subject on which an artist projects meaning, or even as a malleable piece of "clay" transformed by an artist, but as a "catalyzing factor in the conversation." He optimistically states that "data and control systems provide a channel through which ecosystems are able to express an influence in favor of their own protection."[30] But in order for the expression of the data to be heard, we have to be listening.

NOTES

1 An earlier version of this chapter was published as "Eco-Media: Art Informed by Developments in Ecology, Media Technology, and Environmental Science," *Technoetic Arts: A Journal of Speculative Research* 5, 3 (2007): 187–200.

2 Brett Stalbaum, "Database Logic and Landscape Art," video lecture, 24 January 2004, archived on *Netzspannung*, http://netzspannung.org/positions/lectures/mapping/.

3 Marta Braun, *Picturing Time: The Work of Etienne-Jules Marey 1830–1904* (1994; reprinted, Chicago: University of Chicago Press, 1995).

4 See http://34n118w.net/UCHRI/extract.htm.

5 Ibid. Editors' note: in the short time between the writing and publication of this chapter, locative media have become ubiquitous in commercial products such as smart phones, with a corresponding rise in artistic practice and discourse related to locative media. See, for example, the conference Beyond Locative Media: Media Arts after the Spatial Turn at http://isea2011. sabanciuniv.edu/panel/beyond-locative-media-arts-after-spatial-turn.

6 Ibid.

7 Siva Vaidhyanathan, *The Anarchist in the Library* (New York: Basic Books, 2004).

8 Maeve Reston, "Storm over Weather Service Initiatives," *Pittsburgh Post-Gazette National Bureau*, 26 April 2005.

9 Vaidhyanathan, *The Anarchist in the Library*, 190.

10 Sean Cubitt, *Ecomedia* (Amsterdam: Rodopi Press, 2005).

11 Herbert Marcuse, *The Aesthetic Dimension: Towards a Critique of Marxist Aesthetics* (Boston: Beacon Press, 1979), 7.

12 Guy Debord, *The Society of the Spectacle* (Cambridge, MA: Zone Books, 1995).

13 Lev Manovich, "The Anti-Sublime Ideal in Data in Data Art," http://www.manovich.net/DOCS/data_art.doc.

14 Mitchell Whitelaw, "Hearing Pure Data: Aesthetics and Ideals of Data-Sound," in *Unsorted: Thoughts on the Information Arts: An A to Z for Sonic Acts X*, ed. Arie Altena (Amsterdam: Sonic Acts/De Balie, 2004), 45–54.

15 George P. Landow, "The Paintings of Turner and the Dynamic Sublime," http://www.victorianweb.org/philosophy/sublime/turner.html.

16 NASA's Earth Observatory Reference Page, http://earthobservatory.nasa.gov/Library/RemoteSensingAtmosphere/remote_sensing5.html.

17 David Cope, *Computers and Musical Style* (Madison: A-R Editions, 1991).

18 Wang Shixiang, "Pigeon Whistles Make Aerial Orchestra," *China Reconstructs* 12, 11 (1963): 42–43.

19 Johannes Kepler, *Epitome of Copernican Astronomy and Harmonies of the World*, trans. Charles Glenn Wallis (1939; reprint, New York: Prometheus Books, 1995).

20 Cope, *Computers and Musical Style*.

21 Charles Dodge, with assistance by Bruce R. Boller, Carl Frederick, and Stephen G. Ungar, *Earth's Magnetic Field* (1970), Columbia-Princeton Electronic Music Center 1961–73, New World Records, 1998 (CD).

22 See http://www.earstudio.com/projects/listeningpost.html.

23 Gregory Kramer et al., "The Sonification Report: Status of the Field and Research Agenda," National Science Foundation, 1997, http://www.icad.org/websiteV2.0/References/nsf.html.

24 *Climate Change and a Global City: An Assessment of the Metropolitan East Coast Region*, http://metroeast_climate.ciesin.columbia.edu/. This study of the Metropolitan East Coast area is one of eighteen regional components of the U.S. National Assessment of the Potential Consequences of Climate Variability and Change, organized by the U.S. Global Change Research Program.

25 Cited in Andrea Polli, *Heat and the Heartbeat of the City*, Turbulence web commission, http://www.turbulence.org/works/heat. Launched 1 December 2004.

26 Cited in ibid.

27 Cited in ibid.

28 To download the data reader, see http://www.andreapolli.com/datareader/.

29 Herbert Brun, "Technology and the Composer," as read to the United Nations Educational, Scientific, and Cultural Organization (UNESCO), Stockholm, 10 June 1970, http://www.herbertbrun.org/techcomp.html.

30 Stalbaum, "Database Logic and Landscape Art."

CHAPTER FIVE

Sonification of Satellite Data and the Process of Creating Visuals and Sounds for Regina

Craig A. Coburn and A. William Smith

INTRODUCTION

Landscapes have always served as a source of inspiration for musical composers, who have sought to transpose their sense of space and place into meaningful musical experiences. With the advent of powerful digital sound production software, the opportunity to allow the place to be the focus of the music has been realized. Combining science and art, we are a research team comprising a geographer (Coburn) and a new media designer (Smith) who have investigated techniques and technologies for the sonification of satellite images of Canadian urban areas. By allowing the image of a place to control sound production, the various geographies of Canadian urban areas can be explored sonically. The analysis of these data is a complex combination of visual interpretation and digital image processing. Scientists studying satellite image data are primarily focused on retrieving information from the image in a static image-processing environment and are rarely concerned with the aesthetic. However, the overhead views provided by these satellite images present our world from an extremely elevated perspective, displaying the natural interplay of humans and our environment. Our landscapes create

See DVD — Craig A. Coburn and A. William Smith — for a video excerpt from Recording Regina from Eta Carinae.

interesting visual shapes, arrangements, and structures that are identifiable based on the unique spatial patterns that humans create as a result of settlement. We examined a variety of visualization techniques in conjunction with data sonification and composition to explore what satellite images sound like. Here we discuss our research and one of its creative results: *Recording Regina from Eta Carinae.*

PART 1: GEOGRAPHY, THEORY OF SONIFICATION, AND CONTEXT
Craig A. Coburn

The sonification of data is the rendering of sound from data that contain no native acoustical signal.[1] There is growing interest in both the scientific and the artistic communities in investigating the patterns of data in sonic environments to capture the intricate complexities of the data stream and in using these data for purely artistic musical adventures. This often results in interesting synergistic collaborations between the arts and sciences, as was the case for this project. Our overall goal in developing techniques for further exploration of the rich data provided by Earth observation platforms (satellites) was to create musical compositions that not only use data *from* a place but are also *of* a place. This goal led to the development of a variety of compositional techniques that enable the exploration of these data in new ways, allowing novel views of our geographies through sound.

Vast quantities of satellite imagery of the Earth's surface are collected on a daily basis, and the analysis of these data is a complex combination of visual interpretation and digital image processing. As stated above, scientists studying the data from these images are focused primarily on retrieving the information that they contain in a static image-processing environment.

Since the dawn of efforts in space imaging, people have been intrigued by the look of familiar spaces from above. Technological advances have resulted in the development of an extensive constellation of satellites tasked with imaging the Earth on a daily basis. These instruments provide information that allows us to monitor the human effects on Earth and its changing environments. The advent of Earth observation has led to the development of a vast array of image products for public consumption, in particular applications such as Google Earth that allow people with access to the Internet to see what their environments look like from a bird's-eye perspective.

Past efforts in studying the sounds of space looked explicitly at the music created by people living in a place, for example the blues and jazz movements in several American cities,[2] or focused on the sounds of place, for example the pioneering work of Barry Truax at Simon Fraser University.[3] The objective of our research project was to invert the idea of people making music in a place or the specific sounds that characterize a space and look

instead at the ways in which the space can create its own sounds. For this composition, we chose a city landscape (Regina, Saskatchewan) because it was the location of a conference on immersive soundscapes and part of a larger project investigating the sonification of Canadian cities. In general, the modified geography of a city landscape governs how an area looks and the resultant data stream generated from such an environment.

Motivation

Our motivating questions for the Canadian cities project were the following. Do city environments all sound alike? Which factors lead to differences in the sound of a place? Can the sense of place be captured by a combination of physical environment and musical interpretation? In order to answer these questions, we had to address a large number of technical and geographical components, without which a sonic realization of place was not possible.

The use of sound to aid the interpretation of data has found many practical applications, including the Geiger counter, sonar images, and everyday devices such as alarm clocks, telephones, and many emergency or medical displays, to name but a few. In these instances, an auditory signal is more easily interpreted than a visual cue. More recent research has involved the use of sound to help the blind navigate using computer maps and the Global Positioning System (GPS).[4]

With the advent of more user-friendly software applications for sound production, novel ways of using data sonification to interpret complex data sets might become more common. Examples range from analyzing geographic data[5] and climate change data[6] to helping understand atomic particle movement.[7] The majority of these research projects have focused either on the need for complex data analysis or on the transformation of data into sound only. In our project, we presented a variety of visualizations of the actual data in conjunction with the sonification of these data, yielding a true multimedia experience.

Earth observation imagery is a rich source of information normally used for scientific purposes to monitor, map, and model the surface of Earth. Aside from these scientific endeavours, images of Earth have always captivated the public, for people are naturally interested in local geography. In many ways, these more artistic efforts have been some of the most successful efforts of Earth observation. These images have been used to inform people of their impacts on the planet since they can stir emotions and pique interest in the world around them.

Earth imaging has evolved over time, and we are now able to observe the condition of Earth on a daily basis from the constellation of satellites. This rich and varied source of data creates interesting challenges since the sheer volume makes processing difficult.[8] Estimates of the volume of Earth observation data collected on a daily basis exceed four terabytes, and this

volume is increasing. Analysis of such volumes of data using traditional techniques is not possible, and scientists are now investigating cross-disciplinary multimedia technologies and data sonification to assist in data analysis.

Although these tools can be used for scientific analysis, the motivation for our project was to explore satellite imagery as a source of data for creating musical compositions. Composers of music have often used landscapes as a means of motivation, but we wanted to explore the ways in which landscapes, through satellite data and sonification tools, can create their own sounds.

Our research focused on creating a technique whereby image data could be interpreted as musical compositions — in other words, on the creative process rather than on the direct interpretation of these data in a scientific context. When experimenting with the composition of these data, it is important to recognize that artistic products are not cold, objective, and reproducible experiments. Normally, artistic endeavours involve decision making that shapes the nature of the content and its form of expression. Musical compositions can derive from inspirations such as ideas or emotions, and they can use traditional shared musical forms appreciated by others. However, although art is thought of as being mostly subjective and personal, a creator can also utilize concepts that are outside the normal realm of artistic activity.

The Data

All of the Earth observation data used for our project came from the Landsat satellite system (Landsat-7). This system is in sun-synchronous orbit approximately 700 kilometres above Earth's surface, and it has been continuously acquiring images through a sequence of satellites for the management and monitoring of Earth's resources since the early 1970s. The Landsat satellites record data from a variety of regions of the electromagnetic spectrum (from the visible to thermal infrared), yielding many different views of Earth.[9] The imaging systems collect electromagnetic information in a number of discrete spectral regions (called spectral bands). For example, Landsat-7's first spectral band has a spectral range of 0.45 to 0.515 microns, which we would associate with wavelengths of light that we see as blue. Landsat-7 has eight different spectral bands (three visible, three infrared, one thermal, and one high-resolution panchromatic) that it uses to image Earth.

Although the main motivation behind most Earth observation satellites is to provide data on the surface condition of the planet, these images have an inherent visual appeal. The profound natural beauty displayed by the patterns, colours, and textures on Earth is a secondary product of these images, one that is often overlooked. They represent a form of natural art and, as such, can inspire, interest, and move people in many ways.

For our project, we used an image of the city of Regina. Because the satellite imagery provides many different spectral bands, there were several options for the selection of data for sonification. The technique employed in our research was to extract transects of information from the image and to apply various transformations to render sound. The selection of the transect location was therefore vital to the overall nature of the composition of the music. We based our transect selection for the Regina composition on an evaluation of the visual "feel" of the city (basic structure and composition of the cityscape) and on our desire to provide a flow and direction to the musical composition.

A priori knowledge based on personal experiences of being in Regina and knowing the significance of landmarks did affect our choices. The cityscape contains a number of interesting features, including the buildings of the provincial legislature and the campus of the University of Regina. The visual differences between old residential and new residential neighbourhoods also played a role in the composition, as did the dominant urban fringe and regional agriculture.

The selection of transects, while representative for us, was thus completely subjective and based on what we think Regina means as a geographic location. There was little scientific meaning to the choice of areas represented in the sample. The only requirement for our project was that the sample locations had to represent the diversity of the area in the composition.

Sonification

The sonification of the satellite data was performed using the Max/MSP program. It is an object-oriented programming environment that allows for a wide range of flexible options for the transformation of data into sound. The environment contains a list of computer routines that processes numbers in various ways, and the routines are graphically represented by an icon when one selects a routine and places it in a score. The user connects the inlets of one icon/routine with the outlets of another to allow data to be processed in the manner that a composer desires. See Figure 5.2 for an illustration of a Max/MSP "patch" that constitutes the score for our piece *Recording Regina from Eta Carinae*. The composer does not have to write the computer code; rather, he or she can think about the process of altering numbers that will get turned into sounds through MIDI to create the auditory effects.[10] In crafting our musical pieces, values such as the transect coordinates and the spectral bands from the satellite imagery were used to drive different sonic parameters. The result was intended not only to present the data but also to convey a sense of place through sound.

PART 2: SOUNDS AND VISUALS: THE PROCESS OF EXPRESSING "SHAPES IN DIFFERENT DIRECTIONS" FROM *RECORDING REGINA FROM ETA CARINAE*

A. William Smith

Our composition, *Recording Regina from Eta Carinae*, is based on an analysis of the spectral values of the satellite image of Regina. The work is in two movements, "Shapes in Different Directions" and "South Fields," but this discussion will focus on the former. The music has a sense of decreasing while at the same time increasing; in other words, it has a push-and-pull sensibility because of streams of musical notes that start soft, become louder, and then end soft again. Combined with these devices is a sonification of the name of the location, the words *Regina, Saskatchewan*. These three aspects create a unique identity in sound and are not found elsewhere as far as we know.

Figure 5.1 represents how the data appear when presented by geographer Coburn to new media designer Smith. The first column is the sequential number of the datum. The x and y are coordinates of the image transect location. The subsequent columns to the right are of progressing wavelengths, starting with blue and ending with IR3 (infrared 3). The numbers in a column can theoretically go from 0 to 255 because the sensing devices in the satellite

	A	B	C	D	E	F	G	H	I
1		X	Y	Blue	Green	Red	IR-1	IR-2	IR-3
2	1	545402.7	5616946	72	52	43	18	20	16
3	2	545383.6	5616957	71	52	44	17	19	16
4	3	545364.5	5616969	72	52	44	17	19	16
5	4	545345.4	5616981	73	51	44	17	19	17
6	5	545326.3	5616993	74	52	44	18	20	19
7	6	545307.2	5617005	73	52	43	17	20	17
8	7	545288.2	5617017	72	52	43	17	20	17
9	8	545269.1	5617029	71	51	43	17	20	16
10	9	545250	5617041	73	51	44	17	20	16
11	10	545230.9	5617053	73	51	43	18	19	16
12	11	545211.8	5617065	72	51	43	17	18	17
13	12	545192.7	5617077	71	51	42	17	19	17
14	13	545172.8	5617079	72	50	41	17	19	16
15	14	545152.1	5617070	71	51	40	18	18	16
16	15	545131.4	5617061	70	52	41	18	19	17
17	16	545110.7	5617052	71	52	41	18	19	17
18	17	545090	5617043	72	52	42	18	18	17
19	18	545069.4	5617034	74	54	45	18	18	19
20	19	545048.7	5617025	77	57	48	20	23	22
21	20	545028	5617017	76	56	47	20	24	20
22	21	545007.3	5617008	77	56	48	20	24	21
23	22	544989.9	5616996	76	56	47	22	25	21
24	23	544986.7	5616974	73	55	45	28	27	22
25	24	544983.5	5616952	77	60	54	54	51	37
26	25	544980.3	5616929	77	62	54	80	74	48
27	26	544977.2	5616907	74	62	50	102	94	55
28	27	544974	5616885	72	62	48	115	95	50
29	28	544970.6	5616863	71	61	47	115	93	48
30	29	544967.6	5616840	68	57	43	105	87	44
31	30	544964.4	5616818	69	55	43	92	80	42
32	31	544971.9	5616799	82	68	61	85	81	48
33	32	544987.8	5616783	94	78	76	90	94	66
34	33	545003.8	5616767	101	85	85	106	112	84
35	34	545019.7	5616751	92	78	75	120	115	75
36	35	545035.6	5616736	79	67	61	120	111	63
37	36	545051.5	5616720	90	73	72	90	91	59

Figure 5.1 Satellite data expressed numerically.

store data as a standard byte 2^8, which yields 256 unique combinations of values. These numerical values can be used in creative ways. For our research, they were used to control pitch, duration, or volume. A sound designer has to understand the musical synthesis programming and shape the data in a way that a specific computer language can utilize them. The use of data can thus be seen as a parameter in the process of musical composition.

For the sound design, we decided to use all six spectral bands of data (columns) extracted from the pixels from the satellite image layers — red, green, blue, IR1, IR2, and IR3. This was the first time that we used all bands at the same time in a composition after creating more than twenty compositions as part of our sonification project of selected Canadian cities (including Lethbridge, Calgary, Edmonton, Halifax, Ottawa, Vancouver, St. John's, and others). The bands of data were used to create six sound streams, with each one based on a particular set of numbers associated with the pixel analyses. The streams are not continuous; rather, each has a cycle that uses 100 points of data. Each cycle of each stream starts relatively softly, crescendos to its highest point, then decrescendos. It is almost like a visual portrayal of a wave of sound or light that has been interpreted or translated in terms of volume. This ebb and flow also corresponds to the push and pull reflected in the static and time-based visuals.

Attention to this visual aspect is based partly on the fact that an "outer" road from decades ago has been overrun with development, or urban sprawl (clearly seen in the satellite image), and is now part of "inner" Regina. The city seems to be spilling out of its boundaries, and there is a recognizable difference between more densely populated urban space and sparsely populated farmland. Moreover, looking at the surrounding area of Regina in the same satellite image, it is easy to see radiating lines in a purely formal sense of aesthetics based on roads, rivers, and railways that, through no coincidence, converge on Regina. But these lines and the resulting segmentation of the land also give a sense of expansion with Regina as the centre.

In the creation of this musical composition, each data stream was assigned a unique timbre when outputted from Max/MSP through the sound features of Smith's Macintosh laptop, respectively detuned electric piano 2, glockenspiel, vibraphone, santur, whistle, and harp. See Figure 5.2. These instruments were selected through a process of trial and error to give the most appropriate sound. We allowed a random function to determine both when a cycle of a stream started in the horizontal structure of time for the piece and which stream was selected.

The vertical texture then might have from zero to six channels sounding simultaneously, each with its own set of pitches (and timbres) based on data occurring naturally. Because of the overlapping with different starting times, the sound gives the impression of a series of small fountains spurting

Figure 5.2 Score fragment (Max/MSP patch) for *Recording Regina from Eta Carinae.*

and ceasing that wash over the listener. To us, the first movement of the work, "Shapes in Different Directions," is a combination of two processes: addition or accumulation, subtraction or diminishment; in other words, going in "different directions." Thus, there is a push and pull to the sound that mimics the bipolar nature of expansion, resulting from an analysis of Regina's satellite image and an examination of the Eta Carinae nebula, a conceptual factor in the sound design discussed later. Moreover, by establishing a construct of two distant poles (Regina and Eta Carinae) associated in the title of the composition, *Recording Regina from Eta Carinae*, the underlying conceptual basis of an ebb and flow is further strengthened. It is multidimensional.

Finally, one of the complementary features of our production of a unique sonic identification of an area is by using a name array unique to the area — in this case, that based on the letters spelling "Regina, Saskatchewan." This is done by associating each letter with a number as an x-y pair. By using different algorithmic schemes, as shown in Table 5.1, one can derive relative pitch differences. The starting point of the number sequence is chosen for auditory comfort in the MIDI range. It is purely arbitrary; for instance, A in column 1 could have been associated with 61 or 40, and all the ensuing numbers associated with letters would be relative to the starting point. Column 1, which might be expressed by the mathematical equation $60 + (x + 1) = y$, would have Regina translated as 77 64 66 68 73 60. These numbers could be directly translated into pitches in the MIDI range of 0–127 (or 2 to the 7th power), but simple addition or subtraction algorithms could lower or raise the pitch of the entire motif. For instance, by adding 5, one could get 82 69 71 73 78 65. So the relationship among the letters represented by

numbers stays the same, but the sounds are higher. For MIDI, the lowest sound is 0, and the highest is 127, and both notes are uncomfortable because they have wavelengths outside the normal range of human ear vibrations. A comfortable range for human hearing is from 40 to 100.

	#1	#2		#3			
A	60	90	6	90	2	5	11
B	61	88		87			
C	62	86		84	7		
D	63	84		81			
E	64	82	2	78	9		
F	65	80		75			
G	66	78	3	72			
H	67	76		69	8		
I	68	74	4	66			
J	69	72		63			
K	70	70		60	4		
L	71	68		57			
M	72	66		54			
N	73	64	5	51	12		
O	74	62		48			
P	75	60		45			
Q	76	58		42			
R	77	56	1	39			
S	78	54		36	1	3	
T	79	52		33	6		
U	80	50		30			
V	81	48		27			
W	83	46		24	10		
X	84						
Y	85						
Z	86						

Table 5.1. "Regina, Saskatchewan" algorithms.

As one can see, a different algorithm is represented by column 2. It might be represented by the equation $90 - (x - 2) = y$, which would translate the letters of Regina numerically as 56 82 78 74 64 90. Smith liked hearing this sequence better than the first one because it was more distinct.

Although one can use a single algorithm to translate letters for the names of both city and province, there is no logical reason to be dogmatic. Hence,

column 3 represents yet a third algorithm, one that plays a role in the sound design of "Shapes in Different Directions." We used column 2 for Regina and column 3 for Saskatchewan in order to add depth to the musical texture. So we can say without hesitation that the listener is literally hearing Regina, Saskatchewan. Using such a musical device is a reflection of understanding other numerical schemes used in medieval musical practices as well as later historical musical practices, and this suggests to us a continuity of musical thought within Western culture rather than a radical departure.

Because the score is played with real-time music synthesis, there are slight variations each time the music is created, and we have recorded one version on the DVD accompanying this book. We should point out that "Shapes in Different Directions" is quite different in sound from our musical compositions arising from sonifications of other Canadian cities.

Realization of Static and Time-Based Visuals

The visuals for our project are based on the satellite image of Regina. There are three types, depending on the performance venue. All emphasize shapes on opposite sides of the footprint of Regina, but the time-based visuals also suggest viewpoints from varying elevations (vertical distances) that connect to the conception of seeing Regina from distant outer space.

People engaged in design have ideas that shape their work at all stages. Sometimes they discover ideas in the process of execution, but there must be an instigating idea before a work commences. In the case of "Shapes in Different Directions," I imaged the structure of the static and time-based visuals (as well as that of the sound) before any execution commenced on the final product.

At first I thought that, to realize my "idea" related to the visualization, I would need the pen tool using either of the static-image-processing software programs Illustrator and Photoshop to outline shapes found in the satellite image. This would allow me, through a time-based medium, to emphasize shapes first in one direction of the image and then in the opposite direction in order to draw attention to the "push-and-pull" forms actually embedded (from the lines of major roads, rivers, and railways) in the image. In actuality, I used the selection tool in Photoshop to extract shapes composed of pixels and then blended these shapes using layer effects with a corresponding unmodified, though desaturated, satellite image. See Figure 5.3.

One way to share a static-image visual is through a museum-grade gallery print. This can be made any size, but to accommodate multiple viewers a good dimension is six feet by four feet. Such an image can be painted with acrylics or oils or printed using high-grade inkjet media. A static image can also be used in various print media.

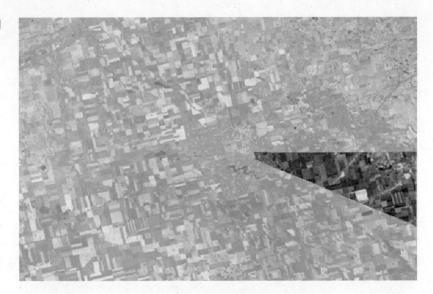

Figure 5.3 Static visual for "Shapes in Different Directions" (original in colour).

The process of using Photoshop to create each unique image of a time-based sequence was accomplished with a digital canvas 1,600 × 1,066 pixels in size. The next step was to bring these images into the sequencing software Director, in which the images were animated to give the sense of growth or push and pull. So, if the shape that we wanted to emphasize lay on the right side of the satellite image of the city footprint, we made the movement of the image go from left to right.

We then exported three different versions (as Quicktime movies) that might have looked at the whole canvas or only a detail (1,600 × 1,066, 1,200 × 800, and 720 × 480). Then we made each movie conform to the dimension of 720 × 480. The original 1,600 × 1,066 image that was exported full size and then reduced to 720 × 480 gave the appearance of being viewed from a greater vertical distance than the others. Thus, there were three unique movies to use as source material giving diverse viewpoint impressions: one distant, one medium, and one close up.

Making three more movies each using the three different viewpoints constituted the second stage. For one, we keyed layers using luminance (a measure of relative brightness of the image) with the close-up movie view as background. Keying is a technique specifying how the pixels from one layer blend with those of lower layers. Most readers have likely heard how using greenscreen allows television weatherpersons to superimpose a human and a weather map. In digital applications, one has many choices for keying. For the second movie, we keyed two layers using chroma against the distant view as background. Finally, for the third movie, we keyed with RGB (red-green-blue) using the medium view as background.

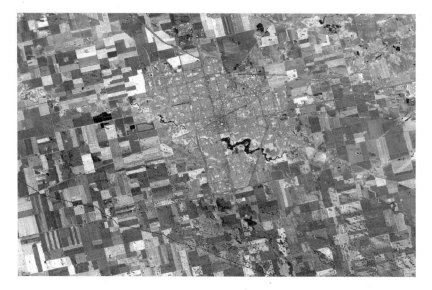

Figure 5.4 Quicktime movie composite still.

In the final stage, shown in Figure 5.4, the three movies were blended, resulting in a single movie with a multidistance perspective. We achieved this by delaying or advancing the three movies in a single timeline and blended them together to make the final version of the single screen visuals, so that the single screen version really has nine layers to it. As such, it attempts to be immersive as it accommodates a variety of audience members who might prefer to see the big picture or focus on details.

A single screen version is practical because some performance venues can accommodate only a single screen with a single data projector. If the work is put on a DVD for a single user who will output it to a computer screen or television, a single screen version is essential.

Another version of the visuals, shown in Figure 5.5, is undeniably immersive in conception. This version requires three data projectors and three screens. It features a centre projection and two side projections, each using one of the close-up, medium, and distant views of the satellite image as time-based imagery. The intent here is to angle the side screens so that the audience feels immersed in the imagery. This emphasizes as well a sense of vertical space, giving the impression of seeing Regina simultaneously from close up and far away.

Whichever way an audience member looks within a comfortable arc, he or she sees imagery from a particular point of view or perspective. While experimental technologies such as "virtual reality caves"[11] allow one or two persons (at most a small group) to feel immersed in an aesthetic experience, our line of research addresses the communal aspect of many people simultaneously experiencing sounds and visuals and having "shared" as well as "individualized" experiences.

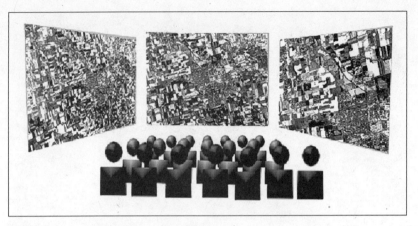

Figure 5.5 Three-screen "immersive" performance.

We do not conceive of the time-based visuals as an experience separate from the sound, though the static image or the sound can be a stand-alone experience.

Inspiration for "Shapes in Different Directions" from Recording Regina *from Eta Carinae*

The satellite image of Regina displays a formal distribution of colours and shapes that results from natural features such as the river, mineral composition, vegetation, roads, railways, buildings, concrete areas, fields, and many other factors. A density of detail can be seen in the city footprint proper. Outside the city footprint is a contrasting pattern of larger areas that signifies fields. Lines signifying transportation networks connect the city footprint with other areas on the continent, areas that we cannot see but know exist.

One can see in the satellite image of Regina the "push-and-pull" feel of the shapes carved out by transportation networks and the natural terrain of Regina and its neighbouring areas. Coburn pointed out that a road created in the 1980s on the east side was intended to be an "outerbelt" but now appears as an uncomfortable barrier to a city spilling outward. So there is a visual sense of outwardness, of expansion.

When one looks at the image of part of Saskatchewan that is a snapshot (row 25) by a satellite going in vertical orbit (column 30), the city footprint of Regina (50° 26' N, 104° 40' W) is not readily apparent because it is so small compared with the extent of the imagery in that snapshot. And one can imagine backing up farther and seeing Regina as a speck in the sparsely populated middle part of Canada. Perhaps the reader has seen a satellite image of the whole of Canada as part of Earth, in which one might not even recognize where Regina is located. Continuing farther away from Earth, Regina and its surrounding area become unrecognizable.

Figure 5.6 Eta Carinae.

Imagine seeing Regina as if in a satellite image from another galaxy or nebula, such as Eta Carinae. It is a stellar system in the constellation Carina (ascension 10 h 45.1 m, delineation –59 ° 41 m) about 7,500–8,000 light-years from the sun. The star Eta Carinae sits in the centre of the bipolar Homunculus Nebula created partly from an eruption of Eta Carinae. See Figure 5.6. Imagine hearing radio frequencies or sounds coming from the physical, concrete, visually perceptible human colony Regina, Saskatchewan, Canada, North America, Earth, in the same manner as we on Earth listen to bodies located in outer space. We map the heavens in radio waves from little beeps that indicate certain frequencies. We focus from our point of view — an undeniably egocentric view. So many people have a vision of themselves figuratively at hand's length, never having been exposed to a more pan-Canadian or pan-Earth or, for that matter, pan-galactic sense of space.

Imagine that radio waves or light beams can go in the opposite direction, which they undeniably are in this case. Rather than being radiated from some heavenly body and collected by large disks on Earth, they are generated in Regina and collected somewhere in outer space.

Eta Carinae has a dynamic push and pull in two directions that mirrors what can be seen in the satellite image of Regina. The city is expanding. It seems inevitable that, as more people have children and they in turn have children, the process of expanding city limits will continue. We see this ever-outward process, called "urban sprawl," in most of the cities of the world. Small areas become large areas. For instance, Montreal (originally the village of Hochelaga) was once small. New York was once small. Paris was once small. Mexico City was once small. Could we humans ever take up so much land for our urban areas — for homes, apartments, stores, parking spaces, streets, and so on — that those areas where we grow plants for food, or harvest natural resources, or raise animals for food could be so limited that cities seem to stretch without end? Some cities, such as New York and Los Angeles, already appear that way.

Although Eta Carinae is unstable, by our analogy we do not want to suggest that Regina is literally going to explode. But according to the city's marketing, Regina has "explosive cultural achievements." Events small or large, such as the Art of Immersive Soundscapes II: Intersections International Conference, can be seen as contributors to Regina's culture (as well as to that of Canada and the world).

Eta Carinae paired with Regina emphasizes the conception of bipolar radiation and seems appropriate for the overall name of the musical set, *Recording Regina from Eta Carinae*. As well, the name of the first movement, "Shapes in Different Directions," seems appropriate.

SUMMARY: IMMERSIVENESS AND IDENTITY

Our work has many dimensions. On one level, there is the consciousness that any city, such as Regina, is but a small blip from the perspective of outer space. It is the sense of what we in Canada would like to believe is part of our national identity — that we are not focused on our greatness but see ourselves in larger and larger contexts or groups. We are in the middle of (or immersed in) many perspectives.

We believe that our created sound itself has both conceptual and realized aspects of immersion. The sound is driven totally by the environment and its analysis, resulting in numbers translated into wavelengths or pitches. Not a single pitch has been added or subtracted that was not part of the original data, except for the name array. The listener is in the "environment," for we are using a space-to-time translation that might even have interested Einstein, a committed musician and musicologist.

That a cycle within a stream of data, for instance that associated with the blue component of light, could create sonic sensations similar to being figuratively born, coming to maturity, and then dying is much like the life cycle of humans who inhabit a certain place on Earth. So the sound of our

work with zero to six streams sounding at different parts of their cycles is much like a community of people with youth, adults, and elders coexisting simultaneously.

The symbolism becomes more profound if one looks at civic infrastructure; buildings and neighbourhoods seem to have their own cycles of growth and life spans. Which city does not have an industrial area with a factory that has closed or a once vibrant inner city street with stores that have closed as shoppers migrate to megamalls? Hence, when listening to our composition, one is immersed further in the truth of what living at this moment means.

A related form of immersion is seen in the changing physical boundaries of a city footprint. Boundaries point at time, at history, so that one can look at a satellite image and get a sense of the time when a city was merely where a handful of people lived. What made that city grow? Why is it growing now? How did certain areas become designated as public areas, such as parks or educational lands? Where do streets converge, and how did such convergences come about? We are looking at the past, present, and future; we are looking at time itself. But how can this abstraction be communicated? By the arts, of course, especially time-based arts. This is another form of immersion.

We have also chosen to add texture and counterpoint to our data streams by simultaneously sonifying the name of the location. It is highly doubtful that one can separate the name from the place. A place is not just a place. You find a symbol to identify it. If you think that this is not so, try swapping names. Call the place named Vancouver by the name Regina and vice versa. The new hypothetical naming conventions would be Regina, British Columbia, and Vancouver, Saskatchewan. Now why doesn't this work?

How our work differs from that of other investigators is that our definition of immersiveness allows an audience to achieve several modes of understanding. Although this chapter, this linguistic exposition, might allow some people access to the experience through the words alone, we want to emphasize that there are sonic and visual dimensions to our conceptualization. So, while some composers or sound documenters might believe that their sonic experiences are adequate to express what they think needs to be expressed, we approach the field through pluralistic means and think that we are better able to reach an audience member who might have certain inherited modes of perceiving the world.[12]

We have articulated an approach to identity of a place through our unique use of satellite imagery and its analyses as a means of generating immersive time-based visuals and sounds. Although artists are always going beyond their traditional disciplines, we know of no others who are crossing science and art as we have demonstrated above.

NOTES

1 Bob L. Sturm, "Sonification of Particle Systems via de Broglie's Hypothesis," in *Proceedings of the International Conference on Auditory Display*, Georgia Institute of Technology, Atlanta, 2–5 April 2000, http://www.icad.org/websiteV2.0/Conferences/ICAD2000/PDFs/BobSturmICAD.pdf.

2 P.H. Nash and George O. Carney, "The Seven Themes of Music Geography," *Canadian Geographer* 40, 1 (1995): 69–74.

3 Barry Truax, *Acoustic Communication*, 2nd ed. (Portsmouth, NH: Greenwood Press, 2001). See also John Connell, *Soundtracks: Popular Music, Identity, and Place* (New York: Routledge, 2002). Many Canadian composers have drawn on Canada's geography for inspiration, and one, R. Murray Schafer, has created works specifically designed to be performed in wilderness environments. See http://www.patria.org.

4 For example, see J. Fanstone, "Sound and Touch: A Campus GIS for the Visually Impaired," *GIS Europe*, April 1995, 44–45; Reginald G. Golledge, Jack M. Loomis, Roberta L. Klatzky, Andreas Flury, and Xiao Li Yang, "Designing a Personal Guidance System to Aid Navigation without Sight: Progress on the GIS Component," *International Journal of Geographical Information Systems* 5, 4 (1991): 373–79; and R. Daniel Jacobson, "Talking Tactile Maps and Environmental Audio Beacons: An Orientation and Mobility Development Tool for Visually Impaired People," in *Proceedings of the International Cartographic Association Commission on Maps and Graphics for Blind and Visually Impaired People*, Ljubljana, Slovenia, 21–25 October 1996, http://www.immerse.ucalgary.ca/publications/llub1.pdf.

5 Haixia Zhao, Catherine Plaisant, Ben Shneiderman, and Ramani Duraiswami, "Sonification of Geo-Referenced Data for Auditory Information Seeking: Design Principle and Pilot Study," in *Proceedings of ICAD 04: Tenth Meeting of the International Conference on Auditory Display*, Sydney, Australia, 6–9 July 2004, http://www.icad.org/websiteV2.0/Conferences/ICAD2004/papers/zhao_etal.pdf.

6 Martin Quinn, "The Climate Symphony: Rhythmic Techniques Applied to the Sonification of Ice Core Data," in *4th Annual Conference of the International Environment Forum*, Orlando, FL, December 2000, http://www.bcca.org/ief/dquinooc.htm.

7 Sturm, "Sonification of Particle Systems via de Broglie's Hypothesis."

8 Ibid.; Quinn, "The Climate Symphony."

9 Thomas M. Lilles, Ralph W. Kiefer, and Jonathan W. Chipman, *Remote Sensing and Image Interpretation* (New York: John Wiley and Sons, 2008), especially 392–481.

10 MIDI, or Musical Instrument Digital Interface, is an electronic music industry protocol that allows a wide array of computers and digital musical instruments to communicate with one another.

11 A virtual reality cave traditionally is an enclosed area where each of the four walls is made with translucent material so that a dedicated data projector's image can be seen. Sometimes there is projection directly onto the floor, requiring a total of five projectors. Such venues can accommodate only a small number of participants, who don goggles and wear gloves as part of the experience.

12 Howard Gardner, *Frames of Mind* (New York: Basic Books, 1985).

CHAPTER SIX
Waldviertel: A Soundscape Composition

Gabriele Proy

INTRODUCTION

In 2004, I was commissioned by the Austrian Federal Ministry for Foreign Affairs to design a composition on certain specifics of Austria as a country for the EU-Japan-Year-2005. One aspect of the EU-Japan-Year was cultural exchange (from "people to people") in order to intensify communication and comprehension between Japanese and Europeans. This meant that I was also invited to present my new composition, *Waldviertel*, about Austria in Japan in 2005.[1] It is included on the DVD accompanying this book.

I wanted to compose a piece containing Austrian soundscapes and decided at last to realize a composition about the Austrian region Waldviertel, a rural landscape in the state of Lower Austria that I have known since childhood. Numerous memories came flooding back, took hold of my sound research, and influenced the process of composition. By listening to sonic atmospheres and rhythms through all the seasons, I conducted intensive sound research for more than a year in the Waldviertel.

Let me tell you a bit about this hidden natural resort, Waldviertel. It is a landscape in the northeast of Austria with forests and farming. In fact, the German word *Wald* means "forest," and the word *Viertel* means "quarter," so that Waldviertel is one of the four quarters of Lower Austria. Before 1989,

See DVD — Gabriele Proy — for a complete audio recording of Waldviertel.

it was there that the border with Czechoslovakia marked the great divide between East and West; therefore, this region was left out of industrial development. Set aside at the outer edge of noisy civilization, the area has remained a calm and traditional part of Austria. You can still discover places with hi-fi soundscapes[2] in the Waldviertel, and you can become involved in the time-honoured customs of people living in the countryside.

In this region, you can still find small traditional farms. The old houses are built of stone and have a wood-burning oven in the kitchen, the main room of the house. This typical regional farmyard consists of four adjoining buildings enclosing a central square courtyard (*Vierkanthof*). The quadrangle includes a farmhouse, cowshed, sty, hen house, and barn. In former days, the manure heap was in the courtyard, but nowadays it is located outside the farmyard. Often three generations live side by side in their farm buildings. There is a small apartment or cottage (*Ausgedinge*) on the estate reserved for parents, and the young farmers with their children stay in the main house.

Life is still rather hard in this region, so many young people move to the cities in order to make a living. Others remain, changing from growing traditional crops to more lucrative organic crops. Cultural life in the region is still embedded within the Roman Catholic tradition. Nearly every little village has its own church, although nowadays several villages might have to share one parish priest. Nevertheless, as I discuss below, the sound of church bells still has an important meaning in daily life in the Waldviertel.

SOUND RESEARCH AND REMEMBRANCE

When I started my sound research, I asked myself the basic question, *What does the Austrian region of Waldviertel sound like to me?* I listened intensively to the sounds of this rural environment and wondered whether there might be exceptional sounds that were characteristic of the area. During many walks dedicated fully to aural experiences, I searched for similarities and differences between my chosen environment and other well-known rural sound environments.

As a child, I spent many summer holidays in the Waldviertel on a farm, and as I walked I recalled numerous sound memories and compared them with the sounds that I was hearing in the present. Which sounds remained? Which sounds still seemed to form the sonic rhythm of this region? Of course, the sounds of this rural area will evoke different associations for a holiday traveller compared with people who permanently live and work there. But I believe that in either case you can discover a sonic rhythm of the year if you only take the time to listen.

In my investigations, I asked questions about the relationships among sounds, places, and times. What do the four seasons in the Waldviertel sound like? What does a single day sound like? While listening to the soundscapes

of the Waldviertel during different times at the same places, I noted both recurring and exceptional sounds. Some sounds were repeated at the same time every day, and some sounds reappeared only intermittently. Still other sounds occurred randomly or rarely. In a small village called Friedersbach, where I conducted much of my research, a stork had built a nest on the church roof. The clattering sound of the stork's beak could be heard especially in late spring and early summer. Later, in the middle of summer, the chirping of crickets and grasshoppers was dominant. But the distinctive sound of the fire siren (an important soundmark that I discuss below) split the air every Saturday at noon.

During my sound research, I was especially interested in the different atmospheres of places and times evoked by sounds. Hence, I made sketches of sonic atmospheres and vibrations. I differentiated between places of calmness and liveliness, noting dynamic variation and fluctuation. I took time to listen to continuous and repetitive sounds, and I tried to transfer the moods of these sonic moments into my composition. Besides duration and the rhythmical repetition of sounds, I focused on the complexity of sound colours. I wanted to emphasize the moods of my chosen places and their various sonic characters within my piece.

The Waldviertel consists of a complex natural soundscape punctuated by villages and just a few towns. Some sounds are immediately evident (e.g., the church bells in the village of Friedersbach), while others require more careful listening (e.g., the deep murmur of the river Kamp, a natural heritage site, or the rhythmical sound of rowing on Lake Ottenstein). Because of its many hi-fi soundscapes, this region offers rich listening possibilities.

Back at home in my studio, I reflected on my sound research and tried to imagine the sounds of each place that I had visited. I explored and catalogued sounds that evoked memories of special times and places that I had experienced in the Waldviertel. Drawing both on my sound memories and on my notes about sonic atmospheres, I designed the shape of my composition. I made a list of all the sounds to include in the piece, and I wrote down all the details about which place, season, and time of day that I wanted to record. There is a fundamental difference between listening to a recorded sound and listening to a sound within its environment. A recorded sound can never tell the same story. Therefore, it was important to clarify which sounds I wanted to record, and why I wanted to capture these special sounds, before setting out to record them.

My sound memories of the Waldviertel became an essential part of my research and process of composition. My sound selection was supported by my sound memories, which in turn gave shape to the piece and influenced my way of processing sound. In my composition, I tried to convey my particular experience of place and time.

The recording of natural sounds is not predictable. Time and patience are required to record specific sounds, but the process also offers marvellous and unexpected sonic moments. During one early morning recording, Roland Hille and I put my Soundman OKM microphones on a pile of wood and waited in the distance.[3] The place and time of the recording were carefully planned. Even so, when listening to the recorded sounds later, I was overwhelmed by the intensity and dynamics of the wonderful morning spring concert provided by the birds. To my surprise, the recording precisely matched my inner idea and remembrance of the dawn chorus in Waldviertel. In this region, the dawn chorus is particularly intense in spring. The mixed forest, fields, and meadows offer abundant food, and nearby is a large area that has remained completely undeveloped since World War II. This 157-square-kilometre area (nearly as large as the Principality of Liechtenstein) is one of the largest military training areas in Europe. It is open only for occasional military training and for farmers to till their fields. The resulting landscape is special in Europe; it supports rare plants and animals and special habitats.

I recorded the early morning singing of birds because it is a special sound of springtime to me. Other special seasonal sounds that I used included the chirping of crickets and grasshoppers in summer and the cosy sound of a fire in the grate in autumn and winter. Perhaps you are wondering why I chose an indoor sound to symbolize autumn and winter. Even on summer evenings it can be rather cold in the Waldviertel. There is enough firewood in this region that people can use fireplaces or wood-burning ovens in their kitchens. Even in private weekend cottages you can often find fireplaces, and the crackling fire provides not only heat but also a deep sense of comfort.

In order to document the traditional life of the Waldviertel, I selected two special sounds: the church bells and the noon-hour sirens of the small village of Friedersbach, where I conducted much of my sound research. I spent many days throughout the year in Friedersbach so that I could record the church bells in several different ways: announcing religious celebrations such as the harvest festival, reminding people about Sunday Mass, announcing the beginning of morning Mass, and marking the hours.

In a region with hi-fi soundscapes, the ringing of the church bells is especially conspicuous, and of course the sounds of the bells depend largely on the materials that they are made from as well as their size. However, as in all Austrian Catholic churches, in Friedersbach how the bells are rung depends on the context of the announcement. The bells ringing to announce Sunday Mass, for instance, last much longer and evince much more variety than the daily announcement of morning Mass. On Sundays, the bells are

Figure 6.1 Church of Friedersbach.

first rung to remind people to get up and are later followed by a solemn and ceremonial peal at the beginning of Mass.

Church bells also ring on the hour and at each quarter hour, with a special tune for each (one strike at the quarter hour, two strikes at the half hour, and so on). A different tune rings out on the hour. For instance, the six o'clock ringing is signified by two tunes: four strikes to mark the hour and six strikes to signify six o'clock. To accommodate tourists, the early morning bell ringing is often interrupted in summer months, and regular ringing only returns with the beginning of the new school year in September. A medieval charnel house stands next to the church of Friedersbach, and because of it the church of my chosen village is a well-known cultural monument (see Figure 6.1).

The second special traditional sound that I selected was the fire siren. In the villages of the Waldviertel, the fire sirens sound every Saturday at noon to announce the end of the workweek and the beginning of the Sabbath. Catholic tradition dictates that people celebrate Sunday together with their families and attend Mass. Any village shops are closed from Saturday noon until Monday morning. Only in cities are the shops kept open until six o'clock on Saturday, but even they are closed on Sunday. Sounding the fire siren is also a way of testing the siren's condition. This regular use of the fire siren every Saturday is a rhythmical sound of the week in the villages of the Waldviertel; however, the sound has a negative connotation for the older generation because it reminds them of World War II, so some of them understandably dislike it.

Recording sirens turned out to be quite tricky. Usually, the fire siren sounds every Saturday close to noontime; however, in my chosen village, it never seemed to ring out at the right time. On five Saturdays, I waited in vain to hear the Friedersbach siren in order to get the recording that I wanted. One Saturday the siren started much too early, just when I was setting up my recording equipment, and on another Saturday the neighbour's noisy circular saw interfered. Eventually, my patience was rewarded with an unexpectedly fantastic recording: it was the first time that I had heard two sirens in sequence. First came the siren of Friedersbach, and shortly afterward I heard the siren of the neighbouring village. Luckily for me, it was a rather cold but dry day, which allowed the sound to carry across a great distance. Of course, I could simply have asked the Friedersbach fire brigade to ring the siren especially for my recordings at an arranged time. However, I was interested not in isolating the sound object but in capturing sounds within their contexts. Waiting was a necessary and valuable part of the process.

SOUND RESEARCH AND COMPOSITION

Listening to my recorded sounds at home in my studio, I used another selective procedure. I organized and composed my sounds with many references to the terminology of soundscape studies to guide my aesthetic decisions.[4] In the field of soundscape studies, we differentiate between keynote sounds, sound signals, soundmarks, and symbolic sounds. A keynote sound forms a kind of background sound that might be so frequent that it is no longer consciously perceived. Living beside the sea, one might become inured to the sound of water ebbing and flowing, yet it influences one's way of listening. There is a special relationship between keynote sounds and sound signals akin to the concepts of ground and figure in visual perception. A sound signal obviously attracts one's attention, like a man standing in the foreground of a landscape painting. Specially noticed or unique sounds of a particular community can be understood as "soundmarks," a term derived from that of "landmark." Keynote sounds heard at particular times and places, along with sound signals, soundmarks, and symbolic sounds, play an important role in my process of composition in the field of acousmatic soundscape music.[5] To me, a soundscape composition is a poetic transformation of sounds and their environmental contexts.

Reflecting on my selected sounds of the Waldviertel, I interpreted the fire siren as a sound signal and the church bells as a soundmark. Sound signals such as fire sirens urgently demand our direct attention. Church bells might also be regarded as a sound signal; however, depending on the context and their projection, they might better be understood as soundmarks. Church bells are community sounds, and by interpreting the church bells

of Friedersbach as a soundmark I underline their special cultural role as they mark the daily life of the community.

I assigned the singing of birds and the sound of rain as keynote sounds of a special place at a special time. For example, songbirds created a particularly intensive keynote sound in spring, but apart from the cawing of crows there was almost no birdsong in winter. As it happened, rain was an almost continuous sound at the beginning of summer. From this perspective, I defined rain as a keynote sound. Rain became a kind of background sound over hours and days that had an ominous undertone. Unfortunately, the high tide at the river Kamp caused devastating flooding in 2006.

On summer evenings, the continuous chirping of grasshoppers appeared as a typical sound, and for me it was most interesting to listen to the changing dynamics. Each time the church bells started ringing in the evening the chirping of grasshoppers became louder. The crescendo and decrescendo of the grasshoppers depended on the duration of the church bells. This dynamic sonic reaction of the grasshoppers became part of my composition.

Forests, meadows, fields, small streams, and fishponds form the typical landscape of the Waldviertel. At the fishponds near the castle of Waldreichs (see Figure 6.2), I recorded the sounds of waterfowl in springtime.[6] I was especially fascinated by the sounds of swans. When swans take off, you can hear a dynamic slapping caused by the rapid flapping of their wings touching the surface of the water. These repetitive beats of the wings on the water are a dynamic and rhythmic sound of movement. You can hear the swan take off, but you do not know its destination. I used the various sounds of swans taking off from the water as a symbol for change and movement within my piece. For instance, the change of place and time from the lively fishpond during the heat of the day to the cottage woodstove on a crisp evening is announced with this repetitive slapping sound of swans' wings.

I decided to compose my soundscape of the Waldviertel like a portrait of a day and, at the same time, like a sonorous passage through the seasons in this rural region. My sound portrait starts with an early morning concert of birds singing in spring and drifts away with winter sounds of crackling fire and the evening peal of the church bells accompanied by the chirping of grasshoppers. Listening to the sounds of a single day and several seasons simultaneously, you can hear how these sounds symbolize a sonic rhythm of the region. By combining the duration of a single day and the passage through several seasons, I wanted to convey a feeling of rural rhythm and continuity of the Waldviertel as a remnant of traditional life in Austria. Yet part of the soundscape is absent, for I presented neither the sounds of farming nor any human voices. Aside from the church bells and the fire siren, I focused entirely on the sounds of nature because I wanted to compose a

Figure 6.2 Fishponds near Waldreichs.

soundscape that touched my inner idea of the Waldviertel. My composition is a poetic transformation of the region and not a scientific document.

COMPOSING AND SOUND PROCESSING

An elaborated concept of my soundscape composition was beginning to form in my mind. As I mentioned above, the recording of natural sounds is often unpredictable, a process that was made more complicated because I wanted to capture sounds within their environmental contexts and not as isolated sound objects. Moreover, I was interested in the moods of sonic environments. During my sound research and recording, I developed accurate ideas of my selected soundscapes. I then edited and transformed my recorded sounds until they matched both my contextual memory and my abstract idea of the sound image.

To record a sound is always to separate it from the context in which it was born. This separation seems to be a fundamental reduction on the one hand, but on the other it opens many possibilities for superimposing former meanings and new correlations and significances within the soundscape composition. My memory of hearing each sound in its original context guided my method of sound processing. For instance, with precise equalizing, I could underline the murmur of the river Kamp or specify the particular sound of flames flickering in a fire. I kept accurate sound colours in my mind and continued editing until the sound character matched my sonic

memory. Elaborate sound editing enabled me to approach my abstract idea of a sound image. My hope is that these abstract ideas of sound images will open possibilities for triggering listeners' own sonic remembrances while listening to my piece.

For me, listening is always a process of remembrance, linking up, and positioning; it is a way of combining sound memories and superimposing meanings. With my composition about the Waldviertel, I wanted to create a soundscape that the listener might immediately find familiar even though he or she was never there before. I aimed to touch his or her inner sonic imagination and to let him or her become immersed in the sound environment of this rural region. An early morning spring concert of birds singing in the woods near the small village of Friedersbach takes us into the midst of the Waldviertel's natural environment. Slow and rhythmical rowing at Lake Ottenstein renders sonic atmospheres of a summer day enriched by the chirping of crickets. The typical Saturday sirens at noon and the pealing of church bells speak of tradition and everyday life in the village, just as the cheery sounds of fire in the grate remind us of long, cold winter evenings.

My composed sonic moments of places and times in the Waldviertel are meant to give you an impression of the sonic rhythm of this particular region. While listening to the poetic dynamics and calmness of my composed soundscapes, you can immerse yourself both in the sounds of the Waldviertel and in the sounds of your remembrance.

NOTES

1 The world premiere of *Waldviertel* took place at the concert Northern Music in Hirosaki, Japan, in 2005. An earlier version of this chapter was presented at the annual conference of the World Forum for Acoustic Ecology in Hirosaki in 2006. The chapter has been significantly expanded for this publication.

2 R. Murray Schafer invented the term "hi-fi" (i.e., high-fidelity) environment. The term refers to environments in which you can listen to sounds clearly without any masking or crowding of sounds. Conversely, a "lo-fi" sound environment is dense and noisy (typical of many urban environments). See R. Murray Schafer, *The Soundscape: Our Sonic Environment and the Tuning of the World* (Rochester, VT: Destiny Books, 1994).

3 I am grateful to Roland Hille for his assistance during the sound recording for this project.

4 "Keynote sound" and "soundmark" are terms created by R. Murray Schafer.

5 The term "acousmatic" refers to the Greek word *akousma*. It is said that the philosopher Pythagoras invented a special way of teaching his students. He talked behind a curtain in order to support their concentration while listening. Sitting in a dark room in front of the curtain, his students were able to listen to Pythagoras without being distracted by his gestures.

6 The large lake of Ottenstein is located near the fishponds of Waldreichs.
 Because motorboats are forbidden on this built-up lake, it is a calm fishing
 and recreational area. A long stretch of the lake's shoreline marks the border
 with the above-mentioned military training area, and this little-used and
 undeveloped space offers a special habitat for waterfowl.

CHAPTER SEVEN

The Hills Are Alive … : The *Wild Fruits* Electroacoustic Soundscape Project

James Harley

As a composer, I have long been both sensitive to and attracted to the sounds of the natural world. I grew up in British Columbia, within easy range of the Rocky Mountains, and the awe that I have felt while hiking in the wilderness there and elsewhere fuels my compositional aesthetic and identity. A full realization of this connection took some years to coalesce, and along the way I struggled to find a way to give this sensibility musical shape.

One of the first compositional manifestations of "soundscape" that I explored connecting musical sound to nature was *A Walk in the Park*, a partially improvised electronic work presented during my undergraduate studies at Western Washington University (WWU) in the early 1980s. A complex "patch" on an analog modular synthesizer produced a sound resembling the burbling of a creek. Various filters, oscillators, amplifiers, and random voltage generators could be adjusted in real time to vary the sonic result, which was enhanced by live improvisation using wooden flutes and other instruments to evoke birds and other sounds of nature. The combination of electroacoustic composition and instrumental improvisation grew out of my varied interests — I had originally embarked on a degree in jazz studies before adding a second concentration in composition, and the jazz

See DVD — James Harley and Ellen Waterman — for a live audio recording of Wild Fruits 2: Like a Ragged Flock, like Pulverized Jade.

milieu at WWU was notably progressive, with visiting artists including, for example, Anthony Braxton and Leroy Jenkins. Combining fixed compositional elements or processes with free or guided improvisation seemed natural given the musical-educational environment within which I worked, although in retrospect the combination might have been somewhat unusual in other milieus where the fields of improvisation and composition often function separately.

Experimenting with synthesizers and other equipment in the electronic music studio was extremely valuable for developing a sensibility for the various parameters of sound. I must admit, however, that·I did far more experimenting (improvising) than composing during my several years of independent study in the studio. In hindsight, I realize that this was nonetheless a productive period. It gave me the opportunity to explore sound, and this experience would have a direct impact on my creative aesthetic when I later embarked on compositional activity in a more focused way (I only began to study composition formally a few years after entering the electronic music studio).

I graduated from WWU in 1982 and moved to London, England, to pursue advanced study in composition at the Royal Academy of Music. I had no access to electronic music equipment there, so I turned my attention to acoustic composition, writing music for voices and instruments. Browsing used books one evening in central London, I picked up a book that would resonate deeply with me: *Pilgrim at Tinker Creek* by Annie Dillard.

The book is a journal of a year-long cycle of living in nature, and Dillard's ability to articulate, among other reflections, the "awe-full-ness" of the natural world strongly connected with the wellspring of my own creative expression. I also responded to her fearlessness in facing all the elements of nature for what they are, beautiful as well as horrifying, uplifting as well as ruthless. I was developing a sense that music also needs to be fearless. I also connected strongly to her sensitivity to the spiritual aspects of life in nature and of course to her courage in trying to articulate the ineffable through poetic words and the prism of the natural world.

For example, Dillard describes her epiphany while on a simple walk:

One day I am walking along Tinker Creek thinking of nothing at all and I see the tree with the lights in it. I see the backyard cedar where the mourning doves roost charged and transfigured, each cell buzzing with flame. I stand on the grass with the lights in it, grass that is wholly fire, utterly focused and utterly dreamed. It is less like seeing than like being for the first time seen, knocked breathless by a powerful glance.... I have been my whole life a bell, and never knew it until at this moment I am lifted and struck.[1]

The transformative aspect of this passage is powerful and speaks directly to the feeling of awe in nature that I mentioned earlier and that underlay what I wanted to express in music as a composer. The visual and sonic imagery here is tied to a spiritual awakening that was important to me.

Dillard also expresses a perspective on human frailty that places us in a context not of domination and control over but of delicate balance with nature:

> I am a frayed and nibbled survivor in a fallen world, and I am getting along. I am aging and eaten and have done my share of eating too. I am not washed and beautiful, in control of a shining world in which everything fits, but instead am wandering awed about on a splintered wreck I've come to care for, whose gnawed trees breathe a delicate air, whose bloodied and scarred creatures are my dearest companions, and whose beauty beats and shines not *in* its imperfections but overwhelmingly in spite of them, under the wind-rent clouds, upstream and down.[2]

In this passage, Dillard seems to be speaking to her struggle to see beauty in nature even when it is damaged and scarred. She expresses an ecological perspective, a deep caring for the environment that I responded to and that was part of what motivated me to find a creative connection between nature and music.

Over the years, I thought many times of setting Dillard's words, from this and other books of hers, to music with singers and instruments. Somehow I could not get past the sense that turning her words into melodies would diffuse rather than intensify their impact. I did, however, title two compositions after Dillard: *Tyee* (1995) for bass flute and percussion and *Flung Loose into the Stars* (1995) for solo piano. Both of these titles were taken from her 1993 historical novel set in the Pacific Northwest, *The Living*. I came back to her writing when I realized that I might set the words *as spoken* rather than as sung, in the context of soundscape composition. By "soundscape," I mean primarily electroacoustic music created from recordings of natural sounds. While a sung voice might well find a place in such compositions, the spoken word seemed to me a more natural fit, perhaps due to my exposure to radiophonic works.

At a certain point in my compositional development, while still living in London in the mid-1980s, far away from my home environment, I began working on a music project that I called *Memories of a Landscape*. My initial idea was to "translate" into music some images of the lakes, hills, and mountains of the Okanagan/Monashee area where I had grown up. One of the main processes that I ended up using was to take the layered contours

of the landscape, as one might view them looking down a valley (in my case, the Coldstream Valley, the scene that I was exposed to daily growing up), and turn them into layered musical contours — a form of counterpoint. My first sketches were for five orchestras (thankfully abandoned!) to make the contours even more distinct, timbrally and spatially. This was eventually transmuted into *Memories of a Landscape II* (1988) for string ensemble, first performed by Thirteen Strings as part of the CBC Young Composers Competition in Ottawa. A related work was *Kekula (Memories of a Landscape III)* for orchestra, composed in 1992, premiered by the Hamilton Philharmonic Orchestra.

Along the way, I came to believe that there was no easy or obvious way to translate natural landscape into musical soundscape, and my aesthetic concerns became more directly focused on the materials of music. The connection to nature remained, but it took the form of "chaotics," adapting to music mathematical algorithms that model the often chaotic or non-linear behaviour of natural phenomena. I was not completely comfortable adapting the random procedures that John Cage had introduced or the stochastic functions with which Xenakis worked. I did study with Xenakis (1985–87) and spent those years working with finite mathematics (particularly probability functions), but I did not arrive at a point where the incorporation of these procedures felt natural. When I discovered the related functions of non-linear or chaotic functions, it was the modelling of natural processes (and even traditional musical processes) that attracted me to this particular mathematical world. Preliminary explorations led me, in 1988–89, to develop my own compositional processes based on chaotics that I have used to varying degrees in subsequent works. Titles of works composed using such methods continued to reference nature, including *Windprints* (1989) for orchestra, *Night-Flowering … Not Even Sand* (1990) for bassoon and electronics, *Daring the Wilderness* (1991) for percussion ensemble, and *Old Rock* (1996) for orchestra.

Access to computer music technology as it developed in the 1990s opened up possibilities for creating and processing sound again, as I had done earlier with analog technology. Digital technology enabled specific manipulations of recorded sounds to be carried out in order to integrate environmental (or other) sounds within a consistent compositional framework. Consistency and integrity were aesthetically important to me given my immersion in modernist new music in London, Paris, and Warsaw. The first work in which I used recorded natural sound was *Spangled* (1996), a short piece primarily built upon looped samples of Jimi Hendrix playing *Star-Spangled Banner* at Woodstock. To frame the sonic intensity of the electric guitar sound, I used some birdsong recordings from a natural setting. I went further with *Jardinages* (2000), built upon several layers of rainforest sounds, highly pro-

cessed, and mixed with references to music by Charles Ives, Olivier Messiaen, and Toru Takemitsu, all nature-loving composers. *On Frogs* (2000) was an experimental work combining loops of frog sounds with a processed voice part. Looking back at the progression of these works and others, I realized that there was an incremental opening out in terms of incorporating a wider range of sonic materials and performative elements based on improvisation. This might ultimately reflect my greater confidence in the materials and the performers (in certain instances) and less need to rely on rigid compositional rules across all layers and levels of the musical structure.

In 2001, I came across the final manuscript of Henry David Thoreau, recently discovered and published for the first time. *Wild Fruits* is a journal of observations of the natural environment that Thoreau lived in and is organized as a series of dated entries on the wild fruits (along with nuts and other edibles) that he observed in his daily perambulations. His entries were added over several years, somewhat haphazardly, but organized into chapters, each of which focuses on a particular fruit. The writing is quirky, sometimes digressive, but mostly factual, based on acute readings of evolving conditions as he found them.

As with Dillard's book, *Wild Fruits* is highly representative of Thoreau's identity as a North American writer: both books are strongly rooted in the natural world. Thoreau notes that "Most of us are still related to our native fields as the navigator to undiscovered islands in the sea."[3] In this journal of primarily naturalistic observations, however, Thoreau cannot resist the occasional political rejoinder: "We will quote to you the saying of Cyrus, the Persian king, that 'it is not given to the same land to produce excellent fruits and men valiant in war.'"[4] Thoreau's politics resonated especially strongly for me living in post-9/11 America and certainly affected my work.

After long years of pondering how I could make a more explicit musical connection to Dillard's writing, the idea of combining her words with those of Thoreau started to give shape to a musical impulse that might bear fruit, excusing the pun. It certainly helped that Dillard makes strong reference to Thoreau in *Pilgrim at Tinker Creek*, his nature writings being an obvious inspiration for her as well. Early in her book, Dillard sets herself up to follow in Thoreau's footsteps: "I propose to keep here what Thoreau called 'a meteorological journal of the mind,' telling some tales and describing some of the sights of this rather tamed valley, and exploring, in fear and trembling, some of the unmapped dim reaches and unholy fastnesses to which those tales and sights so dizzyingly lead."[5] It seemed to me that the more factual, dated entries of Thoreau (e.g., "November 22, 1850. I get nothing to eat in my walk now but wild apples, sometimes some cranberries and some walnuts"[6]) would create an interesting structural foil to the more ecstatic musings of Dillard.

The idea of integrating texts from Dillard and Thoreau with soundscape recordings first took form in 2002 in a proposal to the McKnight Foundation for a Composer Fellowship. With the support of that grant, I was able to outfit myself with portable recording equipment and embark on a process parallel to that of Dillard and Thoreau, recording "observations" of sounds in nature as I found them in various places that I visited. I began to set spoken fragments of text drawn from these two authors into composed soundscapes sculpted from the audio recordings that I was collecting. Gathering these recordings, I worked from no set agenda. I did not seek to find audio relating to a compositional "script"; instead, I recorded whatever nature sounds I could, in a variety of locations. I gathered a wide range of environmental sounds, from predawn mating calls of prairie chickens in western Minnesota to lake sounds in the Kootenays, British Columbia. Then I listened to these recordings and selected portions of them to work with. I was guided mainly by my intuition and by an evolving sense of which sounds would be appropriate for the project.

From the outset, I decided that my compositions needed to be surround-sound, multichannel works in order to immerse the listener in the audio environments that I produced. I have long been interested in the expanded sonic possibilities of working with multichannel technology. My first computer music composition, *Voyage* (1986), created on the UPIC graphic music system in Paris, was conceived as a four-channel work. Beyond the ability to "immerse" listeners in the sound (which can in fact be achieved by projecting two-channel audio through multiple loudspeakers around the audience), multiple channels allow for more precise spatial placement of different elements of the music. Perception is clarified, particularly when the music contains many layers of sound. In addition, multichannel production reflects the reality of listening in nature, where one hears, for example, the sound of the creek straight ahead, the wind in the trees directly overhead, the calling of the loon from the lake far to the left, and so on. Our hearing mechanism is capable of subtle discriminations in direction and distance, and with multichannel audio production one can incorporate these issues effectively into compositional practice.

In addition, I thought of adding visual and performative elements — slide show, actor, musician — to enhance the experience of listening to this music live. The presentation of recorded music by means of loudspeakers alone has long been problematic: many listeners find the experience less than fully engaging given that the normative concert performance involves people onstage, with lighting and visual elements of one sort or another. The problem for me has been to incorporate these performative elements in ways that complement rather than detract from the focused listening that the work demands.

In the case of *Wild Fruits: Prologue* (2004), the visuals are representational, based on photos from nature but somewhat abstracted, and the transitions from one to another evolve slowly (and at times return to previously seen images) in order to complement the sound world being presented. My aim was to create a parallel structure (in terms of timing and succession) that would be interesting but not engage the audience so much that their attention to the music would suffer. The actor was added as a signifier for the incorporation of text into the work, embodying the writer Annie Dillard and speaking the excerpts from her text at the appropriate moments (these spoken excerpts are included in the fixed-media version of the piece as recorded by Theresa Carson).

Wild Fruits: Prologue was originally conceived for six-channel sound, with an optional version that removed the recorded spoken excerpts of the Dillard text so that they could be performed onstage by an actress. The piece was later remixed to eight channels, and the slide show was added. This work incorporates spoken excerpts from both Thoreau and Dillard, and one of the underlying sonic layers includes a recorded Thoreau fragment (originally lasting ten seconds) stretched out using granular synthesis to last sixteen minutes, the duration of the work. This layer provides a somewhat stable "centre" to the textures that are otherwise full of wind sounds and birds (primarily prairie chickens and wild turkeys, recorded near Buffalo River State Park in Minnesota).

In the case of *Wild Fruits 2: Like a Ragged Flock, like Pulverized Jade* (2006) (see accompanying DVD), the performing musician enables the sound world to traverse the continuum from layered natural sounds to more purely musical ones. According to flutist Ellen Waterman, with whom I have performed this work a number of times, *Wild Fruits 2* "is a hybrid, both composition and improvisation, both pre-recorded and live, both fixed and mutable. It is a collaboration in which both partners have complete autonomy over their contributions, necessitating a high degree of trust."[7] During the performance, I mix the improvisational alto flute with the electroacoustic piece, diffusing the flute sound in unpredictable patterns among eight channels of sound. For the performer, as for the audience, the experience is elemental, akin to immersion in a chaotic natural environment of wind and water.

Wild Fruits 2 actually uses no recognizable spoken text. As in the *Prologue*, there is an underlying layer of Thoreau, granulated and stretched, and the title incorporates two fragments from Dillard. This piece, again mixed to eight-channel sound, adds an amplified alto flute (or substitute) to the soundscape sonorities. This flute part is meant to be improvised, guided by two elements: (1) a low drone heard at the opening (and present at the end of the *Prologue*, in case the pieces are performed together); (2) four text excerpts from Dillard. These guiding text fragments refer primarily to the

movement of birds and the creek, themes reflected in the soundscape material that is based on water sounds and massed birdsong (e.g., the dawn chorus).

Wild Fruits 3: Chestnut (2008) is based much more extensively on recorded text, drawn primarily from Thoreau. The soundscape materials, again mixed to eight-channel presentation, incorporate more discrete sounds, including footsteps, evoking Thoreau's walks through the countryside around his home. There is no live performance element in this work, but the intent is eventually to create a video, based on looped and processed imagery, primarily from forest locations.

I plan to complete the fourth work of the cycle, *Wild Fruits: Epilogue*, in 2013. It will incorporate winter sounds and texts from both writers. As the cycle of works has taken shape, it has become clear that the first three pieces might be interpreted as conveying soundscapes more or less specific to the seasons: *Prologue*, spring; *Wild Fruits 2*, summer; *Wild Fruits 3*, fall. This was not a conscious consideration, but as my awareness of this aspect of the music has solidified the element of seasons has influenced the planning of the final work of the cycle. Dillard's book traces her experience living in the woods by Tinker Creek over the course of a year, so there is a structural connection that can be drawn between her work and the music. The aim of this piece is to create an eight-channel soundscape and to reserve some sonic elements that can be triggered and spatialized live.

The soundscape materials for these works, gathered from a great variety of source locations, have been liberally manipulated in the studio. My aim has been to explore the creative potential of these sounds in a personal way while retaining a connection to the environments from which they come. I have a parallel interest in the instrumental music that I compose: to explore the extended possibilities of timbre and instrumental technique while retaining ties to familiar performance traditions. It is possible to alter the sonic qualities of soundscape recordings to such an extent that sources would be impossible to discern, and many composers follow this course, interested more in the abstract or spectral qualities of the sounds than in their geographical/environmental identities. In my case, the roots of my identity as a creative artist are tied to the natural world that I have lived in and around, so I am comfortable retaining the connection between sonic quality and source identity. I do not feel any need, however, to be dogmatic about this, and there are sonic elements in *Wild Fruits* for which it might be difficult to attribute sources.

The texts used for *Wild Fruits* are included to expand the frames of reference in the music and to set up resonances for the listener's imagination as sparks of connection might be drawn and evoke different responses according to one's background and experience. My hope is that listeners can develop an increased sensitivity to both the richness of natural soundscapes

and the need to protect the environments (and creatures) that produce these sounds. Furthermore, in our society, it is a hope with ever-increasing urgency given our heightened awareness of the fragility of the Earth's ability to sustain the present variety of organisms and ecosystems.

Wild Fruits: Installation (2004) is a related project intended for more direct educational use as a contribution to our growing environmental consciousness. A number of birdsong (and other) samples were prepared and loaded into a sampler that can be triggered individually or in combination from a MIDI keyboard controller. The keys can be labelled with the names of the birds and other creatures originating the sounds, and students can play the keys to hear the assigned sounds. As part of the installation, a background soundscape was prepared to run continuously (primarily based on creek and wind sounds). This provides an aural environment within which the sampled sounds can be heard as they are triggered by users. The aim is to familiarize students (and other participants) with the sounds of various birds common to the region (initially prepared for the midwestern United States) so that they can recognize them when out for a walk through nature. The ability to identify the creatures helps them to develop a sense of connection and hopefully a sense of caring for their fate. Beyond its educational value, the installation enables users to experiment creatively with the sampled sounds, to combine them and create their own sonic interactions.

The *Wild Fruits* project has enabled me to connect in a direct way my formal musical concerns and my interest in soundscapes and the environment. An artist is only partially aware of the sources of his or her creativity. I have long sensed that my roots in a geographical region of extraordinary beauty were important for the aesthetic impulse of my musical practice. Only gradually did I become aware that there might be a connection between the complexity of the natural forms of mountains and forests and the subtle colorations of lakes and skies and my predilection for dense textures and rich timbres in my music. The spiritual foundation of the natural world that I intuitively sensed growing up derived, at least to an extent, from the unknowable mystery of the environment. This sensibility was powerfully given expression in words by Annie Dillard. *Wild Fruits* has provided me with an opportunity to explore in music drawn from soundscape recordings my deeply felt aesthetic/spiritual connection to the natural world.

NOTES

1 Annie Dillard, *Pilgrim at Tinker Creek* (New York: Harper's Magazine Press, 1974), 42.

2 Ibid., 212.

3 Henry David Thoreau, *Wild Fruits: Thoreau's Rediscovered Last Manuscript*, edited and with an introduction by Bradley P. Dean (New York: W.W. Norton, 1999), 3.

4 Ibid., 4.

5 Dillard, *Pilgrim at Tinker Creek*, 23.

6 Thoreau, *Wild Fruits*, 209.

7 Ellen Waterman, "Revisiting Haraway's Cyborg: The Non-Innocent Music of Ellen Waterman," *Vague Terrain* (Fall 2006), http://vagueterrain.net/vt-journal.

Relationships

CHAPTER EIGHT

Send and Receive: Technology, Embodiment, and the Social in Digital Audio/Visual Art

Ellen Waterman

> What if my ears could detach and fly around the space, merge with any other ears in the audience? I want to listen from the perspective of audience members as well as from my own point-of-source perspective. —from Pauline Oliveros, "Tripping on Wires" [1]

This chapter focuses on digital audio/visual work by two teams of Canadian artists: Ian Birse and Laura Kavanaugh (originally from Edmonton) and Dominique Skoltz and Herman Kolgen (who worked together from 1996 to 2008 in Montreal).[2] Although very different from one another aesthetically, both partnerships employ digital visual and audio media on a reciprocal basis. *Removable Room* (2006–07 by Birse and Kavanaugh) and *Silent Room* (2003–07 by Skoltz_Kolgen) can both be considered immersive environments in which the very mutability of digital data serves to highlight the embodied nature and social potential of digital audio/visual art. Accordingly, the working processes and performance practices of these artists perform a social and aesthetic ideal that, following Pauline Oliveros, I characterize as "send and receive."

It is an unusual theoretical move, this, using the work of one artist — composer, improviser, and electronic music pioneer Oliveros — as the basis for analyzing work by other artists. Oliveros has no direct connection to

either Birse and Kavanaugh or Skoltz_Kolgen; however, her six decades of creative work with both acoustic and electronic media have opened up a rich territory for thinking about digital performance as both embodied and social. Oliveros began experimenting with electronic music in the 1950s and was unusual in putting improvisation at the heart of her work in the studio. In the 1970s, she turned her attention from sounding to listening, working in collaboration with a group of women in San Diego to develop a series of participatory compositions that she called *Sonic Meditations*.[3] These works, in turn, influenced the evolution of her Deep Listening philosophy of "listening in every possible way to everything possible" and indeed all her subsequent work in electronic and digital media.[4]

Oliveros presented the idea of sending and receiving as a socio-musical technique in her piece *Sonic Meditation III*: "Telepathic Improvisation." She calls on both performers and audience members to "send and receive" long tones by listening deeply, visualizing the receiver, and mentally sending the tone.[5] A key factor in this feedback loop of sending and receiving is that audience members are also invited to influence the performance by mentally focusing on the start and stop times, dynamics, tone quality, and emotional character of the tones. Oliveros thus implies that music making is a profoundly social act in which the musical outcome is a by-product of an "active, fully embodied aural perception."[6]

Furthermore, aural perception is connected here to visualization, as if sonic and visual signals are part of the same phenomenology, setting Oliveros' elision of auditory, visual, haptic, and emotional responses in contrast to the traditional separation and hierarchy of the senses found in Western culture. Philosopher Wolfgang Welsch, for example, has written about the objectness of visual culture versus the immersiveness of audio culture.[7] In *Undoing Aesthetics*, Welsch argues that the Platonic worldview from which our visually dominant culture derives is based on the idea that we can identify and know (and thereby distance and objectify) our world. Sound, on the other hand, is by nature immersive and therefore more intimate. Proponents of an auditive culture believe that it fosters a stronger sense of community: in order to understand one another sonically, we must both speak and listen (send and receive).[8] But in "Telepathic Improvisation," sonic and visual (and other sense) stimuli are not set in opposition; instead, the different senses influence and inform one another in a "multimodal" dynamic to articulate the "inhabited space" of performance.[9] Pedro Rebelo explains that "The elaboration of links between the sensory modalities of hearing, seeing, tasting, smelling, or touching defines the nature of our presence. Each of these modalities participates in a complex negotiation that inherently exposes contradictions and paradoxes."[10] Sending and receiving need not elide these differences. New media artists (and by this term I refer to artists who employ

both digital sound and image) might strive for a heterogeneous social ideal that encompasses a plurality of embodied experiences, a philosophy that is fully present in *Removable Room* and *Silent Room*.

REMOVABLE ROOM

Removable Room is one element within Ian Birse and Laura Kavanaugh's *Instant Places*, a project that they began in 2003 and describe as "an ongoing series of researches into Place as a field of possibilities from which singularities emerge, moment by moment" (www.instantplaces.ca). The artists explain that

> "Instant" also points to the transformative power of the moment of performance, a time-world of infinitely short duration that may serve as an opening to motion at right angles to history and clock time. During performance we invite visitors to step with us into a space in which time is suspended. The immediacy of physical presence is vital: it is clear to us that the possible value of a performance lies in the consciousness of every person in the room. (www.instantplaces.ca)

With this artists' statement, Birse and Kavanaugh confirm both the social nature of performance (involving "every person in the room") and the specificity of time and place that lends it "immediacy." The following analysis of *Removable Room* draws both of these threads together with a consideration of the role of technology in their work.

Birse and Kavanaugh took *Removable Room* across Canada in 2006 and 2007, creating and installing it in several cities. I experienced it at the 2007 Send and Receive Festival in Winnipeg, where I documented the performance and interviewed the artists. Birse and Kavanaugh arrived in Winnipeg a couple of weeks before the festival to begin their work, which initially involved walking the city, picking up odd bits of detritus, and documenting their walks with sound recordings and photos. As they explained it to me, the "performance" begins at the moment when they begin to interact with the environment. Kavanaugh told me that,

> As soon as we arrive and start on a project, the attention and the focus that comes with that has a lot of the same kinds of intensities [of] marked-off performance time.... Also, we investigate: we walk around town, we take photos, we take sound samples, and it is inclusive of the performance aspect because, when you're out trying to get strange photos and recording things, people are very aware around you. You become a performer in a sense, because you are very attentive to where you are directing your focus, but there's also, generally, "incidental audiences," we call them. People are aware that you're up to something.[11]

Birse and Kavanaugh use the artifacts that they collect to transform the performance space, in this case the stairway, entrance, and first room of Ace Art Gallery. Contact mikes, small objects, a resonant coat rack, and a tiny "room" (built around an inflatable wading pool that they found in the space) "performed" along with constantly mutating photos and sound recordings controlled via Max/MSP and Jitter software.[12] Birse and Kavanaugh's personal experience of Winnipeg was installed and created in this "removable room," which they then presented during a three-hour improvised performance.

Before discussing their performance, I want to suggest that, as both audio and visual artists, Birse and Kavanaugh employ an interactive approach to new media performance that marks a distinct evolution from earlier experiments in the minimalist electronic music aesthetic that their sound palette continues to reference. Curtis Walker argues that certain genres of digital music performance that were popular beginning in the late 1990s (e.g., microsound and glitch that derive their sonic materials directly from digital processes) offered particularly open spaces for reception since the artist strove to "disappear" in the very process of live performance.[13] Indeed, the Send and Receive festival in Winnipeg, like its big sister Mutek in Montreal, was founded on the growing audience that crosses between club-oriented electronica and more "listener-based," or self-consciously "art music," forms of digital music. The usual form for such concerts includes serial 45–60-minute-long sets during which the audience listens intensively as relatively static but texturally intense soundscapes slowly unfold. The self-effacing performance practice of the laptop artist contributes to an emphasis on an immersive, auditive culture.[14]

"Disappearing," for Walker, "suggests both an activity *in process*, and a state with a range of potentialities.... In other words the artist is disappearing in the *reception* of the art, not at its *conception*."[15] How does this work? In laptop performance, of course, we do not actually see the cause and effect of sound production, such as the bow across the string that produces a sustained tone on the cello. As Walker points out, laptop performance is non-matrixed: "Depending on the software being used and the performer's utilization of his/her software, the same gesture (a keystroke or mouse-click) will produce vastly different effects."[16] This ambiguity can lead to a suspicion that "there is, in fact, nothing going on behind the monitor — that digital sound being heard is not being produced in real time, rather it is simply being replicated by the computer that created it in the first place."[17] Because of this ambiguity, the role of the performer is effaced, leaving the listener free to interpret the music without undue reference to the sender; the emphasis is instead placed on the creative act of receiving.[18]

Another important component of Walker's argument about the dis-appearing artist is the inherent neutrality of digital data: "In its 'untranslated' state digital data can represent anything [equally sound or image], it only becomes imbued with meaning when it is translated by a program."[19] Walker is not suggesting that laptop artists do not self-identify as the creators of their work; indeed, there is often a strong tension between the artist's desire for total control of the output and the audience's demand for an "authentic" live experience. The paradox of the disappearing artist is that the audience has come precisely to "see" a live version of music that they normally encounter through recordings. But Walker insists that the self-effacing performance practice associated with laptop music creates an open space for interpreta-tion at the level of reception. One aspect of the disappearing artist, then, is this sense of the body's dissolution into "pure" data.

At its most rigorous, minimalist laptop music (in common with its aca-demic cousin electroacoustic music) strives to focus the listener's attention "purely" on sound. Kim Cascone, an influential laptop artist and theorist of the music, has argued that laptop performance should resist the distraction of eye candy, such as video, and retain its emphasis on listening. He states that "the aura this type of music presents is located in the musical content, not stage sets and costumes."[20] Another highly respected artist, Francisco Lopez, regularly blindfolds his audiences to remove visual distractions. Although such techniques, as Walker argues, can shift the emphasis away from performance and toward reception, they nevertheless reinforce the traditional gulf between artist and audience. The artist controls the con-ditions of performance, and the audience is invited to come to it only on specific terms. The disappearing artist is only an illusion, for artistic mastery is firmly at the centre of laptop music. In this music, sending and receiving appear to be separate rather than reciprocal activities.

While Birse and Kavanaugh continue the tradition of self-effacement in laptop performance, they place themselves in direct contact with their audi-ences, and I think that this shift is determined by the integrated approach that they take to sonic and visual materials that unfold within an impro-visational context. Performers and audience together become immersed in the audio/visual environment created by *Removable Room*.[21]

Throughout their three-hour performance at the Send and Receive festival, Birse and Kavanaugh concentrated totally on their tasks, avoiding eye contact with each other and the audience and always moving with a ritualistic slowness. Birse, for example, told me that he refrained from tak-ing off his sweater, even when he became too hot, because he did not want to distract the audience and disrupt the "through-line" of the performance. Such attention to bodily movements is all the more striking given the task-oriented quality of the performance, which consisted solely of keyboard and

mouse movements, plus small manipulations of the various miked objects. Kavanaugh described the performance, despite its non-matrixed quality, as a strongly embodied experience. Speaking of a moment in the long performance when she simply ran out of ideas, she said that "Sometimes your body will start to do something that's the right thing. And that's the best.... [Y]ou're distracted, and then you just find that something's happening and is making a sound, and you can go with that."

The audience, in fact, had a great deal more freedom to move around the performance space than the performers. Because this version of *Removable Room* was effectively in the entrance way to the gallery (and served as an antechamber to the bar and reception area, where people could buy tickets for other festival events), people flowed through the performance, brought chairs in and sat awhile, or wandered around in the space; several people took video during the performance, not hesitating to go right up to the artists.

For Birse and Kavanaugh, this fluid interaction is highly desirable, although they do expect (and got in this case) quiet attention, which their own quietly intense performance gestures encourage. The audience might have been responding to the "micro" sound world of the performance, in which tiny movements of objects are amplified by contact microphones (tapping a thin wire on metal or spontaneously scratching a tiny microphone directly on a wall). Even when digitally transformed and distributed in space, layered and looped, the sounds retain an intimate "whispered-in-your-ear" quality whose intelligibility requires close and active listening. It also seemed to me that the mainly Winnipeg audience members (Send and Receive is a small, local festival) were attentive to the morphing visual imagery that referenced the everyday life of their city.

In contrast to Cascone's dismissal of video as a distraction in laptop performance, the visual aspects of *Removable Room* are wholly integrated with the sonic experience — part of its performative aura. They are integrated at a symbolic level, since both visual and sonic materials are culled from the artists' encounters with the city, and at an aesthetic level, since both the sounds and the visual materials share an immersive sensibility. Visual images are projected on three walls and on the small "pool" at floor level, and several computer monitors are visible to the audience, so that the very Max patches (graphic maps of the work) become part of the visual field; similarly, the artists create sounds on suspended objects, on the walls, and on the floor. The entire space is animated both sonically and visually.

Birse and Kavanaugh's collaboration is founded on a hybridity of human and machine interaction, but the artists do not consider this a "neutral" or "cold" condition. As Kavanaugh told me, "I don't see [technology] as cold; it's warm, it's lovely, it's designed by human beings.... [I]t's part of us, you know. We're not disconnected; it's not this other thing over there." Birse also pointed

out that along with their peripatetic lives and autonomy as independent artists comes a particular socio-economic relationship with technology. In 2007, they were both still working with Mac G3 computers. Birse noted that

> There's a social, kind of political, ... aspect to that, ... you know, there's always this pull or this desire to work in higher-resolution formats, that it's closer to reality. You see a nice high-resolution, crisp photo, and you go, "Wow, that looks great. I want to process video in that resolution, and now [there's] high-def, and I want to do that." But the people who are working at that edge of technology are [usually] connected with an institution of some kind that has serious funding, and how does that affect your status as an artist in society, being independent, being a mobile kind of unit...?

As these comments indicate, for Birse and Kavanaugh, working with digital technology constitutes a form of social interaction, a politics that at the same time shapes their own relationship to society.

Interestingly, the transience of both *Removable Room* as an installation (it is made entirely of found objects that are discarded after the event) and the audience mirrored the transience of Birse and Kavanaugh at the time that I interviewed them. In order to have maximum flexibility to develop projects at remote locations, they had given up their home base in Edmonton in favour of a nomadic lifestyle. And, because they liked to stay in the performance location for extended periods of time (several weeks at least), they often tried to sublet an apartment or house-sit; thus, their daily lives were also a process of creating "removable rooms" inside other people's living spaces. As Kavanaugh put it, "Well, it's economic, and it is also related to the project ... because *Instant Places* and *Removable Room* [are] about space and time and moving around and the impermanence of things and transience of things...." Once a *Removable Room* has been disassembled, all that remains is a kind of digital shadow — an archive of Max patches, images, and sound files. The performative force of the work lies in the articulation of a particular social context that is nevertheless entirely ephemeral.

Skoltz_Kolgen have similarly constructed temporary environments in their work *Silent Room*, but as we will see, in contrast to Birse and Kavanaugh's articulation of quotidian life, they have created and documented a surreal and fantastic world.

SILENT ROOM

At the time that this chapter was written, Dominique Skoltz and Herman Kolgen described themselves as a "plurimedia work cell" that plumbed "the integral linkages between sound and image" by "inhabiting a space between

film, photography, audio art, and installation." As "architects of worlds, Skoltz_Kolgen penetrate[d] the ephemeral skin between solid matter and the unsubstantiated, the intimate and the objective, [and] their work conjures bewitched worlds that gestate betwixt accident and intent."[22] Although the duo dissolved in 2008, the following analysis of their most ambitious project, *Silent Room*, shows the interlacing of technological, biological, and political signifiers that pervaded their work.

Between 1996 and 2008, Skoltz_Kolgen created projects across a wide aesthetic range, from the high-tech generative software used in the video *Epiderm*, to improvisational performances, to the multivalence installation/DVD/book/CD project called *Silent Room*, which I discuss here.[23]

Like Birse and Kavanaugh, the Skoltz_Kolgen duo fully integrated their art and lives. Trained as artists, they worked for about a decade in high-end television advertising, a legacy that can be seen in the extreme polish of their productions. The terrorist attacks on the World Trade Center in New York on 11 September 2001 caused them to make an immediate decision to dedicate their lives to personal artistic pursuits. They severed their ties to commercial work for a time but benefited from the economic security that their previous career had afforded them.

It is worth discussing their collaborative process, since the duo saw brainstorming as an integral part of their creative process. The two francophone artists generously allowed me to interview them in English,[24] and I have retained their syntax here because it conveys something of their great liveliness and intensity:

> **K:** We brainstorm a lot, very deeply for each project.... Each project has a notebook, and we make notes, inspiration, research on the Net, we glue some photos, references. We each work separately at the beginning, and then we brainstorm. We need to have some oxygen. If we connect too fast at the beginning, then maybe it will influence the [other's] direction.... The brainstorm is a pleasure.

> **S:** It goes with a coffee in the morning, with a drink at night. For us, art is not disconnected with life. It's not like working nine to five.

> **K:** We don't need an appointment to brainstorm! ... When we have a project in our head, it returns in discussion all day. It's part of life. The brainstorm is important not only for the project but to make sure we have time to go deeper and in all possible directions. After that we want to find the simple, perfect line — what is the [most] strong and simple thing to say with this project. We want each project to say something different. The first thing is to find this guideline.

The above dialogue points to a striking similarity between Birse and Kavanaugh and Skoltz_Kolgen. Their collaboration was both a negotiation and a result of their social as well as their artistic partnership; they consciously made creative room for one another, but the final product came from the team, literally underscored by the name: Skoltz_Kolgen. What began as an entirely open-ended process culminated in a "simple, perfect line."

The artists described *Silent Room*, which they began brainstorming in 2000, as a "film-poem ... steeped in discontinuity, where unusual and poetic communications unfold wordlessly, through a contamination of the senses."[25] It comprises a number of short vignettes,[26] each set in an imagined interior space in which dream states and psychological fantasies, both surreal and nostalgic, are played out in sepia tones, decaying black and white, or blue washes. Each room contains one or two people: the pig-headed concierge dancing in his bathrobe to a distorted cowboy blues; an elderly couple draped in wisps of gauze, sitting worlds apart on either side of the marriage bed; two dripping-wet women in raincoats, literally hung up to dry (clothespins fastened to their collars); a blasé woman standing barefoot in her cluttered kitchen, ironing meat. Fascinating glimpses into interior lives, the vignettes can be viewed on DVD in any order, our choices providing accidental linkages and associations. For example, in room 469, Rudolph, a fat, dishevelled man in a suit, struggles to hook himself into a huge pair of diaphanous wings accompanied by shards of distorted parlour piano; in another room, perhaps just down the hall, Akhar struggles to find his way out of a suffocating mosquito net, gripping his fly swatter, as abstract clicks and pops punctuating a vaguely Middle Eastern melody are overtaken by a cacophony of buzzing insects.

Rather than "scored" in the usual sense, minimalist textures of music and sound provide both narrative structure and emotional affect, an idea discussed further below. Skoltz_Kolgen's sonic palette includes samples, sparse piano and cello, and a range of digital artifacts (glitches, pops, subliminal hums, and throbbing drones) that indexes the work to contemporary electronica more than electroacoustic music.[27] The DVD version frames the work in the atmosphere of a noble but crumbling old apartment building. Once we select a room from the apartment "directory," the camera peers down through a circular staircase, and we are immersed in a soundscape of echoing footfalls, murmuring voices, and stray snatches of half-recognized music.

We sense that sound bleeds through the rooms in a way that visual images cannot. In room 274, we meet Gustav, an elderly and emaciated but beatific man. Wearing only a flowered bathing cap with a plastic inflatable beach toy around his midriff, he breathes moistly through a snorkel. The empty room is an underwater wash of blues and greens, punctuated by the bright flash of goldfish in a bowl. Single notes and open intervals played on piano

drop heavily into the breathy texture. Next door a grotesquely fat man in singlet and briefs eavesdrops with the aid of an elongated stethoscope. As I watch this poor, pathetic man yearning for inclusion in Gustav's world, I become aware of my own role as an audience member. I am both detached, a voyeur, and irresistibly drawn into the illusionary space of the film, immersed in the melancholy and nostalgic atmosphere created by the music.

Skoltz and Kolgen deliberately created this tension between visual image and sound in *Silent Room*. They employed hand-held video footage and animated still photography to obtain fractured, nervous visuals (10,000 photographs were created by multiple still cameras on timers throughout the shoot). The visual image seems always in motion, always restless, while sound provides a coherent structural framework. For Skoltz_Kolgen, sound is both an architectural and emotional, but above all a cultural, substance.

> **K:** We build a kind of mood with different hardness, or depth, or softness of sound.
>
> **S:** It's not music, we say more like sound structure into space….
>
> **K:** Cultural sound, maybe we can say, cultural sound. At the same time, we have the impulse to share something, to have a certain … abstract harmony. We need to have both a cultural architecture but with a human sense inside it.
>
> **S:** It's not intellectual, it's not mathematic — it's something we have to feel. Always to serve the concept — if it doesn't go with the concept, we'll avoid using certain technology, even if it interests us.

This attitude toward sound helps to explain the intimate interaction of sound and imagery in their work. For *Silent Room*, they explain, they constructed "digital frequency-sensitive image-generating software that instantaneously shadows the audio track — somewhat like a heartbeat monitor that shadows the frequencies of a heartbeat, but in this case each frequency of sound can generate its image equivalent…. The music … express[es] a state of affect within the rooms and the internal reality of the characters. This is the film's narrative track."[28] The sound tracks were in fact created first and played during the shooting in order to influence and inspire the actors, who were encouraged to improvise on the scenarios provided. Improvisation resonates in different registers here: during shooting, the actors respond spontaneously to environmental stimuli; in the editing process, sounds order and reorder visual images captured from many sources; engaging with the work, the audience are interlopers, wandering the hallways at random,

eavesdropping, and peeping through keyholes. *Silent Room* is an unstable world epitomized by chance encounters.

Most of the shooting took place in 2001 in an old textile warehouse in which Skoltz and Kolgen repeatedly constructed and destroyed the individual "rooms." It is telling, in fact, that *Silent Room* was originally conceived as an installation in which the videos would be projected in individual rooms that contained related artifacts (it was presented this way in an Italian fortress at Transart in 2006.) For Lucinda Catchlove, the installation version "reveals the artists' intent to place the audience within the work — to engage us as participants not merely observers. We are asked to interact, to become attached and implicit, and to enter into the Silent Room rather than observe from a safe distance."[29]

Their intimate connection with the audience was confirmed in my 2005 interview with Skoltz and Kolgen after a showing of their film *Epiderm* at Montreal's Mutek festival. *Epiderm* is an abstract film created with a kind of generative software (first used in the Hollywood film *Matrix*) that allows sound to influence the "choreography" of visual images as they interact on the screen. In this case, the images appear as a strange ballet of fantastic amoebas and other imaginary microcellular creatures. At Mutek, a circular screen was fastened to the ceiling. Audience members were welcomed to the space by the artists and invited to watch *Epiderm* from a prone position on yoga mats (with head rests thoughtfully provided). Above us, leaning on the railing of a darkened gallery, Skoltz and Kolgen observed the audience as we watched their film. Kolgen talked about why they insisted on being present at every screening: "We prefer to be there to monitor the tech [and to make sure that the sound and image are set up right for the room] but also to feel the feedback from the audience. It's subtle, but for us it's important.... It's a kind of confrontation with the piece and with the audience."

Indeed, the duo continually modified their works to suit different performative and presentation contexts so that they took on a fluid, morphing quality. Interestingly, however, they also had an urge to archive *Silent Room* in the the form of a limited edition (1,000) "box" containing DVDs in both NTSC and PAL formats, a handsome catalogue with photographs and essays, and two CDs that bring a new, and explicitly social, dimension into the work.

For *Apartment Music*, Skoltz and Kolgen commissioned thirteen musicians (Scanner, Steve Roden, and Sebastien Roux, among others) to create pieces using ambient sounds recorded in their own living spaces. For *Chamber Music*, they commissioned forty-five-second recordings of performances by nine musicians from various backgrounds and aesthetics (including Lisle Ellis, Sawako, and Taylor Deupree) that Skoltz_Kolgen then mixed to create small virtual ensembles: duos, trios, and so on.[30]

Similarly, the box set chronicles the many permutations of *Silent Room*: as a "performance" of the rooms distributed across five screens and mixed live, as an installation piece, and as a ten-minute remix or "distillation." The DVD of *Silent Room* not only allows us to plot our own routes through the rooms but also takes us into the "corridors" between them with footage of the shoot that contains candid glimpses of the artists and their actors, crew, and friends. There are eighteen of these intimate glimpses, shot in the same fragmented and non-didactic format, into Skoltz_Kolgen's working process, providing a weight of documentation that balances the creative work. Throughout, ambient soundscapes serve to link the various segments on the DVD, constantly immersing us in the acoustic space of the shoot.

What I take from the *Silent Room* "box" is the meeting of the modernist concept of a contained, preserved, and limited edition artwork (reinforced by Skoltz_Kolgen's nostalgic use of surreal imagery and samples of fin de siècle music) with a postmodern notion of networks of affiliation (signified through the work's fractured qualities and multiple entry points). This is a specifically social approach that allows for the participation of numerous and diverse voices and, in so doing, invites us to reorder and reframe the materials. Even as a DVD, *Silent Room* "performs" as an interactive experience: the "receiver" charts his or her own trajectory through the piece, both "on" and "off" stage.

DIGITAL TECHNOLOGY, EMBODIMENT, AND THE SOCIAL

It is not difficult to analyze both *Removable Room* and *Silent Room* as artistic expressions of the *social*. After all, the artists choose to work in partnerships, and their artistic products are a direct result of social interaction. Going further, the holistic approach to digital technology taken by Birse and Kavanaugh, Skoltz and Kolgen, emphasizes *embodiment* as an inherent quality of their artistic materials. Indeed, embodiment is a precondition for sending and receiving as Oliveros understands it.

Skoltz_Kolgen and Birse and Kavanaugh, as we have seen, consider audio and visual data as mutually constitutive in their art; certainly, their work reflects the rapid advances in real-time digital technologies that we have seen in the new millennium. But there is also a distinctly organic quality to their discourse on technology. Kavanaugh's characterization of technology as "warm" is predicated on the idea that electricity equates to heat, movement, and energy. Similarly, Skoltz_Kolgen's use of generative digital software demonstrates its fluid and dynamic properties. Digital data here are considered as neither "pure" nor "neutral" but a kind of living substance that can be endlessly manipulated and transformed and that is significantly shaped by the specific context of performance (a location that puts senders and receivers into dialogue). This idea suggests that there is a distinctive link between new media technologies themselves and embodiment.

Although technology theorist N. Katherine Hayles is most famous for a book entitled *How We Became Posthuman*, she resists the idea that bodies have become obsolete in the context of the digital age. Hayles posits a "certain kind of postmodern subjectivity" that has "emerged from theories of the discursive construction of bodies ... and is constituted by the crossing of the materiality of informatics with the immateriality of information."[31] Her argument is obvious, at least in postindustrial societies: digital technologies have shaped us as both senders and receivers of information.[32]

Indeed, Hayles insists that digital technology can absorb "the body" as a general concept, but "embodiment" (as particular experience) persists: "Embodiment is ... inherently performative, subject to individual enactments, and therefore always to some extent improvisational. Whereas the body can disappear into information with scarcely a murmur of protest, embodiment cannot, for it is tied to the circumstances of the occasion and the person."[33] When audience members are invited to roam freely through Birse and Ka-vanaugh's performance of *Removable Room*, or when Skoltz_Kolgen invite other artists to participate in organizing the structure of *Silent Room*, they are emphasizing not just the social but also the embodied nature of their art.

A focus on embodiment means a focus on context and environment — an inversion of Cartesian logic. Hayles states that, "Whereas the causal thinking that Descartes admired in geometry and sought to emulate in philosophy *erases context* by abstracting experience into generalized patterns, embodi-ment *creates context* by forging connections between instantiated action and environmental conditions. Marking a turn from foundation to flux, embodi-ment redefines the role and importance of context to human cognition."[34] Embodiment "creates context" because of its articulation of space and place: the bringing together of "instantiated action" (here artists' sonic and visual expressions and audience members' varied ways of receiving them) with "environmental conditions" (e.g., a particular room and transmission technolo-gies). The specificity of place articulated by both *Removable Room* and *Silent Room* underscores the idea that identity and place are mutually productive. To quote sound art theorist Gascia Ouzounian, "identities can be mapped out in terms of real and imagined distances (e.g. to memories, experiences, other bodies) that are brought to bear in moment-to-moment situations that connect particular constellations of distances (bodies and identities) in place."[35] Ouzounian's formulation captures the social dynamics of the "rooms" articulated by these works: the complex interplay of image and sound both from the artists' conception and in the moment of performance/reception.

A focus on embodiment returns us to Pauline Oliveros' idea of "active, fully embodied aural perception," an idea that is both social and political. In her sensitive analysis of Oliveros' *Sonic Meditations*, Martha Mockus points out that Oliveros' "compositions ... call for collaborative music-making"

and "insist on a 'continuous circulation of power' between listening and sounding."[36] Oliveros' more recent work extends the idea of sending and receiving to the Internet2 realm of Second Life, where all the performers and audience members meet (in customized animated bodies) in cyberspace to improvise together in real time across vast physical distances. Contrary to the sense of dematerialization that one might expect in this situation, performers report that they feel completely engaged, as if *physically* present, in Second Life.[37] Latency issues have been overcome to the degree that real-time improvisation is possible, and a genuine sense of ensemble can be created. Not only are visual and aural perceptions interrelated in the performative act of sending and receiving, but also embodiment itself, as Oliveros' work demonstrates, is deeply implicated in technology. In her 2004 article "Tripping on Wires," Oliveros muses on the relationship between technology and her own performing body:

> *Sonic Meditations* were explorations on my part concerning how at-
> tention is directed in creative work and spontaneous performance.
> I needed to find a way into how the mind works to make music.
> Electronic music had expanded me. The electricity in my own body
> seemed to be flowing differently than before my exposure to electronic
> sound. However, there were no answers for me other than my own
> experiences. There were no guidebooks concerning the effects of im-
> provisation and new sounds on the body. I had to find my own way.[38]

In my view, Skoltz_Kolgen and Birse and Kavanaugh share a kinship with Oliveros. Both *Removable Room* and *Silent Room* highlight the interactive potential of performative digital media: of sending and receiving as recipro-cal processes that encourage a continuous circulation of power, enabling the listener to "find her own way." These works act as sites of an embodied and heterogeneous sociality that can dissolve hierarchies of media (audio and visual), experience (performance and reception), and perhaps even materiality (human and technology).

NOTES

1 Pauline Oliveros, "Tripping on Wires: The Wireless Body: Who Is Impro-
 vising?," *Critical Studies in Improvisation/Études critiques en improvisation*
 1, 1 (2004): n. pag., http://journal.lib.uoguelph.ca/index.php/csieci/article/
 view/9/32.

2 The research for this chapter was funded by the Social Sciences and Hu-
 manities Research Council of Canada and stemmed from my larger com-
 parative study of experimental music performance at eleven festivals across
 Canada. Earlier versions were developed for presentation at the Second To-

ronto Electroacoustic Music Symposium and the Kill Your Timid Notion festival of experimental music and film (Dundee, Scotland) in 2008. Ian Birse, Laura Kavanaugh, Dominique Skoltz, and Herman Kolgen were very generous with their time, for which I owe them great thanks. Pauline Min- evich kindly commented on an early draft; Lloyd Whitesell and graduate students in the McGill Music Colloquium Series (2009) offered very useful feedback; finally, Charity Marsh's invitation to speak at the Interactive Media Performance Lab, University of Regina, gave me the opportunity to complete the chapter.

3 The first twelve meditations were published as "Sonic Meditations," *Source* 5, 2 (1971): 103–07. The complete score was published as *Sonic Meditations* (Baltimore: Smith Publications, 1974).

4 Pauline Oliveros, "Acoustic and Virtual Space as a Dynamic Element of Music," *Leonardo Music Journal* 5 (1995): 19–22, 19. See http://www.paulineoliveros.us and http://www.deeplistening.org for more information on Oliveros and her Deep Listening Institute.

5 Pauline Oliveros, "*Sonic Meditation III*: Telepathic Improvisation," in *Sonic Meditations* (Baltimore: Smith Publications, 1974). "Send and receive" is a term often associated with radio broadcasting.

6 Martha Mockus, *Sounding Out: Pauline Oliveros and Lesbian Musicality* (London: Routledge, 2008), 44.

7 Wolfgang Welsch, *Undoing Aesthetics* (London: Sage, 1997), especially Chapter 9, "On the Way to an Auditive Culture?," 150–67. "Vision sets things at a distance and holds them fixed in their place. It is the objectivizing sense through and through.... Hearing, on the other hand, does not keep the world at a distance but admits it.... Such penetration, vulnerability and exposure are characteristic of hearing" (158).

8 Ibid.

9 Pedro Rebelo, "Haptic Sensation and Instrumental Transgression," *Contemporary Music Review* 25, 1–2 (2006): 27–35, 28.

10 Ibid.

11 Unless otherwise indicated, comments by Birse and Kavanaugh are from my interview with them in Winnipeg on 11 May 2007.

12 Max/MSP and Jitter are interactive programming environments commonly used to create and control audio and visual data in live digital performances.

13 Curtis Walker, "The Disappearing Artist: The Creative Act of Listening to Microsound and Glitch" (MA thesis, Trent University, 2004). I had the pleasure of supervising this thesis and am grateful to Curtis and the other members of the committee, Dr. Veronica Hollinger and Dr. Susan Fast, for stimulating my thinking about digital performance.

14 Fans of minimalist laptop music value this kind of immersion because it promotes a trance-like, deep listening experience. Ellen Waterman, participant intercept interviews with audience members at Send and Receive, 2005.

15 Walker, "The Disappearing Artist," 4.

16 Ibid., 93.

17 Ibid., 94.

18 Walker also notes the late-1990s practice of providing equally minimalist graphics for recordings from labels such as Mille Plateaux and 12K; blank CD sleeves with few or no titles were favoured.

19 Ibid., 38.

20 Kim Cascone, "Laptop Music: Counterfeiting Aura in the Age of Infinite Reproduction," *Parachute* 107 (2002): 52–67, 57; quoted in Walker, "The Disappearing Artist," 107.

21 *Instant Places* is documented at www.instantplaces.ca; the specific performance of *Removable Room* discussed here is archived at http://instantplaces.ca/aceart/aceroom_10.html.

22 Skoltz_Kolgen's biography was posted at http://www.skoltz_kolgen.com/anatomy.html until 2008, when the website was taken down after the artists decided to pursue separate careers.

23 *Silent Room* boxed set (Montreal: SK Faktory, 2003–07). *Silent Room* was conceived in 2000 and presented in a number of installations, performances, and finally as a boxed set between 2003 and 2007.

24 Unless otherwise indicated, comments by Dominique Skoltz and Herman Kolgen are from my interview with them at Mutek in Montreal on 5 June 2005.

25 "//silent room," http://www.skoltzkolgen.com/silentroom.html. Site no longer accessible. See note 23.

26 On Skoltz_Kolgen's website, *Silent Room* was described as having sixteen rooms, but the DVD version discussed here features fourteen. The work has also been "remixed" in a number of other formations. At the time of writing, several excerpts are available on YouTube. See, for example, *Silent Room* Film 01, http://www.youtube.com/watch?v=isX7IvevM4Y; *Silent Room* Film 04, http://www.youtube.com/watch?v=iThdEexKr QQ&feature=related; *Silent Room* Film 06, http://www.youtube.com/watch?v=GpKQp4b5OWI; *Silent Room* Installation, Balzano Italy, http://www.youtube.com/watch?v=zTAgNcWYkwY; and *Silent Room* Perfo 1 (five-screen remix), http://www.youtube.com/watch?v=4cpAcs5PWgo&feature=related.

27 In fact, Skoltz_Kolgen were much supported by Mutek, Montreal's popular festival of new digital music and video in which dance music is programmed alongside the latest experiments in digital performance art. See http://www.mutek.org.

28 "//silent room," http://www.skoltzkolgen.com/silentroom.html. Site no longer accessible. See note 23.

29 Lucinda Catchlove, liner notes for *Silent Room* boxed set (Montreal: SK Faktory, 2003–07).

30 The complete artist listings are as follows: *Apartment Music*: Nathan McNinch, Sébastien Roux, Akira Rabelais, Sawako, Ryoichi Kurokawa, Fm$_3$, Steinbrüchel, Kempf, Magali Babin, Steve Roden, Scanner; *Chamber Music*: Lisle Ellis, Sawako, Stefano Tedesco, Yoshio Machida, Erik Griswold, Agf, Fm$_3$, Taylor Deupree, Kenneth Kirschner.

31 N. Katherine Hayles, "The Materiality of Informatics," *Issues in Integrative Studies* 10 (1992): 121–44, 123.

32 As I type this, I think of my carpel tunnel syndrome (my neurologist describes computers as "pathological") and the way that my teenager is constantly wired (to laptop, mp3 player, or both).

33 Hayles, "The Materiality of Informatics," 129.

34 Ibid., 134; emphasis added.

35 Gascia Ouzounian, "Embodied Sound: Aural Architectures and the Body," *Contemporary Music Review* 25, 1–2 (2006): 69–79, 72.

36 Mockus, *Sounding Out*, 10. Mockus is quoting Suzanne Cusick's influential essay on listening as a lesbian. "Cusick suggests that most western art music practices, such as composition, performance, pedagogy, and analysis, encourage a 'power-over' relationship with the music, and she argues for a serious re-examination of that paradigm. More specifically, she describes 'a preference for musics which invite extremely heightened, sensual, cognitive attention, musics which *invite* and allow me to participate or not as I choose, musics with which I experience a continuous circulation of power even when I let the music be "on top"'" (9). See Suzanne Cusick, "On a Lesbian Relationship with Music: A Serious Effort Not to Think Straight," in *Queering the Pitch: The New Gay and Lesbian Musicology*, ed. Philip Brett, Elizabeth Wood, and Gary C. Thomas (New York: Routledge, 1994), 67–83, 76.

37 Conversation with Ione, November 2007, in Evanston, Illinois, at the International Society of Improvising Musicians conference.

38 Oliveros, "Tripping on Wires," n. pag.

CHAPTER NINE

ITU: The Din of Recovery

John Wynne

> Unnecessary noise, or noise that creates an expectation in the
> mind, is that which hurts a patient. It is rarely the loudness
> of the noise, the effect upon the organ of the ear itself, which
> appears to affect the sick. Unnecessary noise ... is the most
> cruel absence of care which can be inflicted either on sick or
> well. —from Florence Nightingale, *Notes on Nursing*[1]

I spent a year as artist-in-residence at Harefield Hospital, just outside
London, one of the world's leading centres for heart and lung trans-
plants.[2] Working closely with photographer Tim Wainwright, I recorded
patients, the devices attached to or implanted in them, and the hospital
environment itself.[3]

During my time at Harefield, I noticed that noise seems to come
in waves: sometimes it is quiet enough to hear nurses' uniforms swishing,
birds singing outside, and the snapping of latex gloves, but the atmosphere
regularly builds to a cacophony of bleeps, bells, phones, pagers, voices,
trolleys, bins, bags, and plastic apron dispensers. My observations and
interviews confirm anthropologist Tom Rice's assertion that in hospitals
sound takes on "a more affective quality *because* of the drought in other
sensory modalities."[4] As one of the project participants, heart transplant

*See DVD — John Wynne and Tim Wainwright — for the complete video record-
ing of* ITU.

recipient Kate Dalziel, puts it, life on the ward "involves a curious mixture of sensory deprivation and sensory overload."[5] Particularly if restricted to bed, what a patient sees is very limited, smells are generally overpowered by disinfectant, and the food is bland. Consequently, hearing becomes arguably the most important sense for understanding the environment and making sense of one's experience.

THE INTENSIVE TREATMENT ENVIRONMENT

As you walk along the gently curved corridors of E-ward, in addition to the more generic features of the hospital soundscape, you can often hear the clicking of ventricular assist devices (VADs) coming from patients' rooms — sounds that someone has to live with twenty-four hours a day, sometimes for a year or more, while waiting for a transplant. Particularly noticeable and disturbing at night are the occasional sounds of pain or distress from the patients themselves. In the ITU (Intensive Treatment Unit), both the care and the sonic environment are even more intense and unceasing: it is an open ward, and, in addition to the accumulated noise of the life-maintaining machinery and accompanying alarms and reminders, verbal communication among staff often conveys a sense of controlled urgency. When new equipment was installed in the ITU, with alarms that were more thoughtfully designed, some of which (the non-critical warnings) could be reduced in volume by staff, the resultant lowering of tension in the facility was immediately palpable.

A study at Johns Hopkins University has shown that sound levels in hospitals have been rising steadily from a daytime average of 57 dB(A) in the 1960s to 72 dB(A) in 2005.[6] The latter figure is equivalent to busy traffic heard from a distance of five metres, hardly an ideal environment for healing or indeed working. A 1994 study of noise levels in intensive care units in the United Kingdom found that the daytime range was from 50 to 75 dB(A)[7], similar to the range that I measured recently in the Harefield ITU of 54 to 74 dB(A) (though this measurement was taken on a relatively calm day). The International Noise Council recommends that noise in acute areas of hospitals should not exceed an average of 45 dB(A) during the day and 30 dB(A) at night.[8] "For adequate rest and sleep, noise levels below 40 dB(A) are recommended. Several studies ... have shown that sleep deprivation is a common problem in ICU; the amount and quality of sleep were adversely affected. Rapid Eye Movement (REM) sleep, which is believed to be 're-storative' sleep, is markedly reduced in patients in ICU."[9]

As well as sleep deprivation, other physiological responses to noise can negatively affect healing, as the UK study demonstrated. "The hypothalamic-pituitary-adrenal axis is sensitive to noise as low as 65 dB(A) ...," resulting in what is described as a "stress response." [10] "Noise also has undesirable

effects on the cardiovascular system; exposure to noise greater than 70 dB(A) results in increases in vasoconstriction, heart rate and blood pressure."[11] Moreover,

> Exposure to moderate levels of noise can cause psychological stress. "Annoyance" is a common psychological reaction to noise. It includes feelings of bother, interference with activity and symptoms such as headaches, tiredness and irritability. The degree of annoyance is related to the nature of the sound, its meaning, whether it is controllable or unexpected, and the individual sensitivity. Intense noise can cause personality changes and a reduced capacity to cope. Sudden and unexpected noise can cause a "startle" reaction which may provoke physiological stress responses.[12]

Staff in the Intensive Treatment Unit are aware that it is a noisy place, but on a day-to-day basis there are, of course, usually more urgent and important things to consider. Individuals spoke about measures that they take to minimize discomfort for patients: one mentioned that he always makes sure the hissing vents of CPAP (continuous positive airway pressure) machines, which I measured at 79 dB(A), are not directly next to a patient's head, for example. Although, as far as I know, there has been no systematic attention paid to sound in this hospital on an institutional level, the manager of the facility (who keeps a can of WD40 handy to tackle annoying squeaks) has taken a keen interest in my work, so perhaps sound will move up the agenda somewhat. Although my data may not be considered accurate enough for a scientific study, at least it has provided a catalyst for discussion.

In addition to the more or less constant noise of machinery and staff in the ITU, there are regular but unpredictable transient sounds that can be quite jarring, even if one is well. Mazer has shown that in the hospital environment "erratic sounds that create apprehension and expectation contribute to the need for restraints, requested pain medication, and nursing assistant calls."[13] At Harefield, rubbish bins that banged shut were recently replaced by ones with dampened lids, but I notice that they still bang when opened; this happens frequently because nearly everything used in the ITU is disposable or comes in disposable packaging (the crumpling of which is another regular and not insignificant source of sound). One patient said that "the day that the new bins came 'round was incredibly exciting, really exciting, because the new bins have got dampened lids, whereas the old bins, all of them just clang."[14] There are bins throughout the ITU: at a distance of five metres, they measured 72 dB(A) and, at one metre, 76.1 dB(A). The alarm on a ventilator measured 75 dB(A) at one metre, and a blood pressure monitor alarm was 67 dB(A). Some of the loudest transient peaks

were caused by a cleaner moving furniture — 85.9 dB(A) — and, when the telephone at the nurses' station was added to the ambient sound, peak levels regularly reached 74 dB(A).

AUDITORY WARNINGS, VOICES, AND PSYCHOSIS

ITU is a place which is best forgotten for me. It's ... a very emotional part of what you go through, which is a shame because the people in there are marvellous, really, really lovely, and the few folks that I've met outside ITU ... you meet them as humans, you know, rather than as ... I don't know.... It's such a strange environment because you're deprived of sleep, you're deprived of natural light, you've always got noise, always, twenty-four hours, noise.... I can't remember it distinctly because there's a blur between what I remember and what I think were nightmares from the morphine. I was into beats, rhythms — very, very much — and I was measuring the rhythms in my head in ITU. There's lots of rhythms around.... There was a particular door that had a noise, and it was a busy door, ... and it created this rhythm that kept going in my head. There's another sound, and I don't know where this one came from, which was the sound of helicopters, which you'll appreciate is very much connected with what goes on here [helicopters are used to bring organs for transplant]. But I always thought I heard the sound of helicopters whirring at night, so I presume it was an air-conditioning unit or something like that. I don't know where it actually came from, but to me it was a helicopter all the time. And then the other one of course: with the Jarvik 2000 [an internally fitted ventricular assist device], there are a number of alarms, one of which is the power off alarm, which means that your heart pump has stopped, which is pretty dangerous if you haven't got sufficient backup. And that alarm, would you believe, is almost exactly the same as the alarm of the doctor's call, you know, the call alerts they wear on their belts, so whenever any of the doctors were alerted, of course, the first thing I would do was reach around in panic for the Jarvik controller to make sure that it wasn't me.[15]

Different manufacturers of equipment used in environments such as hospitals have historically had little or no coordination between them with regard to designing alarms, so there has been scant consideration of the effects of the various sounds in relation to each other or to their cumulative effect on the environment.

Another patient spoke of a particularly creative but not entirely effective strategy for dealing with the omnipresent alarms on the ward:

Well, I guess as with whatever environment you become familiar with, you gradually lose the acute sensation that you first get. I mean, you can really be overwhelmed with the noises, especially if you have a room in the centre of the ward. As you know, there are loud alarm bells that clang and ring frequently; very loud, raucous buzzers for people that require nurses coming to their rooms. Gradually, that fades, and you can almost not notice it. I spent the first week trying to turn the bells into flocks of Greek sheep and goats and imagine them up mountainsides, but it wasn't really very successful, and I ended up with great sympathy for Mohammed, who hated bells, didn't he — that's why he has towers with imams calling off them, because bells were out of favour. I can see why.[16]

Audible alarms must be used in many critical environments because visual warnings are effective only if the intended recipient is looking in the right direction. Auditory warnings in helicopters came into use only after an incident in which a pilot flying in heavy fog ended up in the sea when he failed to see the flashing light telling him that his altitude was getting dangerously low because it was obscured by the control stick. In his study of auditory warning sounds, R.D. Patterson explains that "Warning sounds are useful because hearing is a primary warning sense. It does not matter whether operators are concentrating on an important visual task, or relaxing with their eyes closed; either way, if a warning sound occurs it will be detected immediately and routed through on a priority line to the brain."[17] But there are also limitations and drawbacks to using auditory warnings: they can cause confusion and anxiety and thus interfere with clear thinking, and there is a limit to the number of auditory warnings whose specific meanings can be remembered, even with training. And, for a patient on an open ward, there is constant anxiety that the alarm might indicate something urgently wrong with him or her:

Alarms all the time.... My mum was scared to come into intensive care because of what happened to me in the other hospital. Every time an alarm went, dong dong dong, just through a minor movement, my mum was panicking because she thought that was it again. But me, alarms, I hate alarms. I don't like being put on the telemetry monitors because if you just make a sudden movement the alarm goes, you think what's going on, what's going on, because it's experiencing of the alarms going off when you have a cardiac arrest. I remember them going off when I had a cardiac arrest, but every time it goes off now I think it is a cardiac arrest. Obviously it's not, but[18]

I have a long-standing interest in auditory warnings and have done a number of public installations using alarm sounds of my own design, the first of which was banned by the City of Copenhagen for allegedly "frightening and confusing" the public.[19] Even with my subsequent, more ambient, work with alarm sounds, it is often difficult to anticipate the degree to which people can be annoyed by even relatively quiet, innocuous alarms. One of the works to emerge from the *Transplant* project, *Flow*, uses synthesized sounds based on the auditory warnings of equipment used during a lengthy and complex operation that we recorded at Harefield. When it was installed at the Old Operating Theatre Museum, *Flow* prompted complaints by some of the museum staff, even though sound pressure levels of the installation were lower than in the ITU and many visitors described the work as subtle and unobtrusive. Perhaps, by intensifying and temporally compressing the sounds of the hospital environment, I was unintentionally exposing museum staff to an experience similar to that of long-term patients, though I am constantly astounded by the capacity for even apparently inoffensive and relatively quiet sounds to arouse hostility, particularly among staff who might not be particularly interested in contemporary art. The same people, I suspect, tolerate a great deal of noise in their everyday lives and object when they experience sounds that they do not like in an environment in which they believe they have a right to exercise some control.

Voices also contribute significantly to noise levels in the ITU. High levels of background noise lead to the "Lombard effect," in which the volume of speech is raised by way of compensation, so that "noise from staff conversation is most disturbing to patients … as it is usually unexpected, variable, and may have a meaning."[20] Patients can be almost totally incapacitated, but their hearing often remains active, and they can sometimes overhear things that they should not. While in ITU, one of the patients with whom we worked overheard that his new heart had come from a young Irish motorcyclist and that the heart was a good one. When he said to the staff back on the ward, "I hear I've got a great heart from Dublin," he quickly had a couple of hospital managers at his bed asking how he had found this out. "All I could say was that I don't know who told me, I just know I heard it while I was asleep."[21]

The loudest sound that I measured in ITU was the voice of a consultant doctor demonstrating how he calls to a semi-conscious patient. "HELLO, CAN YOU HEAR ME? IF YOU CAN HEAR ME, SQUEEZE MY HAND" measured 105.4 dB(A) at a distance of half a metre. Balancing clinical necessity with sensitivity to the broader effects of sound is not easy to achieve.

There is a recognized phenomenon known as ICU psychosis, which some people experience in intensive care units; sound is widely acknowledged as a significant contributing factor (along with drugs and sleep deprivation, of course).

One patient described a dream in which the flimsy curtains around his bed stopped the bullets flying around from automatic weapons wielded by intruders. When a patient is wheeled into ITU from the operating theatre, curtains are drawn around the bed to minimize the potential distress to other patients as the newcomer is attached to various monitors, pumps, suction devices, and drips. But the curtains do nothing to attenuate the sounds; indeed, they heighten auditory sensitivity and arouse the imagination. ITU patients spend much of the time heavily sedated on strong pain killers, and they often suffer from paranoid, sometimes violent, hallucinations, moving in and out of consciousness amid what Rice has called "the cacophony of disease."[22]

> This builder ... got some blokes in ... with guns, and I could see them all, and they sealed off the ward, and they was going around everybody's bed taking people's hearts out, for the wife. And they came to me, and I cried my eyes out, I said, "Please don't take my heart." ... He had a wife and kids and everything. In the end, I remember two doctors came to the bed next to me, and in my mind they were SAS soldiers. And they solved all the problems. My wife came in, and I said, "For God's sake, don't come in here, they're killing people," and I tried to get out of bed, and I had all these drips coming off of me, and the doctor said, "Get back, don't move," because I was lifting up and the waste was going back in me. In the end, he said, "Sorry, Gus," and he went [jabbing motion] with two needles in my legs and paralyzed me totally so I couldn't move. [laughs] But that was strange, really strange.... That was real — the doctor done that. And, as I say, the dream was actually real, because I could see these people, and I could see the guns, and I could see the blood of people being mutilated to get their hearts out. Everything was real, absolutely real.[23]

Such violent and vividly real hallucinations are typical of many patients' experiences during recovery — hardly surprising when, as heart recipient James Tottle describes it, one falls asleep listening to "nice music" and wakes up feeling like "someone has cut you in half with a chain saw."[24] There is little doubt that both the violence of surgery and the intensity of the sound environment into which one emerges contribute to such reactions.

THE CREATIVE RESPONSE

Conveying the intense, immersive nature of sound in the ITU as well as some of the visual and psychological experiences of patients moving from unconsciousness to consciousness through pain to the beginnings of recovery was an interesting challenge. Unlike with our work on the wards, in the ITU we needed to preserve the anonymity of the patients, most of whom

Figure 9.1 Still from *ITU.*

were not capable of providing informed consent — but this was not the primary reason for shooting the entire video through curtains. Curtains often dominate a patient's field of vision in the ITU. In one patient's hallucination, the curtain stopped a bullet that otherwise would have killed him, and Michael Spink spoke about what happens when there is an emergency situation in another bed: "[T]he nurses come and shut your curtains. You know something bad's going on, and you think, 'That's going to be me next.'" Photographer Tim Wainwright wanted to find a visual composition that would create a kind of empty vessel for immersive sound. See Figure 9.1.

ITU, with its 5.1 soundtrack, could be considered a kind of acousmatic video piece. In 1974, François Bayle coined the term "acousmatic music" to describe the art of composing with sound that is "shot and developed in the studio, projected in halls, like cinema."[25] More broadly, acousmatic art is characterized by sounds whose sources are unknown to the listener, and the art was "conceived from its beginnings to be heard without visual intervention."[26] The original *Akousmatikoi* were students of Pythagoras in the sixth century: he is said to have delivered his lectures from behind a screen or curtain to reduce distraction and enhance their ability to concentrate on the content of his teaching. In the video, as in the ITU itself, this idea is contradicted by the way in which the curtain raises expectation and curiosity.

There is a sense of urgency to the movements of the shadowy figures, but the curtain frustrates the gaze and denies voyeurism; the sound meanwhile envelops the audience to a degree that some have found unbearably

oppressive. Figures seem to float past the screen, but their footsteps make no sound because all staff in the ITU wear soft-soled shoes, adding to the somewhat dreamy atmosphere.

> But sounds.... All I could remember when I woke up.... I couldn't see properly, and that is an absolute nightmare.... I could ... make people out, but everything in the background was grey or silver. And, I'd love to know why that would be, but everything was grey and silver, and people were black.... It wasn't that they *were* black, there was like a black shape around them.... You couldn't tell who anybody was. You could hear voices, but you don't know anybody anyway, because you'd gone in totally sedated. You can hear voices of people talking to you. Only that was in the early days, very fleetingly, and all those strange dreams just keep coming at you thick and fast.[27]

We did not think of it at the time of making our piece, *ITU*, but this apparently hallucinatory description of how ITU staff appeared to Robert Linton as he regained consciousness after having his VAD implanted is strikingly similar to what human forms actually look like through the curtains in Harefield. Curtains also suggest theatre and performance: the movements of people behind the screen almost seem choreographed, a sense enhanced by the apparent dislocation of sounds from the activity behind the curtain.

I have been interested for some time in the relationship between sound and still image. Sound is inextricably time based — if stopped, it ceases to exist — whereas photography is a kind of "flat death," as Roland Barthes puts it. The *Transplant* installation exploits the tension inherent in this relationship to create an experience in which time appears paradoxically to both stop and continue, implicitly transcending the symbolic death embodied by photography in the same way that transplantation offers to transcend physical mortality. The imagery of *ITU* is moving, but the curtain imposes a strange stillness. The atmosphere is suggestive of a kind of limbo as the viewer is drawn into feeling that he or she is waiting for something — and waiting is a common theme in hospitals, especially for long-term patients such as transplantees. As well as the usual waiting for tests or injections or examinations, those in need of a new organ are in the unenviable position of waiting — often months or even years — for someone to die so that they might live. But because of the shortage of donors, many die waiting: "Waiting and waiting and waiting. Either waiting to live or waiting to die — not quite sure which ...," as Harefield psychologist Claire Hallas puts it.[28]

In order to convey through sound the emergence into consciousness experienced by patients in ITU, I adopted a kind of "sound mass" approach. The piece begins with a massive drone chord created by filtering and reso-

nating five separate recordings of the space (one per channel). Gradually, over the course of the video, the drone subsides, leaving the audience surrounded by the actual (though layered) sounds of the Intensive Treatment Unit, mirroring the strange, intense, and disorienting reality into which patients emerge. My aim in starting with the manipulated sound and slowly revealing the environmental sound from which it is derived was to induce listeners to perceive the "natural" environmental sound differently than if they were immersed in it without first experiencing the distilled and abstracted version.

Noise is notoriously subjective. Sometimes the noise of activity in the hospital is seen as a positive thing, even by patients: "It's quite nice to hear the phone go and remind yourself that you're actually not on your own in this environment. It's nice to remind yourself that you're still in reality. Sometimes, particularly if you're ill, things start to slip occasionally."[29] The same sound can drive others to distraction. Some patients never get used to the sound of an "artificial heart": these ventricular assist devices are usually seen as a "bridge to transplant" or as a means of assisting the heart long enough for it to recover from some physiological trauma, but patients often have to live with them for many months or even years. One patient said that he would have gone mad if they had not "explanted" his VAD when they did; another got used to his quite quickly and actually missed his "little brother"[30] when he finally got a new heart.

Sustained high levels of sound can negatively affect people working in noisy environments, reducing concentration and causing "annoyance" and tiredness. But for staff, too, noise can be positive. Sherrie Panther, the Transplant Unit's modern matron, told us that

> Nurses become very familiar to sound — like the ringing of bells ... and like VADs — when they're actually making the noise, and the ringing and the buzzing in the background, it's quite comforting in a sense because you know the patient is alive. Or there's a tone — a red tone — which means there's an emergency occurring, so noise and sound is very important to nurses in terms of working with and communicating with patients, and it's also a touch-base situation with patients wanting nurses. So therefore bells and buzzers are part of nursing. Sometimes you go home, and you hear a familiar sound, and you think, "Ooh, it's a patient buzzing," but it's actually an alarm clock or an alarm outside. When you have complete quiet, a nurse actually becomes worried because silence is not part and parcel with nursing — silence equates with patients not talking or not being alive even.[31]

As blogger David Perez points out,[32] Sherrie inadvertently echoed the campaign slogan of AIDS activists, ACT UP, SILENCE = DEATH. Equating silence with death is also interesting in relation to John Cage's familiar declaration that there is "no such thing as silence." There is no true silence until consciousness ceases.

One viewer at the premiere of *ITU* told me that she had to leave the cinema because of the sound; several others with personal experiences of intensive care facilities spoke to me about how "accurate" and emotionally moving they found it. Two museum employees found the sound of the installation *Flow* disturbing and irritating and wanted the volume turned down; a registered nurse with experience in intensive care units said that she wanted to hear the same piece "really loud," and another visitor described the work as "soothing."

This last adjective I found particularly interesting because it was also used by a patient to describe the sound of his IV pump, one of the sounds that I used in different ways in many of the works from this project. Early in the residency, a transplantee from another hospital visited our website and e-mailed to ask if I could record the sound of the electric pump that stands next to a patient's bed and administers intravenous fluids at a set rate: it was the first sound that he remembered hearing when he came to consciousness in the intensive care ward, and he therefore associated its "mesmerizing" and "musical" sound with recovery. When I subsequently worked with one of our subjects to record his pump, he described it as "a quiet, dull sound. It's very hard to hear because I've got the telly on, but if you knock the telly off it's a soothing sound, I suppose, a humming."[33]

Sound, by nature, is "ubiquitous, unstoppable, immersive,"[34] and it forms an important role in the dynamic context in which often fragile patients and their families experience long-term health care. In the hospital, "patients' acuity is high [and] their adaptive capacity is low, resulting in a greater sensitivity to these kind[s] of environmental stressors."[35] And the acoustic ubiquity of technological devices that monitor, assist, or replace bodily functions contributes to a potentially overwhelming soundscape in which "the boundary between bodily interiority and exteriority is challenged in sometimes disturbing ways."[36]

Sound in the ITU is "so pervasive, so indicative of crisis, urgency, vital information, so continuous, disruptive and disturbing, yet the people who occupy that environment as patients are as vulnerable as human beings can be."[37] The soundscape often includes emotionally potent sound events such as moaning or retching amid a complex and immersive orchestration of sounds that inevitably affect both patients and staff. The inclusion of such sounds in an art milieu raises ethical and aesthetic issues and challenges for both artist and audience. Similarly, the artistic use of auditory warnings,

an unavoidable element of the hospital context, presents interesting challenges because of their high annoyance factor; I find their abstract beauty fascinating, but it is something that some listeners will never accept because of their role in the immersive soundscape of everyday life.

NOTES

1 Florence Nightingale, *Notes on Nursing: What It Is and What It Is Not* (New York: D. Appleton, 1860), 31.

2 *ITU* was funded by Arts Council England and supported by the Royal Brompton and Harefield NHS Trust and rb&hArts (whose manager, Victoria Hume, was indispensable to the project). This chapter has been developed from shorter contributions to *Autumn Leaves: Sound and the Environment in Artistic Practice*, ed. Angus Carlyle (Paris, France : Association Double-Entendre in association with CRISAP, 2007); and *Static: The Journal of the London Consortium* 6 (2008), http://static.londonconsortium. com/issue06/static06_wynne.php.

3 The various sounds and images that we gathered have given rise to an extensive body of work in various forms. Throughout the project, we kept an online audiovisual diary (www.thetransplantlog.com) that, as well as providing project participants and their families with an opportunity to see and hear what we were doing, proved to be a valuable exercise for us, forcing us to work with the materials while we were still engaged in the residency and allowing ideas to develop in direct response to our experiences rather than waiting until we had finished collecting our materials to begin work. I was commissioned by CBC Radio to make *Someone Else Has Died* and by BBC Radio 3 to make a half-hour "composed documentary" entitled *Hearts, Lungs, and Minds*, which won the bronze award at the Third Coast International Audio Festival in Chicago. ("Composed documentary" is a term coined, I believe, by radio producer Alan Hall in reference to my first radio piece for the BBC in 2005.) *Part and Parcel* is a twenty-minute, eight-channel sound piece described by David Toop in the *Transplant* book as "an immersive spatialised field of whirring and bleeping, crashing and humming, disembodied distant voices and near-field speech" (32). Works in collaboration with Tim Wainwright include *Flow*, a site-specific, seven-screen video installation with six-channel sound made for the Old Operating Theatre Museum in London, and *ITU*, a single-screen, surround-sound video piece that showed first at Tate Britain and then inside Europe's oldest surviving operating theatre at the aforementioned museum. *Transplant*, a collaborative, twenty-four-channel photographic sound installation has shown at the Nunnery Gallery in London and at Brunel University, Uxbridge. With editor Victoria Hume of rb&hArts, we have published a book and DVD, also entitled *Transplant*, with essays from a wide range of perspectives on the project and the wider issues that it raises. See www.sensitivebrigade.com/ Transplant_book.htm.

4 Tom Rice, "Soundselves: An Acoustemology of Sound and Self in the Edinburgh Royal Infirmary," *Anthropology Today* 19, 4 (2003): 5.

5 Kate Dalziel, "A Patient's Perspective," in *Transplant*, ed. Victoria Hume (London: rb&hArts, 2008), 23.

6 Ilene J. Busch-Vishniac, "Noise Levels in Johns Hopkins Hospital," *Journal of the Acoustical Society of America* 118, 6 (2005): 3630.

7 P. Kam, A. Kam, and J. Thompson, "Noise Pollution in the Anaesthetic and Intensive Care Environment," *Anaesthesia* 49 (1994): 982–86.

8 Ibid., 983.

9 Ibid., 985.

10 Ibid., 983.

11 Ibid.

12 Ibid.

13 Susan E. Mazer, "Sound Advice: Seven Steps for Abating Hospital Noise Problems," *Health Facilities Management*, May 2002, http://www.healing-health.com/d-resources/seven_steps.php.

14 David Botting, heart transplant in 2005, recorded in 2007 by John Wynne.

15 Ibid.

16 Kate Dalziel, heart transplant in 2006, recorded in 2007 by John Wynne.

17 R.D. Patterson, "Auditory Warning Sounds in the Work Environment," *Philosophical Transactions of the Royal Society of London* Series B.327 (1990): 486.

18 Michael Spink, VAD implant in 2006, recorded in 2007 by John Wynne.

19 Council of the City of Copenhagen, letter to the Sound/Gallery, 1997.

20 Kam, Kam, and Thompson, "Noise Pollution in the Anaesthetic and Intensive Care Environment," 985.

21 Anonymous project participant, recorded in 2007 by John Wynne.

22 Tom Rice, personal correspondence, April 2007.

23 Anonymous project participant, recorded in 2007 by John Wynne.

24 James Tottle, heart transplant in 2000, recorded in 2007 by John Wynne.

25 Quoted in Francis Dhomont, *Acousmatic, What Is It?*, http://www.electrocd.com/notice.e/9607-0002.html, 2002.

26 Ibid.

27 Robert Linton, heart transplant in 2007, recorded in 2007 by John Wynne.

28 Claire Hallas, consultant health psychologist, Harefield Hospital, recorded in 2007 by John Wynne.

29 Simon Hope, double lung and heart transplant in 2002, recorded in 2007 by John Wynne.

30 Ian "Geordie" Wood, heart transplant in 2007, recorded in 2007 by John Wynne.

31 Sherrie Panther, senior nurse/modern matron in the Transplant Unit, recorded in 2007 by John Wynne.

32 D.M. Perez, http://rhizome.org/editorial/fp/blog.php/255.

33 Kevin Mattick, double lung transplant, recorded in 2006 by John Wynne. Kevin, who suffered from cystic fibrosis, died in 2007 at the age of thirty-two. He was one of several patients whose relatives asked me for a copy of my recording sessions after the deaths of their loved ones — an unanticipated but important benefit of our residency.

34 David Toop, "The Art of Noise," *Tate etc* 3 (2005), http://www.tate.org.uk/context-comment/articles/art-noise.

35 Mazer, "Sound Advice."

36 Tom Rice, "Sound and the Boundless Body," in *Transplant*, ed. Victoria Hume (London: rb&hArts, 2008), 44.

37 David Toop, "Depths and Clamour; Inside and Outside," in *Transplant*, ed. Victoria Hume (London: rb&hArts, 2008), 31.

CHAPTER TEN

An Imaginary Meeting: The Making of *MotherVoiceTalk* (2008)

Hildegard Westerkamp

M*otherVoiceTalk* occupied fifteen minutes in a seventy to eighty-minute performance entitled *Marginalia: Re-Visioning Roy Kiyooka (1926–1994)*, a visual and sonic tour-de-force in honour of Roy Kiyooka, performed three times, 21–23 February 2008. The piece is also included on the DVD that accompanies this book.

As a second-generation Japanese Canadian, Kiyooka remains a singular and important figure in the artistic landscape of our country. His diversified and extremely creative approach through a multitude of new forms and media challenged and enlightened notions of what contemporary art can be, celebrated the everyday, made the personal political, and found beauty in an endless process of invention.[1]

Kiyooka first made a name for himself as a painter. In the 1960s and 1970s, he expanded his artistic output to include sculpture, photography, poetry, film, video, and music improvisation. In 1978, Kiyooka was awarded the Order of Canada for his achievements as a painter as well as for his success as a teacher. Significantly, he not only spanned many art disciplines throughout his lifetime but also worked across the entire width of Canada, teaching in art departments in Halifax, Regina, and Vancouver. In the mid-1970s, he

See DVD — Hildegard Westerkamp — for a complete audio recording of MotherVoiceTalk.

became involved with the Japanese redress movement in Vancouver as well as in issues of Asian Canadian identity, and his artistic output and writing from this time reflect this involvement. In a recent review of his book *Transcanada Letters*,[2] Tara Lee characterizes Kiyooka and his written work in ways worth mentioning here:

> Roy Kiyooka has long been haunting the margins of Asian Canadian literature where his fragmented poetics and his straddling of artistic boundaries have eluded more nation-based categorizations.... Kiyooka resists canonization by remaining an intriguing question mark that unsettles any attempts to locate him within a fixed literary location.
>
> ... Kiyooka believed that "my own mere whiff of a life is inextricably woven in & thru other lives" (181) because of the intertextuality that he saw as an integral part of intellectual and creative expression. Thus, while the letters provide momentary glimpses into the preoccupations and vulnerability of their sender, they equally emphasize the strong interdependencies between Kiyooka and the world around him.
>
> As a result, not only does Kiyooka exist within the noises and silences of the letters, but Canada and its artistic and literary communities also take shape in the unfolding space of the text. With Kiyooka serving as the connective tissue, disparate people and places come together in the letters in intimate and often startling conversation.[3]

In the fall of 2007, I faced a difficult task. I had accepted a commission that was supposed to happen within the context of *Marginalia*, a project produced by Vancouver New Music. The problem was that I had accepted the task without understanding "what I was letting myself in for," as Kiyooka himself might have said. Three other BC composers, Jocelyn Morlock, Stefan Smulovitz, and Stefan Udell, had also accepted this challenge. Vancouver New Music sought compositions that would illuminate Kiyooka's work:

> The new compositions will take cues and motivations from specific characters, ideas and passages in Kiyooka's works and will become an organic stimulus for an inner dialogue between Kiyooka, his displayed works, the composers, the performing musicians and the audience. Like a musical palimpsest the dialogue among the various components of *Marginalia* will not be just an echo of Kiyooka's work, not simply a response; it will have a life of its own in the interactive relation between the composers and Kiyooka, his cross-cultural and polymorphic artistic approach and his inner dialogue and research.[4]

Such a task seemed to be a rather tall order and in fact turned out to be yet another "startling conversation" with Kiyooka. He died in 1994 and left a huge body of writings, paintings, photographs, sculptures, sound recordings, and many important memories of musical improvisational sessions for those who had "jammed" with him. Although I knew of him, I had never met him personally, nor had I participated in the cultural events in which he was involved while living in Vancouver.

In my artistic statement to the granting agencies, I had stated that the commission would pose an interesting challenge for my compositional practice and that I envisioned it as a type of dance-dialogue between two mature artists' creative processes. Over the years, my own working process in creating soundscape compositions has consisted of an ongoing conversation with the sonic environment. The challenge in this work is to find a balance between my own compositional voice and the sounds of the environment that are to be highlighted and honoured — in other words, in a soundscape composition, both the existing language of the soundscape and the artist's compositional language want to meet as equal partners.

I envisioned my dialogue with Kiyooka's work in a similar way but perceived it as a more challenging process, for I did not know Kiyooka and his work in the same way that I know the sounds of the environment and my relationship to the soundscape as a whole. In order to meet Kiyooka's work on an equal level — work that is mature, well-established, and highly interdisciplinary — I sensed that I would have to push my own artistic boundaries. No longer could I rely exclusively on the familiar processes that I had developed over the years. This commission I envisioned as a meeting between two artists' languages, which together would create an entirely new work.

BEGINNINGS

Like the other three composers, I proceeded to do as much research into Kiyooka's life and work as I could, and it became a fascinating journey of discovery, expanding with every step that I took and growing into an ever-more-complex process. I wanted to find points of resonance with his work that would somehow enable and inspire me to find my way into a composition, to find its instruments and sonic materials. How would I transform my dialogue with his writings, visual arts, and musical/sonic improvisations into a sound piece? It is one thing to like or even to be passionate about another artist's work. It is another to internalize his work to such an extent that his artistic inspiration and process can inform my own and vice versa — that my compositional process can become the medium through which his voice and work are made audible and meaningful to the listener. I experienced this task as utterly enormous. Was it going to be possible to find this place

of inner resonance that would connect two artistic processes, two human beings? And, even if it was possible, how could my compositional work resonate with a public audience, especially with those who had known Roy Kiyooka intimately during his lifetime: family, friends, and colleagues?

The task, then, became to listen thoroughly and deeply to Kiyooka's artistic voice and bring it into dialogue with the musical, sonic tools of my own compositional voice. The final piece somehow had to emerge out of this process of listening, and in the end it was, to say the least, a bit of a surprise to me. The making of *MotherVoiceTalk* had become a most intense journey in search of resonance with the work and life of Roy Kiyooka. Perhaps I could call it a "thought piece in sounds and words."

Kiyooka's varied artistic output resonated less with my own form of artistic practice, which has largely focused on composing with environmental sounds, than with my multidisciplinary engagement in fields outside the arts: namely, acoustic ecology and soundscape studies. Both of our artistic outputs have been deeply informed by our diverse approaches. The difference is that Kiyooka was an artist first and always; he moved among various visual art forms, writing, and music making, all of which informed each other. My artistic/compositional work emerged from my involvement with soundscape studies and environmental listening. In fact, it was precisely the knowledge and experience gained from these pursuits that sparked my creative output.

Most importantly, though, I was fascinated by the relationship between Kiyooka's Japanese Canadian past — his coming of age during World War II and thus inside Canada's so-called enemy alien culture and language — and his strong position inside the contemporary English Canadian cultural scene during his adult life. Like me, Kiyooka grew up in another cultural context. The difference is that he grew up in Canada and had to build inner and outer bridges throughout his life between his Japanese background and the English Canadian world around him, whereas I grew up in Germany and immigrated to Canada as a young adult, twenty-three years after the end of World War II. Although Kiyooka was born in Canada, he, like all Japanese Canadians during the war, felt deeply abandoned by the country that he had always called his home.

After Japan's attack on Pearl Harbor in 1941, the Canadian government moved all Japanese Canadians who lived on the West Coast to internment camps in the interior of British Columbia. Although families like the Kiyookas who lived farther east in the Prairies did not have to suffer the same fate, they did get fingerprinted and registered as "enemy aliens" and, as a result, lost their livelihoods and cultural freedom. Under these circumstances, the Kiyooka family was forced to relocate from Calgary to the village of Opal, north of Edmonton. With the help of generous friends, they eventually

moved to a small farm, and with a lot of hard work (including the teenaged Roy) managed to survive there throughout the remaining war years. His mother remembered later that "Those of us who lived all over the prairies in small communities couldn't put a face to the hatred we felt but we knew its ugliness by heart."[5]

Similarly, though to a much lesser degree, many German immigrants who came to Canada in the late 1940s and early 1950s initially suffered under the legacy of having come from an enemy country. By the time that I arrived in 1968, there was no longer any danger of being perceived as an enemy alien; however, Kiyooka and I — in common with all immigrants — carried within us another culture and learned more or less to integrate it into the cultural environment of the new world. This makes for a unique inner dialogue, even if at times it means dealing with a split self, and has found artistic expression in our work, however conscious or subconscious it might be.[6]

Listening to some of the many recordings that Kiyooka had made himself or that had been made of his readings, musical improvisations, and presentations, I was struck by the multitude of moods and expressions in his speaking and sound making. Short excerpts became the sonic/musical materials for *MotherVoiceTalk*, such as sounds from his zither (or "harp," as he called it), from a whistle or recorder, and from his voice in various contexts. Two films were of significance to my process. Michael de Courcy's "album of video snapshots recorded in early 1991 through 1992" shows Kiyooka making music and performing with musician, poet, and artist friends.[7] And his daughter Fumiko was gracious enough to show me her almost completed film about her father, entitled *Reed*, a portrait of his life and work from the perspective of a daughter. Both films gave me important insights into Kiyooka's life realities and creative processes, to the extent that I could begin to trust my own perceptions of Kiyooka and the significance of his work.

Kiyooka's book *Mothertalk: Life Stories of Mary Kiyoshi Kiyooka* accompanied me throughout the making of *MotherVoiceTalk*. The book was created from interviews conducted in 1993 with his mother, who shared memories of her upbringing in Japan, her arrival as a married woman in Canada, and her family's experience in Alberta during the Japanese internment period. Roy seemed to connect frequently and strongly with his mother in her old age,[8] just as I have been connecting with mine for many years now — connecting, in other words, with their powerful female presence, their stories, and thus the languages of our childhoods, Japanese and German.

FINDING THE WAY

Even though I had come to know Kiyooka's work extensively and had found definite points of resonance, I still did not feel enough connection with it

to inspire a composition. I decided that I had to leave town, go somewhere quiet for several days to "meet" the "real" Roy Kiyooka. Friends offered me a place on Salt Spring Island. I took with me everything that I had collected of Roy's work up to that point: books, images, recordings, and my own notes. I also took recording equipment, sensing that the soundscape of the island might offer some inspiration, if not actual sonic materials, for the piece. Since the West Coast was "our" common chosen home, I thought that the sonic language of a more pure West Coast environment away from the city might offer the context for a "dialogue" between two artists to happen and be fruitful.

Indeed, many of the recordings that I made on Salt Spring Island made it into the composition — in particular the water sounds of a small creek and various raven calls — and contributed significantly to the "tone" or feel of the piece. The journey of these sounds from their original location in the environment to the recording and finally to the place that they occupy in the composition itself was quite surprising to me. Noticing minute details and first impulses, seemingly mysterious connections and inexplicable associations, were the seeds for *MotherVoiceTalk*. Similarly, it seems that much of Kiyooka's work, particularly his photography (e.g., *StoneDGloves*, *Japanese Elders*) and poetry (e.g., *Pear Tree Poems* among others) and to a certain extent his musical improvisations, sprang from the same origins.

On the first morning after my arrival on the island, I walked out of the house in which I was staying and heard distinctive calls from two ravens. My search for inner dialogue with Kiyooka and his work had been so intense during the previous months that my ears were alerted immediately to these two birds "speaking" to each other, almost as if they were mocking my state of mind. I was particularly delighted by a deeply sonorous, two-tone call coming from one of them, a call that I had never heard before. Strangely, it reminded me of how Kiyooka intoned the words *my mother* in a recording made during readings from *Mothertalk*. At that moment, it seemed to my inner ear that the ravens echoed his intonations. Not surprisingly, I later placed this raven call close to the opening of *MotherVoiceTalk*, created from Kiyooka saying "my mother."

The way in which he spoke these two words alerted me right from the beginning, mostly because they were followed by a small but noticeable gasp produced by a short, rapid exhalation of breath. This gasp gave the words *my mother* a particular emphasis in my perception, a somewhat heavy significance. Later I realized that this little gasp after a word or phrase was characteristic of Kiyooka's style of speaking. As a result, the gasp itself became a sound object that appeared independently from the words, slightly processed with reverb, in various parts of the piece. Coincidentally, another raven call from the same recording, repeated three times in a certain tempo

and sounding more typically raucous, ended up playing a somewhat comical role throughout the piece as it echoed one of Roy's rather dry, ironic laughs, "Ha Ha Ha!"

After that first morning's recording, I felt encouraged and decided to find a location where I could record my "meeting" with Kiyooka. It had to be a place and time that would allow me to contemplate deeply his artistic presence. This seemed to be a pivotal point in the creative process, one that I could not do without if I was going to compose this piece. The next morning I set out to find the "right place," one where I would feel comfortable, relaxed, and inspired to record this imaginary meeting. Even though I really had no idea what this would entail, I trusted that such an inner encounter could only add positive, if as of yet mysterious, results, ideas, and perhaps even concrete recorded sounds. The "right" place, so I thought, needed to have certain qualities, which would reveal themselves only in the search itself and allow this meeting to happen.

The day, 30 November 2007, was spectacularly sunny and bright. I went to Ruckle's Park on Salt Spring Island because I had been there before and remembered it to be a very special place. It took me a while to find the appropriate location where I could make a good-quality recording since it was a windy day. I needed to find a place not only where the microphone would be protected from the wind but also where it was relatively quiet, where the few other people walking in the park would not be distracted by me or I by them, and where I could feel alone yet safe, focused, and inwardly connected. The place that I eventually found was relatively exposed, with a good view all around, at a picnic table near the rocky shoreline. I managed to shelter the microphone from the wind. The water could be heard softly in the background like a shifting and phasing broadband sound.

My own voice during this meeting was a thinking and searching one. With it, I hoped to connect with Roy Kiyooka's voice, his words and sonic expressions that I had brought with me to this place in my inner ear, so to speak. By this time, I had heard Kiyooka on a variety of recordings. To my utter delight, I had found out that he had used the microphone incessantly, recording and documenting his life, his poetic thoughts, and his personal matters of the heart. I had heard his voice in many contexts: the intimate, thinking one in his studio, sometimes accompanied by his zither; the public one, reading his writings to an audience; the singing/speaking one in group sound improvisations; and his Japanese one, speaking mostly in the company of his mother. These manifold recordings had given me a sense of connection to Kiyooka, a sense that a dialogue might be possible after all.

I had also been recording for many years, mostly the sounds of the environment but within that context also my own speaking voice, as in *Soundwalking*, my radio program on Vancouver Cooperative Radio (broadcast in

the late 1970s), followed by other types of soundscape and voice recordings. I brought these experiences to the "meeting"; I brought my various voices to meet Roy's. It occurs to me as I write this that, for those of us who carry a first language and culture inside us, different from the second language and culture in which we now live and function, our ears are alert in a specific way, always trying to decipher the meanings of the culture and environment that we joined later in our lives, trying to negotiate our way through it. I know first-hand that recording my new environment and my voice has helped me as an immigrant to orient myself in my new country, to affirm my place here, and to discover a genuine sense of belonging. This process helped to build a cultural bridge and ultimately became very much a part of my cultural other, the English-speaking persona that in the end enabled me to become an artist in Canada. Perhaps the microphone played a similar role in Kiyooka's life.

The Japanese voice belonged to Kiyooka as a child. But no matter how much he moved into an English voice as an adult, he found himself inserting Japanese words and sentences regularly into his writing and speaking, more so as he got older. As he said once during a reading in the early 1990s, "There's bits and pieces of Japanese thrown into these poems. Given who I am that is inevitable."[9] One phrase that appears repeatedly in his writings and readings is "*umeiboshi* throat." From the context, it is clear that Kiyooka meant it to refer to his Japanese voice and background. When I inquired what *umeiboshi* actually means, however, I found out that it is a traditional Japanese food. *Ume* is a fruit, like a plum or apricot, that is picked when still green and cannot be eaten raw. It is preserved through pickling, which shrivels it. Typically, in times of food shortage, it is put inside a ball of rice, which keeps the rice itself fresh longer and adds nourishment. From this, I can only deduce that *umeiboshi* throat most likely represents a voice, Kiyooka's own voice, born and steeped in a strong Japanese tradition. His use of the two words reveals an imagination of extraordinary depth and cultural scope. It expresses the intensity of that inner dialogue between two cultures that Kiyooka carried within himself, and it was only natural that these two words should somehow be included in *MotherVoiceTalk*.

The Japanese voice of the adult Kiyooka was most genuine and natural in the context of the interviews with his mother. Once I discovered the original interview tapes with his mother in Special Collections at Simon Fraser University, another rich sonic world opened up for my composition: the Japanese voice of Mary Kiyoshi Kiyooka. Of course, I did not understand a word of what she was saying, but I found her voice extremely interesting in its power and expressiveness, its varied intonations. When it came to selecting excerpts for possible use in the composition, I listened for interesting intonations, strong expressions of emotions such as crying or laughing, place names and names

of her children, or other words that I might recognize, such as *samurai* (Roy's grandfather had been a *samurai*, and Mary had thought that Roy, of all her children, had been most like him). In the section that finally made it into the piece, the word *samurai* is heard, and she speaks in an emotional way about Roy and his support for her in her old age.

Coincidentally — or was it really a coincidence? — much of *Mother-VoiceTalk* was composed when I visited my then 100-year-old mother, Agnes Westerkamp, in Germany. Mary Kiyoshi Kiyooka, who survived her son Roy, had also lived for 100 years and died shortly after. Hearing her, and the way that Roy spoke about her, I sensed that she must have been as powerful a woman as my own mother. Both had gone through the hardships of war and political changes and not been crushed by them. In fact, one could say the opposite: their life experiences seem to have transformed and strengthened them. Both Roy and I chose to stay in close touch with our mothers: we got to know them better in their old age and conducted interviews with them. It seems that both our mothers loved to reminisce and tell stories. Parallel to Mary Kiyoshi Kiyooka's voice, I introduce the voice of my mother into the composition when she relates a dramatic time in her life near the end of World War II.

Although I had no intention originally of bringing my mother into the piece, I included her precisely because I happened to be with her when working on *MotherVoiceTalk*. In fact, it would have seemed strange not to include her. The togetherness and connectedness that I felt while in my old home environment with her resonated with the togetherness that I could sense listening to the interviews with Mary Kiyoshi Kiyooka. Roy did not actually conduct the interviews, which were largely done by Matsuki Masutani, a friend of the family, but as far as I could hear Roy was present during quite a few of them. This process interests me because I always interviewed my mother myself, but I found it easier to listen to her when someone else asked the questions: that is, when the communication between us was mediated through a third presence, a third ear. A certain amount of distance seemed to make the listening easier and thus brought the "mother voice" out more clearly and genuinely. Paradoxically, it also helped to create more closeness between us.

Masutani also translated the interviews into English, transcripts from which the book *Mothertalk* was then compiled and edited. Thus, the Japanese mother's voice entered the English world of Roy Kiyooka, which can be understood as another step in the integration of his two worlds. In a public reading in which he presented excerpts from *Mothertalk*, Roy said, "[I] got to pry myself up here to get into my mother's voice if I can."[10] In other words, his own voice became the medium with which he transformed the Japanese voice of his mother, its tone and energy, into an English-speaking voice and

thus introduced it to his English Canadian audience. For my composition, I selected two statements from that reading that addressed issues of old age — a topic that has come to the forefront in my own life recently and that occupied Kiyooka more and more as he saw his mother grow older.

> Young people these days have nothing but money on their minds. They want to make enough money to be able to put their parents in an old age home and visit them once a month. What they don't realize is that most people end up dying of loneliness. By the time you know what your parents have given you and you want to say thanks for the gift of life, it's usually too late. That's what the old proverb used to say.
>
> It isn't a simple matter raising children, because they have got a mind of their own from the start. You won't understand this feeling 'til you have your own children. Ah, but it's odd, but when they grow up they think they did it all by themselves. Ha Ha Ha.[11]

Although Kiyooka lived, as he put it, "the sometimes 'mean' even scurrilous life of an obsessed artist,"[12] he did connect with his original family, especially as he became older, and *Mothertalk* is perhaps the strongest manifestation of this. His inner struggle between the artist Kiyooka and his private self as husband/partner and father of his three daughters accompanied him throughout his life, as revealed most clearly in Fumiko Kiyooka's film *Reed*, mentioned earlier. Yet he remained an artist first — artist through and through — never to be disturbed when he was working in the studio. From where did Kiyooka take the inner authority and strength to be the artist he was in a world where male and female roles were changing significantly and where men/fathers were challenged to partake more actively in family matters? Was it precisely his Japanese background along with a mother who was deeply proud of her son — who likened him to his grandfather, the *samurai* — that gave him the cultural backup necessary to pursue his strong convictions as an "artist first" in, as irony would have it, the English Canadian cultural arena?

These questions constituted a strong undercurrent of thought while I was finding out more and more about Kiyooka and then working on *Mother-VoiceTalk*. Like him and many other artists, male and female, I also know intimately the struggle of combining the life of an artist with that of the private family person, the wife/partner and mother. Perhaps this knowledge drew me to search for the deeply personal aspects of the artist Kiyooka. Is it not a fact that the most fundamental conditions, hardships, and struggles of our lives (I am thinking here of Kiyooka's deep cultural split, emphasized through the hardship of his teenage years in the Prairies, trying to survive together with his Japanese Canadian family as enemy aliens, and then his

later immersion away from his original culture into the English Canadian artistic scene) can be the most powerful agents of creativity and profound change, no matter the circumstances?

In the end, the process of finally "meeting" Roy Kiyooka was invaluable, and I felt that I had indeed found inner resonance with him as a person and artist — enough at least to be able to compose *MotherVoiceTalk*. The piece was finally woven into the *Marginalia* production as a whole, together with Jocelyn Morlock's *Scribbling in the Margins*, Stefan Smulovitz's *Triptych K*, and Stefan Udell's *Lattices of Summer*. The "weaver" was Vancouver New Music's artistic director, Giorgio Magnanensi, who added an electronic improvisational layer to the performance.

Response to the evening was varied — from consternation and puzzlement to total enthusiasm. It was heartening to hear that various people who had known Roy Kiyooka were moved by the performance. Rhoda Rosenfeld, a friend who had regularly improvised with him, expressed to all of us in writing what others communicated to us directly after the performances:

> We were just blown away by the beauty and sensitivity we heard in the music. A loving generosity (Roy's great quality) moved about the theatre. Congratulations to all concerned for creating an event that treated Roy's work with so much respect. I can't imagine he would have wanted anything more than to have his work become a source for another generation of artists. I think he would have been thrilled.

Whether Roy Kiyooka would have felt moved by the piece I have no idea, of course. But that is not the object, is it? As Giorgio Magnanensi stated in the concert program,

> The concept driving *Marginalia* was to create an environment of counterpoints where the compositions, the visual elements and the sound art would come together with a life of their own and where a conversation between them would take place. The composers have taken cues and motivations from specific characters, ideas and passages in Roy Kiyooka's work; the set and video extrapolations from his visual elements and iconic designs; and newly created vocalizations include and are inspired by his words. *Marginalia* attempts, respectfully, to encompass the breadth of Roy Kiyooka's work in concert, and to honour his legacy as an artist.

I suspect that Kiyooka would have listened deeply and attentively to the performance and then smiled and laughed "Ha Ha Ha!" — like the raven, which has the last "word" in *MotherVoiceTalk*.[13]

1 http://www.newmusic.org/07_08archive.htm.

2 Roy Kiyooka, *Transcanada Letters* (Edmonton: NeWest Press, 2005).

3 http://literaryculinaryrambles.blogspot.com/2007/10/roy-kiyookas-trans-canada-letters.html.

4 http://www.newmusic.org/07_08archive.htm.

5 Roy Kiyooka, *Mothertalk: Life Stories of Mary Kiyoshi Kiyooka*, ed. Daphne Marlatt (Edmonton: NeWest Press, 1997), 139.

6 Kiyooka's mother actively ensured that her children would not forget their original culture: "I want my kids to keep going back [to Japan]. How else will they know there's a landscape etched in their hearts which got sown in a bamboo grove? There's a landscape-of-the-heart you won't locate in any geography book and I'm not about to let them forget it, not while I'm still alive." Ibid., 160.

7 http://www.michaeldecourcy.com/roy_kiyooka/movie_voice.htm.

8 Although this statement never made its way into the printed book, Mary Kiyoshi Kiyooka mentions on the original cassette recordings in a voice trembling with tears, how frequently and caringly Roy connected with her in her old age. This statement appears in *MotherVoiceTalk* at about 8:40 minutes.

9 Michael de Courcy, *Voice: Roy Kiyooka a Film*, http://www.michaeldecourcy.com/roy_kiyooka/movie_voice.htm.

10 Roy Kiyooka, Reading at the Vancouver Art Gallery, 1991.

11 Ibid.

12 Roy Kiyooka, *Pacific Rim Letter*, ed. Smaro Kamboureli (Edmonton: NeWest Press, 2005), 6.

13 Many thanks go to Giorgio Magnanensi and Vancouver New Music for setting up this challenge and to Matsuki Masutani and Fumiko Kiyooka for unearthing some of Roy's recordings. And my special thanks go to Peter Grant, Margaret and Tom Taylor, Agnes Westerkamp, Renate Buck, and Jolanta Penrak. They provided me with the places and times for retreat that I needed for this "meeting" between two artistic/personal languages to occur and *MotherVoiceTalk* to emerge. A contemporary ensemble of excellent instrumentalists (Vancouver's Standing Wave Ensemble — A.K. Coope, clarinet; Vern Griffiths, percussion; Peggy Lee, cello; Allen Stiles, piano; Rebecca Whitling, violin — plus Mark Ferris, violin, and Reg Quiring, viola) performed the three other composer's pieces. *MotherVoiceTalk* is an electroacoustic composition but with the option of spontaneous improvisation for the musicians during the performances. As the ensemble got to know the piece during rehearsal, I left it up to them entirely to improvise with the piece if musical ideas came to them naturally and genuinely. During the last two performances, when everyone felt comfortable with the flow of the evening, some of the musicians did indeed choose to contribute improvisations to *MotherVoiceTalk*. I was delighted by the subtle approach that they took and how much these instrumental sounds added to the spirit of the piece. In hindsight, this aspect could possibly have been developed further. In addi-

tion to the compositions, poet and vocalist Kedrick James contributed with improvisations of Kiyooka texts, Hanif Janmohamed created the video and set design, and David Murphy and Jason Levis contributed with the video production and performance.

CHAPTER ELEVEN
Shadow-walks: A Sound Art Project

Viv Corringham

INTRODUCTION

As a sound artist and vocalist with special interests in the sense of place and in environmental sound, I have incorporated walking into my work as a direct way to experience a location. Art writer Lucy Lippard has stated that a place can "be felt as an extension of the body, especially the walking body, passing through and becoming part of the landscape."[1] Previous projects include *Vocal Strolls*, recorded walks in which vocal improvisations were made in response to the sonic landscape.[2] I began my project *Shadow-walks* in 2003 with the intention of incorporating other people's experiences of place into my work.

Traditional links exist among walking, singing, and a sense of place, including the Aboriginal song lines and the Kaluli song paths, the latter being particularly relevant to my work. Anthropologist Steven Feld has studied the Kaluli people of Bosavi, Papua New Guinea, and described their practice of song paths, the poetic song texts through which series of named places are sung and that take listeners on a journey through a local area. The flow of these song paths is emotionally and physically linked to the sensual flow of the singing voice, and in performance the flow of voice

See DVD — Viv Corringham — for a complete audio recording of Shadow-walk: Cal State University, Fullerton.

merging with the flow of sung place names creates what Feld describes as "waterfalls of song, a sense of place resounding."[3]

Song paths operate as maps in which places are placed in memory and relate to cultural identity. Places embody cultural memory; they "place" memory. Ultimately, the song path embodies the notion that "Knowing where you are is knowing who you are."[4] This combination of a described journey, a singing voice, and the sense of place, inherent in the song path form, resonates strongly with my own concerns. Feld's writings were an important influence in the development of this project.

THE PROJECT

The ongoing project known as *Shadow-walks* involves three main elements: walking with others, listening to environmental sounds, and improvised singing. The project developed through an interest in our relationships with familiar environments.

An idea attributed to James Joyce is that places remember events, and I found this very interesting — everything that happens leaves traces that we might be able to sense. I wondered whether it was only the large events that we call history that are remembered or whether places also remember the small events of ordinary lives. If, throughout a lifetime, a person walks through certain places repeatedly, along the same route, does that ground retain traces of the person's history and memories? This question led me to *Shadow-walks*. It is an attempt to make a person's traces, his or her shadow, audible.

Shadow-walks have occurred so far in eighteen different locations in Europe, Asia, and North America. The process is straightforward. I ask to be taken on a special walk, one that has been repeated many times and has meaning or significance for that person. While walking together, I record environmental sounds and conversations. A solo walk follows in which I attempt to sense my previous companion's traces on the walk and to make the memory audible through improvised singing. Recordings are later combined and edited to become the final composition.

Shadow-walks have been disseminated in various ways: as audio walks, radio pieces, at listening posts around a town, and, most frequently, as sound installations in art galleries.

FOUND OBJECTS

As I follow the person's route, I collect everyday objects from the street. This was inspired by the practice of British artist Richard Long, whose work bridges conceptualism and land art. Because his walks usually occur in rural locations, the materials that he transfers to the gallery tend to be natural, such as mud, stones, or slate. My walks take place in cities or towns, and

therefore the objects that I find, with the exception of occasional feathers and leaves, are typically debris and litter.

Richard Long and Hamish Fulton are walking artists whose attitudes toward documentation through the collection of objects are very different. Fulton practises low-impact walking and embraces the wilderness ethic of "leave no trace," taking nothing and leaving nothing behind: "in the gallery I'd rather see artworks made of plastic than materials taken directly from the landscape."[5] Many of my documentary objects are made of plastic, but they have indeed been removed from the landscape. This creates an interesting irony; by breaking the wilderness ethic, I am actually improving the location, removing objects that should not be there and leaving behind a cleaner space. For me, these found objects are easily ignored traces left behind by others, and they create a fascinating collage of a place through its detritus.

EXAMPLES OF *SHADOW-WALKS*

To consider what it is that makes a walk meaningful to someone, and how my improvisations can reinforce this, I will describe three *Shadow-walks* from Britain, Ireland, and the United States.

London, Britain

The first ever *Shadow-walk* occurred in London with John, a personal friend. He selected the walk to school, for it had occurred almost daily for seventeen years with two sons of different ages and would end that summer when the younger one changed schools. It was special for him because it occurred so frequently and because of its connection with his family life. That it would end soon gave it added resonance for John.

The walk had a distinct dynamic structure, starting with a hurried urgency to leave the house on time and moving into a lively journey with his bright and entertaining son. There was a natural pause on arriving at the school gates and a slower return, ending with a slightly melancholy mood at the prospect of the empty house and eventual "empty nest." John mused: "You get home and there's the smell of breakfast, the pots are in the sink, and you think, 'Now what?'"

The shape of this walk became a loose score for my later improvisations, which also included words that John or his son had spoken, often remembered at the place where they had been uttered. I began by chanting his son's repeated phrase before we had set out — "Gotta get me glasses" — and John's "Come on! We're late!" Then I sang short melodic phrases on the outward journey, gradually moving to more pensive long tones for the last section of the walk.

The title of this project, *Shadow-walks*, came from the strange sensation I had while repeating John's walk alone that I was not only shadowing John, as

a private detective might, but also, in a certain sense, actually becoming his shadow. Since this was my first attempt to sing somebody's walk, I repeated it several times, always beginning at his home. Most startling were the occasions when John himself appeared: in the distance as I turned a corner, cycling past in the traffic, in the school playground as I stood at its gates, and once through a curtain as I sang outside his house. The experience was quite ghostly, almost as if I were replaying a life that I had once occupied but was no longer mine.

It occurred to me then and since that in this project my gender might be helpful. I have never been asked to account for my movements or loitering, unlike many male sound artists of my acquaintance. For example, I have the freedom to stand for some time, with no apparent purpose, just outside a school. Also, it is possible that people find it easier to trust me, share confidences, and take me on a walk because I am female and therefore not seen as a threat.

This first walk in London was a useful template for later *Shadow-walks*, which have aimed to reflect the structure of the walk, its emotional content, and the underlying meaning for that person.

Cobh, Ireland

Cobh, formerly known as Queenstown, is situated in Cork Harbour, Ireland, and has a significant history. It was the main departure point for Irish emigrants to North America until well into the twentieth century. Queenstown was also associated with the great steam ships, including the ill-fated *Titanic* and *Lusitania*. In recent years, both industry and tourism have declined.

During my artist residency there, five local inhabitants volunteered to take me on their special walks. Hilda was an elderly woman, born in Cobh, who led me through places that spoke to her of her life and the history of the town. We began the walk outside the house where she was born, then walked to the dock where, as an eight-year-old girl, she was regularly sent by boat to babysit a cousin on a small island. We stood by the beach, or strand, as she described her children's games with stones and painted a vivid picture of the town in steamship days, when people bustled in from all directions and "all the locals knew the times of the tides." She told me of her husband's death and her present life in a home for older people.

My singing followed the mood of regret and nostalgia in her reflections, and I tried to repeat her walk at the same pace as the original. This reduction in speed from my usual stride affected the way in which I vocalized, creating more time to breathe and therefore allowing a greater variety of long tones and phrases. Hilda had paused often to describe her memories: "Those steps used to be so beautiful!" and "We had some good times." When I stopped in those places, I felt a strong sense of her presence and did not need to calculate how to sing her walk but simply allowed it to emerge through my voice.

Every special walk contains an element of an interior journey through a personal landscape, but Cobh provided the most extreme example as I was guided on a walk without moving. John was eighty-seven years old and could no longer physically walk, but he offered to describe his favourite route as we sat in his room looking out to sea.

His description of the walk used both current and former place names and combined personal reminiscences with history and mythology: his midwife grandmother's story of infanticide by the docks, a creation tale about the island foxes, memories of growing up in an Irish republican family, and much more. Our walk, unrestricted by the speed of an actual journey, lasted several hours. Usually, I am able to participate in the sensory experiences of a person's walk, but that obviously was not possible in this case. However, the quality of John's storytelling created a common ground where I felt included in his inner walk. As I retraced his route through the real streets of Cobh, I had the strong sensation that I was not only in this time and place but also in the old Queenstown, walking through many layers of history and memory. This was reflected in my improvisations, which combined free vocalizing with echoes of traditional Irish music and keening.

Cal State University, Fullerton, California

I was interested in attempting a *Shadow-walks* project in the area of Los Angeles, reputedly an unlikely place to find people with any kind of regular walk. However, I was optimistic that students on a university campus for several years would develop relationships with their surroundings, and this did prove to be the case. I was invited as composer-in-residence to Cal State University in Fullerton, where I stayed for two weeks on campus. Without a vehicle I was quite isolated, especially at night when the absence of students created an island-like emptiness. This gave me great freedom to sing without causing disturbance or embarrassment, so I made many of my repeat walks at night.

Eleven students and two staff members from the music faculty took me on their special walks around the campus, including routes from class to parking lot, to places of tranquility, or to their part-time employment. One mature student retraced a walk that he had done at a time when the future seemed gloomy for him that had led to, in his words, "an epiphany on the way to the food court," where he had felt a moment of joy in simply being alive. Conversations touched on worries about the future, memories of the past, and, as might be expected from music students, issues of noise, music, and silence.

I recorded environmental sounds, focusing on characteristic sounds of the campus. They included overlapping rehearsals and scales in the various practice rooms. Layers of drones were a constant reminder that many machines are necessary to sustain a university. Every building had at

least one dominant hum outside and more within, drones of many pitches, always present just beneath the human sounds. I used an electromagnetic microphone to record the normally inaudible buzzing and whirring from drink-dispensing machines, ATMs, sensors, emergency equipment boxes, and, mysteriously in one instance, under a paved yard.

I made vocal improvisations, as usual, along each walker's route and with that individual in mind, but the final sound work was edited as a composite, layering all the recorded walks together, just as the routes of the original walks had frequently overlapped. My *Shadow-walk* of Cal State University, Fullerton, is included on the DVD accompanying this book.

CONCLUSION

I began this project by asking what it is that makes a walk special or meaningful to someone and how my vocal improvisations might relate to that person's sense of identity in his or her selected location.

The Special Walk

I wondered how Steven Feld's study of "waterfalls of song" might be relevant for "those of us enclosed in a world where everybody seems to be on the move, displaced or disemplaced."[6] I considered a key element of the traditional song path to be highly relevant — that sense of place which, according to social scientist Clifford Geertz, seems barely to be diminished in the contemporary world: "For it is still the case that no one lives in the world in general. Everybody, even the exiled, the drifting, the diaspora, or the perpetually moving, lives in some confined and limited stretch of it — 'the world around here.'"[7]

Certainly, in my own project, I have discovered that walkers generally select routes that reinforce connections with their own localities, however mundane. Few choose walks where natural beauty is the main feature; mostly, the walk is embedded in their daily lives and, even with young people, often relates to their own histories.

Vocal Improvisations

My vocal soundings have not become formalized into a system but remain intuitive responses, often to the undercurrents of the walk. After listening to my recording of the original walk, I consider what it is that I perceive to be the essence of that person's walk. This can be a particular mood, a sense of history, some aspect of her observations, the sound of her words, or many other factors. As I set out alone to walk the route, I try to embody this essence and allow my singing to emerge freely from this source.

However, while my improvisations aim to honestly express another person's walk, the fact remains that, as I follow his or her path, I am also taking

my own walk at a different time, with changed climatic conditions and sonic environment. As an improviser, I naturally respond with sound to these elements as they occur. My walk acknowledges the "now" as well as the "then."

Improvisation is a form that celebrates the moment and seems to be perfectly suited to the act of walking, which perhaps can also be considered in this light, as novelist and psychogeographer Iain Sinclair suggests: "The joy of these days out lay in the heightened experience of present tense actuality."[8] Both the spontaneous composition of music on a walk and the walk itself share certain characteristics: each requires negotiation of its territory, adaptation to current circumstances, and compromise with unexpected changes. The motion of walking allows a certain mental freedom that translates a place to a person kinesthetically, and intimately connected to the body's movement is the voice, as Douglas Kahn asserts: "Speak of the voice per se and one necessarily speaks of the body."[9] The singing voice and the speaking voice are equally affected by this mental freedom: both solo improvisations and shared conversations flow easier with the motion of walking.

Attitudes to walking might differ in certain ways among Britain, Ireland, and the United States, but the notion of the "special" walk seems to be widely understood. Through my improvisations and compositions, I am trying to convey people's special relationships with familiar places and how they link to the interior landscapes of personal history, memory, and association. As Italo Calvino writes in *Invisible Cities*, "Your footsteps follow not what is outside the eyes, but what is within, buried, erased."[10]

NOTES

1 Lucy Lippard, *The Lure of the Local: Senses of Place in a Multicentered Society* (New York: New Press, 1997), 34.

2 Viv Corringham, "Vocal Strolls," *Musicworks Magazine* 86 (2003): 22–27.

3 Steven Feld, "Waterfalls of Song," in *Senses of Place*, ed. Steven Feld and Keith H. Basso (Santa Fe: School of American Research Press, 1996), 92.

4 Steven Feld, "Lift-Up-Over-Sounding," in *The Book of Music and Nature*, ed. David Rothenberg and Marta Ulvaeus (Middletown, CT: Wesleyan University Press, 2001), 205.

5 Ben Tufnell and Andrew Wilson, *Hamish Fulton: Walking Journey* (London: Tate Publishing, 2002), 109.

6 Clifford Geertz, "Afterword," in *Senses of Place*, ed Steven Feld and Keith H. Basso (Santa Fe: School of American Research Press, 1996), 260.

7 Ibid., 262.

8 Iain Sinclair, *London Orbital* (London: Granta Books, 2002), 120.

9 Douglas Kahn, *Noise, Water, Meat: A History of Sound in the Arts* (Cambridge, MA: MIT Press, 1999), 290.

10 Italo Calvino, *Invisible Cities*, trans. William Weaver (London: Vintage, 1972), 91.

Possibilities

CHAPTER TWELVE

Putting Concert Music Performance in Its Place: The Open Ears Festival of Music and Sound as Installation

Peter Hatch

PRELUDE

I am sure that the organizers who invited me to the 2004 Art of Immersive Soundscapes summer institute in Regina, Saskatchewan, expected me to take advantage of the wonderful octophonic sound diffusion system that had just been installed at the University of Regina. I spoke to the organizers about the possibility of doing something quite different: instead of immersing the audience in a world of sounds, I wished to immerse my sounds in the world of the public. The result was the first of a series of *Guerrilla Sound Events*, which I will describe later in this chapter. My approach to this concept of sonic "immersion" grew out of creative work that I have been doing for years, both as a composer and as a curator of events such as the Open Ears Festival of Music and Sound. Recently, I have become interested in combining these interests in a study of curatorial practices in music. Here I will examine the perspective of the Open Ears Festival as a giant sound installation, performed and installed throughout the city of Kitchener, Ontario.

See DVD — Peter Hatch — for a video excerpt from Guerrilla Sound Events: "Car(r)ying Play."

CONCERT MUSIC SPACES

I live next door to the Kitchener-Waterloo Chamber Music Society (KW-CMS), also known as the Music Room, in Waterloo, Ontario. Although this name might conjure up the image of a quaint nineteenth-century concert hall or a room in a community centre, the KWCMS is housed in an old home, set on the edge of a park. The music performed there is true chamber music in the original sense of the term: music performed in a palace chamber or some other comparatively small, intimate room. The seventy or so concerts presented there each year are advertised by word of mouth, by a dedicated e-mail list, and by a thorough dispersion of home-printed, 8 ½ × 11-inch, photocopied posters spread throughout Kitchener-Waterloo by one of the main organizers, Jan Narveson, a now-retired philosophy professor. The audience members arrive through the side door (one of the posters taped onto a post in the lawn outside assures them that "this is the place") and into a small vestibule lined with bookcases full of decades-old *National Geographic* magazines and the like. After purchasing tickets in the kitchen (with Jan, his wife Jean, or a volunteer taking tickets), the audience proceeds upstairs to what appears to be a large living room with bookshelves lined with LPs. The "stage" is a small corner of the room surrounded by up to eighty-five chairs, the front row literally inches from the performers.

Acoustically, the room is far from ideal, with a reverberation time of perhaps half a second and very little reflected sound possible when filled with an audience. Nevertheless, this space attracts some of the world's top performers, and audiences frequently near capacity are eager to experience chamber music in a truly intimate setting, armed with both a sense of adventure and an intention to participate in highly concentrated listening. KWCMS posters are of the format used by organizations advertising folk song circles, club parties, or raves. The location, kitchen ticket sales,[1] and general ambience suggest a Newfoundland kitchen party. The performers and instruments featured, and (especially) the list of composers named, identify it as a classical music concert, while the informal dress code and presentation suggest otherwise. As a folk music gathering, the KWCMS would likely be considered mainstream. As a concert music venue, it is "alternative."

TRADITIONAL CONCERT HALLS

The traditional concert hall grew out of rooms not unlike the KWCMS Music Room. In the early days of classical music, chamber music was performed in dedicated rooms in the homes of aristocrats. In his book *Buildings for Music*, Michael Forsyth discusses how, before the development of concert halls,

Music was already performed widely in private circles at the palaces and princely courts of Europe, where performances generally took

place in any suitable ballroom, drawing room, salon, or hall. These rooms had not necessarily been built solely for music, as orchestral music ... requires no special equipment beyond the orchestra itself. Even if, in the original design of a residence, a room was set aside for concerts, it would generally differ little from any other room, except perhaps in decorative detail or the addition of a gallery.[2]

The public "concert hall" as we know it did not become common until the eighteenth century, when the burgeoning middle classes and the popularity of music demanded larger, more specialized, symphony and opera venues. Although musical acoustics were far from an exact science, these spaces were geared to concentrated listening. They were also elegant social gathering places for the privileged. When classical concert halls developed, their architectural design reflected the history of musicians as servants performing within the household of an aristocrat. At the same time, their acoustic design was reminiscent of the "sacred" space of the church: musicians in these spaces were both servants and priests.

Christopher Small comments on how traditional concert halls are built to keep performers separated from the audience:

> The auditorium's design not only discourages communication among members of the audience but also tells them that they are there to listen and not talk back.... Nor does the design of the building allow any social contact between performers and listeners. It seems, in fact, designed expressly to keep them apart. It is not only that the orchestra musicians enter and leave the building by a separate door from the audience ... but also that the edge of the platform forms a social barrier that is for all practical purposes as impassable as a brick wall.[3]

The concert halls retained their status as social gathering places for an elite class. Even today the socializing, both pre- and postconcert, that goes on in the various gathering areas in and around the corridors surrounding Amsterdam's Concertgebouw seems to be almost as important as the music that goes on within the great hall, and, for many attendees, New York's Metropolitan Opera House is as much a place to see and to be seen in as it is a place to hear opera.

Large concert halls became so popular that they seemed to become "must-haves" for respectable communities. Presenting "classics" in these familiar and ritualized surroundings is still considered an important part of a "respectable" city in many parts of the world. The danger, of course, is that rituals can become strictly habitual, and classics can turn into commodities. In many symphony halls, standing ovations appear to be almost automatic

for any concerto performance, whereas the spontaneous applause or shouts of "bravo" that occurred during many nineteenth-century performances of concerti are almost never heard. The success of live performances by present-day classical musicians is often measured against those captured on highly edited CD recordings

In recent years, the formal concert hall environment has become problematic for many. Max Wyman, in his book *The Defiant Imagination*, cites a study of music habits in the United States and United Kingdom, published in the Policy Studies Institute's *Cultural Trends* magazine in 2002, that "showed that the stuffiness of classical music concerts in Britain threatened to turn off an entire generation of potential audiences. Attendance by individuals under the age of forty-seven dropped sharply in the 1990s.... Among the reasons cited: the formality, elitism and 'authoritarian' image of cultural institutions."[4] Greg Sandow cites similar reports conducted by the National Endowment for the Arts.[5]

USE OF ALTERNATIVE SPACES

In reaction to charges of "elitism" and "authoritarianism," and in an attempt to rejuvenate the concert experience, classical and postclassical groups have started choosing to perform outside the concert halls designed for them. In moving away from traditional concert spaces, there is the possibility of recontextualizing the music presented.

Using "alternative venues" for concert music, especially new music, has become increasingly common in North America, a trend supported by government arts funding programs. Recently, the Canada Council reinstituted its Music in Alternative Spaces program, with much of the money going to art galleries presenting music as part of their programming. For many years, the Canadian Music Centre's New Music in New Places program resulted in many Canadian composers having their work presented in unusual contexts, including beaches, riversides, malls, wineries, and airports.[6] Partly driven by the "outreach" funding from these sources, ensembles previously found only in concert halls have shown up in all kinds of venues, from clubs and dance theatres to building atriums, barns, abandoned factories, and a variety of outdoor sites. Classically trained musicians are now found somewhat frequently in places such as Toronto's Transac club and Montreal's Casa del Popolo. Symphony orchestras regularly appear in parks, shopping malls, public schools, and soup kitchens.

Some musical organizations have made presentations in alternative spaces part of their core identities. The Sound Symposium in Newfoundland has been presenting work in unusual venues for years; for example, specially composed harbour symphonies sound the horns of ships docked in the harbour and can be heard throughout downtown St. John's. Vancouver's

Redshift ensemble has the use of alternative urban spaces as part of its core mandate and has presented concerts in the atrium of the Vancouver Public Library and around a lake in Stanley Park. Toronto's Music Gallery has found itself (more by necessity than by choice) housed in a church (as has New York City's Wordless Music series). An interesting development at the Music Gallery has been the discovery of the "sacred" space of the church by postrock and indie bands (featured in its pop-avant programming), just as classically trained musicians are moving out to perform in local clubs.

Some of the most remarkable uses of alternative spaces can be found in the work of iconic Canadian composer R. Murray Schafer, particularly in his mammoth twelve-part series of environmental music dramas *Patria* (begun in 1965). In his essay "The Theory of Confluence II," Schafer talks about the need to

> accomplish an art that engages all forms of perception.... [W]e need not only to strip down the walls of our theatres and recording studios, but also the walls of our senses. We need to breathe clean air again; we need to touch the mysteries of the world in the little places and the great wide places; in sunrises, forests, mountains, and caves and if need be snowfields or tropical jungles.[7]

Schafer's works often take place in highly unusual places and at striking times of day. His work *Patria 6: Ra* begins at sunset and ends at sunrise — audience members walk from scene to scene in robes and take part in activities that include sipping tea and taking a nap. Attending a concert of his *Patria the Prologue: Princess of the Stars* involves being bused to a location beside a wilderness lake before sunrise: the performance begins at daybreak with the ethereal sounds of a mezzo-soprano stationed far away on the other side of the lake.

ACOUSTIC MATCHES

One of the attractions of alternative spaces is the opportunity to make use of striking acoustics — a shopping mall or business tower's atrium might be one of the few spaces apart from a large concert hall or church with a reverberation time considered optimal for acoustic music (around 1.5 to 3 seconds). These spaces can conjure up the illusion of a large concert space, each having its own "aural architecture," as Barry Blesser and Linda-Ruth Salter put it, separate from its "visual" architecture.[8]

Less optimal acoustic spaces are often compensated for, or even replaced by, amplification systems. In many ways, our reference point for musical sound is now amplified sound — music today is listened to primarily through loudspeakers, whether our mode of experiencing it is a radio, car

stereo, iPod, television, movie theatre, elevator, or shopping mall. Pure acoustic music is a rarity — even most acoustic musicians perform through loudspeakers. For instance, the traditional Irish band Danu appeared at a local church several years back as an amplified group despite the acoustic environment that they were placed in, one that was almost perfect for their acoustic sound. It seems that, after years of having to adapt to poor acoustic environments by using amplification, they had simply lost the ability to play with one another acoustically.

Nevertheless, one of the attributes of much classical and postclassical music is its emphasis on acoustic sound, so moving into spaces not designed for acoustic music can pose huge challenges. Many spaces suffer not just from very short reverberation times but also from high ambient noise levels caused by refrigeration units, traffic noise, crowd chatter, telephones, and so on. Frequently, musicians try to perform in such spaces, which "look great," only to find that they really cannot be heard. A string quartet asked to play at a large, noisy social function in a beautiful garden is a common example. The use of amplification to try to overcome ambient levels can be a problematic solution — many concerts have suffered from badly miked instruments played through an inferior sound system — the levels often mixed by people used to working only with amplified sound and therefore not familiar enough with the acoustic sound that they are trying to represent.

Despite these challenges, with careful planning the pairing of an "alternative" acoustic sound environment and the events within it can produce a sound as beautiful as that of music within a concert hall, and each unique pairing of event and environment produces a hybrid experience, highlighting the dialogue that occurs between any sound event and its acoustic environment. Blesser and Salter comment that

> [t]he experience of listening to a sermon in a cathedral is a combination of the minister's passionate articulation and spatial reverberation. A performance of a violin concerto combines the sounds of musical instruments with the acoustics of the concert hall. The soundscape of a forest combines the singing of birds with the acoustic properties of hills, dales, trees and turbulent air. To use food as a metaphor, sonic events are the raw ingredients, aural architecture is the cooking style, and, as an inseparable blend, a soundscape is the resulting dish.[9]

However, there is more to this mixture than acoustic sound. The moment that one enters a space not designed for concert performance, one begins a dialogue with that space and its "voice," which includes its function and the people, past and present, who have used the space.

An awareness of, and tampering with, the traditional "frame" within which music is presented mirror similar changes in curatorial approaches in the visual arts, in which "the white box" is seen as just one alternative to presenting art. The postmodern notion of moving from the presentation of the "art object" to a stress on multiple interpretations and identities is at the heart of more recent art museum curatorial practices. As long ago as 1969, a UNESCO conference entitled Problems of the Museum of Contemporary Art in the West developed a statement by leading European gallery directors that "put a question mark against the old museum structures, still based on the principle of artistic performance. Nowadays, while the artist is still taken as the starting-point, attention is more focused on the community."[10]

Recent curatorial practice presents an artist's work within a much broader contextual field than earlier practices (which often featured "great art" works and accompanying titles alone within a neutral environment) and in a manner that invites multiple interpretations. In her article "Showtime: Curating Live Art in the 1990s," Lois Keidan explains that "Who the work might actually be addressing is as various as the nature of the practice — new audiences, new spaces, the academy, potential programmers, the field itself. The representational relationship here is primarily as facilitator."[11] Art galleries now commonly offer wide-ranging interpretive approaches to an artist's work; for example, a 2006 show on Canada's Emily Carr showed not just her well-known paintings but also art and artifacts of the First Nations people who greatly influenced her work as well as some of her lesser-known commercial work. Presenting her work in this way not only explains the cultural influences on her work but also contextualizes it within the society in which Carr lived: her art stands beside other cultural artifacts of her time and place rather than apart from (or even "above") them. The show illuminated a much wider cultural area than just her art.

In a similar way, using alternative spaces moves concert music out of the concert hall, but it also moves it out of the associated traditions, rituals, and expectations and into a new relationship with "the community." Recontextualization of concerts results in new and hybrid rituals and traditions. In the case of the KWCMS Music Room, classical music is presented in a context very different from the traditional concert halls described earlier. Having audiences literally "rubbing shoulders" and sharing tea with performers stands in great contrast to the divisions between audience and performers analyzed by Small. Performers in this context are less "servants" or "priests" and more "friends" or "neighbours," albeit ones with particular musical talents. The concert experience at KWCMS might seem a bit bewildering to those accustomed only to traditional concert halls, but in general the

atmosphere encourages a wonderful inclusiveness that cuts through audience members' varying degrees of musical expertise.

THE OPEN EARS FESTIVAL OF MUSIC AND SOUND

Between 1998 and 2013, I was the artistic director of the Open Ears Festival of Music and Sound, a biennial festival based in Kitchener. The focus of the festival is on the act of listening. With a mix of local, national, and international artists, our events have featured concerts from traditional ensembles such as string quartet, orchestra, and choir to turntable art, *musique actuelle*, outdoor electroacoustic events, multimedia, and dance. A late-night series concentrates on cutting-edge work from the world of live electroacoustic and improvised music. Concerts are presented indoors and out, in traditional concert halls and churches as well as alternative spaces, including several buildings that have been abandoned for many years and are brought to life for the festival. Sound installations are presented both in traditional galleries and in "found" spaces.

In fact, we normally use more than a dozen different venues. We attempt to find events that resonate well with their venues, both physically and culturally, although sheer logistics make this activity more of a serendipitous art than a craft. My comments here reflect both my experience as artistic director of Open Ears for over a decade and my continued practice as a producer of concerts.

When I enter a space that I am checking out for a possible concert, often the first thing that I do is clap my hands or cluck my tongue. This is my way of "seeing" the aural environment of that space — of "looking around" at it and deciding if it is suitable for my needs. The important element is not the actual sound (I know well what my clapping hands or clucking tongue sound like) but the reverberation — the resonance that I hear in response to it. As Alvin Lucier shows so eloquently in his *I Am Sitting in a Room* (a piece in which a text is continuously played back into a room and rerecorded until the acoustic of the performance space causes the text literally to disintegrate), each acoustic environment has its own resonant "personality." But the resonance of each space extends beyond pure acoustical factors such as reverberation time. I see this physical act of testing acoustics as a metaphor for what I do as an artistic director on a conceptual level — I clap my idea into the social environment and listen for its cultural resonance. I consider the idea "How about a concert of string quartet music here?" or "How about an amplified sound installation here?" within the context of both the city and the venue in which it is to be presented. The resonant environment speaks back in terms of both physical sound and social/cultural heritage. For example, placing a string quartet in an old, abandoned department store not only made use of its "optimum" reverb time but also created a dialogue

with the idea of cultural heritage in a building in danger of demolition (and now, happily, home of the Waterloo Regional Children's Museum).

Festival as Sound Installation

Traditionally, each Open Ears Festival opened with an event that we called "Klang," in which we rang all of downtown Kitchener's church bells, thus announcing our wish to "resonate" the city sonically. It also represented a different, "top-down" approach to programming: we began with the city and ended with the details of the programming.

I try to think of the Open Ears Festival as a kind of giant sound installation, spread throughout downtown Kitchener for a fixed period of time. The festival shares two defining features of sound installations: their privileging of the aural over the visual and their time-based, performative nature, as environments in which one is encouraged to wander. Of course, the scale is quite different: sound installations are typically housed within constrained areas that can be experienced in one continuous period of time. In contrast, the Open Ears Festival takes place within a radius of a few kilometres (it is designed so that it is possible to walk from event to event) and over a period of six to ten days. Transitions are important. Walking through the city (often past the street people and construction sounds that symbolize Kitchener's evolution as a city) can be considered part of the festival's activities. In a sense, the intervals between events are like the silence between the movements of a musical work: they work to create a sense of continuity between what has just been heard and what is still to come.

The idea of "open ears" is to provide an environment in which people can interact with their physical and social surroundings, primarily with their ears. We do this through activities such as our soundwalks, in which people are taken on a walk while various soundmarks (from running water to buses to factory noises) are pointed out. Great attention is paid to the environments in which our concerts are placed, from the acoustic of the hall to the quality of the sound equipment. The range of presentation venues is an important element in the festival: our ears and attention prick up when in a different acoustic, and walking through downtown Kitchener between events connects us to the city, and to the rest of the world, in a way that staying in one location never would.

We try to present artists who are engaged in similar dialogues through their work, especially musicians who are expert at using a given venue's acoustic properties to maximal effect. Gordon Monahan, in his *New and Used Furniture Music* (2003), caused the structure that the audience was seated on to resonate through low frequencies produced by his theremin, creating a powerful throbbing effect that was not just audible to but also literally felt by the audience.

One of our more successful evenings was a double-bill in 2005 that juxtaposed performance artist Diamanda Galás performing in a church with a concert by the politically charged group Negativland performing in Kitchener's City Hall council chamber (and actually sitting in the councillors' chairs). The dialogue at these events was interesting in that what went on inside the venue was at almost exact odds to its usual function. Galás's gothic appearance and message of darkness, evil, and despair challenged, and was challenged by, the Christian heritage of the church. In the Negativland concert, the council chamber (emblematic of order, policy, and rules) was filled with the band's anarchic, chaotic, rule-breaking themes and sounds. The "counterpoint" between act and space was integral to each event.

At our 2007 festival, we presented *Legion of Memory*, a site-specific theatre production created by Kitchener theatre director Andy Houston. The production was inspired by, and took place at, Kitchener's Legion Hall, formerly a social club for war veterans. By 2007, the building had been vacant for a number of years, with much detritus from decades of social events left lying about the space. *Legion of Memory* was based on extensive research into the history of the building and its occupants, interviews with Legion members and contemporary issues such as immigration and Canada's military presence in Afghanistan. The work was truly site specific, drawing its ideas from the site in which it was performed. Houston contrasts this idea with work that is simply "installed" in its venue without reference to that venue's historical or social context.

Legion of Memory took place throughout the three-floor building, with the audience completely immersed, and at times participating, in the performance. At one point, audience members, who generally moved freely (with loose guidance) through the space, were invited into the kitchen (the floor left in its "found" state, with broken pipes and old equipment strewn about), where a performer spoke to them while cooking soup. Similarly, they participated in a dance contest hosted by a slightly crazed DJ. Other "found objects" (e.g., old newspaper articles) decorated the space. A twelve-part audio diffusion system helped to bring the space alive by surrounding the audience with a mix of "environmental" and musical sounds — these sounds mixed seamlessly with the acoustic sounds coming from the performers and audience. The work was noteworthy for its resonance with the building, its former occupants, and the issues surrounding their tenure there. Months later the building still reverberated from the performance. Formerly just an "interesting old building," it now lives on with a redeveloped personality for those who were in attendance.

My own *Guerrilla Sound Events*, an ongoing collection of works begun in 2004 and presented at the 2005 festival, literally "take to the street" in addressing issues of acoustical and cultural engagement. As sound-based,

spontaneous public interventions, they challenge notions of the performative "fourth wall" by circulating operatically singing cell phone users and performative sound installations through unsuspecting urban crowds. The venue is the city itself. My *Guerrilla Sound Events* are created in such a way as to respect the theatre of everyday life in which they are presented: they come and go with the ordinary flow of people and time. A short example recorded at the 2007 Junction Arts Festival in Toronto is featured on the accompanying DVD. The viewer sees what looks like a mother wheeling a baby in a stroller. She wanders down the street oblivious of the soundscape of a children's playground emanating from the sound system concealed in the stroller. (Listen carefully and you will hear this over the noisy ambient street sounds toward the end of the clip.) In these works, all levels of interaction (including no interaction) are acceptable, and the range of reactions to these pieces has been amazing. The same "scene" might have some people ignoring it completely while others nearby are literally moved to tears.

Challenges

Working with alternative venues forces us to deal with technical issues never found in regular concert venues. In 1998, the Open Ears Festival presented a concert in an old school theatre that had been boarded up for years. Doing so involved literally punching a hole in the back wall of the stage area to bring in electricity, calling in plumbers to resuscitate old washrooms, and housing volunteers at all exits in case of fire. All of this work was accomplished with the tremendous participation of staff of the City of Kitchener, many of whom had been students at the former high school and were now in positions of power as fire marshal, insurance expert, and so on. Similarly, our production of *Legion of Memory* was in question almost up to the time of the first concert, with repeat performances in doubt as well, all due to technical issues related to fire safety. That these events happened at all was due to heroic efforts by the festival crew and city officials and workers. Perhaps Kitchener's modest size promotes a level of cooperation that would be harder to achieve in a larger city.

Sometimes how an event and a venue are interpreted by the audience can differ dramatically. For example, a few years ago the Guelph Jazz Festival (just down the road from Kitchener-Waterloo) brought in Supersilent, a Norwegian electronic improvisation group known for its ambient sound created by the "pop" instrumentation of guitars and drums. Theoretically, Supersilent was a great fit for a late-night presentation in a downtown shopping mall, for the band's cross-over music could appeal to university students returning to a new school term. Indeed, the long reverberation time of the mall was a very good fit for Supersilent's ambient sound, which could be experienced either close up, with a clearly defined sonic and visual image, or

far away, where a heavily reverberating "wash" of sound was unconnected to a visual image of the band playing. However, organizers did not foresee that the mall environment would encourage students to do what they always do in malls — talk — with music assumed to be experienced in the background. Part of this response might have been related to visual cues. Without a proper stage and an elaborate lighting system, the group was somewhat lost visually, and only a small crowd gathered closely around the group could really see them. They were the only ones listening attentively; throughout the rest of the space, people chatted and socialized while what seemed like very strange "muzak" played on in the background. This was okay for some, but for others, who had come to experience a "concert" as opposed to background music, it was an alienating experience.

One Open Ears concert featured the combination of harpsichord and Chinese *zheng* — two instruments with established histories as "women's instruments" and performed by female soloists. This concert was accompanied by the surprising last-minute addition of the sounds of a soup kitchen in the adjoining room. Whether or not these sounds and/or their associations with "traditional women's work" were a bother or a bonus (or were even noticed) differed from individual to individual in attendance.

Classical music presents particular challenges: the social/cultural association of classical music with the traditional concert hall is so strong that tampering with its rituals is almost a taboo. Linda Smith and John Oswald's *Orchestral Tuning Arrangement* was performed by the Kitchener-Waterloo Symphony at the 1999 edition of Open Ears. This work played with the ritual of musicians tuning their instruments on stage just before an orchestral concert. At one point, two members of the orchestra actually got up and hugged each other. Not all of the members of the orchestra seemed to appreciate this effort to add more humanity to this opening tradition. At the concert, one musician made his own "guerrilla" addition by showing up for a few moments at the back of the orchestra dressed as a gorilla. His mockery not only derailed the sincere intentions of Smith and Oswald's piece but also transgressed the strict protocol expected of orchestral musicians faithfully to follow the music's instructions.

On the flip side, the relationship between classical music and "alien" environments can be antagonistic enough to be weapon-like. Kitchener City Hall successfully used piped-in classical music as a deterrent against groups of teenagers who had developed the habit of hanging out by the front doors after hours. Their sense of cultural identity was so alien to that of classical music that they chose to go somewhere else to socialize.

The Open Ears Festival of Music and Sound is just one among many initiatives to enliven the culture of contemporary classical music in Canada and to use "alternative" venues to do so. This increased activity promises to help change concert music culture in unexpected ways. For many years, the Canadian Music Centre's New Music in New Places program offered "the general public an incredible opportunity to experience first-hand the creativity of our Associate Composers. [It] is designed to bring Canadian contemporary music out of the concert halls and into the lives of Canadians."[12] But the real reward of programs that bring music into alternative spaces is perhaps not just the exposure of new audiences to the world of music but also the exposure of musicians to the worlds of the audiences.

Any use of an alternative space involves substantial work by a group of individuals from varied backgrounds who must sort out a host of logistical, technical, and political issues, from setting up a temporary box office to addressing fire regulations. Producing concerts in "real-world" environments cannot help but have an impact on all the people involved. Artists learn to respect the responsibilities of city bureaucrats, just as city workers learn to respect the often strange requests of artists.

Small uses the inclusive, active verb *musicking* to refer to anyone involved in the production of a musical event,

> whether by performing, by listening, by rehearsing or practicing, by providing material for performance (what is called composing) or by dancing. We might at times extend its meaning to what the person is doing who takes the tickets at the door or the hefty men who shift the piano and the drums or the roadies who set up the instruments and carry out the sound checks or the cleaners who clean up after everyone else has gone. They, too, are all contributing to the nature of the event that is a musical performance.[13]

These other kinds of "musicking" become more exposed when concerts move out of traditional concert halls and the concert experience is revealed as a much broader "performance," involving many more people than composers, performers, and audiences. An expanded perspective on the musical experience helps to create a more inclusive environment for all involved and points to a new sense of "place" for concert music.

NOTES

1 Remarkably, the series exists with no government or foundation revenue, relying instead on ticket sales and audience donations for revenue.

2 Michael Forsyth, *Buildings for Music* (Cambridge, MA: MIT Press, 1985), 21.

3 Christopher Small, *Musicking: The Meanings of Performing and Listening* (Middletown, CT: Wesleyan University Press, 1998), 27.

4 Max Wyman, *The Defiant Imagination* (Vancouver: Douglas and McIntyre, 2004), 129.

5 Greg Sandow, "The Future of Classical Music?," http://www.gregsandow.com.

6 This popular program was cancelled in 2013 due to budgetary constraints.

7 R. Murray Schafer, *Patria: The Complete Cycle* (Toronto: Coach House Books, 2002), 93.

8 Barry Blesser and Linda-Ruth Salter, *Spaces Speak, Are You Listening? Experiencing Aural Architecture* (Cambridge, MA: MIT Press, 2007), 5, 7.

9 Ibid., 15.

10 Georges Henri Rivière et al., "Problems of the Museum of Contemporary Art in the West: Exchange of Views of a Group of Experts," *UNESDOC Museum* 24, 1 (1972): 5–6, http://unesdoc.unesco.org/Ulis/cgibin/ulis.pl?catno=2576&set=493E742F_0_270&gp=0&lin=1.

11 Lois Keidan, "Showtime: Curating Live Art in the 1990s," in *Curating: The Contemporary Art Museum and Beyond*, ed. Anna Harding (London: Academy Group, 1997), 39.

12 Canadian Music Centre, New Music in New Places, http://www.musiccentre.ca/nmi.cfm.

13 Small, *Musicking*, 9.

CHAPTER THIRTEEN
Toward a Wider Immersion in Sound Art

Darren Copeland

I am an independent sound artist and the artistic director for New Adventures in Sound Art (NAISA). My professional base is in Toronto, but I live outside the city in Brampton. My work is made for the concert hall, radio, and site-specific installations. I have also developed my craft through close contact with theatre, which gave me a creative outlet for exploring composition at an early stage of my development. In this chapter, I tell my story in sound art, sharing the motivations behind my work and the concerns that propel me forward from the perspective of my work as a sound artist and as a curator. I will discuss my creative work before addressing my curatorial work.

CREATION
My past compositional work focused on the use of environmental sounds and straddled two aesthetic approaches that have had a lot of influence in Canada: the Schaeffer-influenced acousmatic tradition that emerged from Quebec and the Schafer-influenced soundscape tradition that originated in British Columbia.[1] When I started my studies, these two aesthetic positions were traditionally viewed as oppositional in their approaches to environmental sounds and somewhat bound by their geographical and cultural origins. In the 1950s, Pierre Schaeffer and his colleagues at the Groupe de

See DVD — Darren Copeland — for a complete audio recording of Lapse in Perception.

Recherches Musicales (GRM) in France proposed that sounds from the environment could be recorded and used as musical objects if the composer, and by extension the listener, ignored the associative aspect of the sound and focused instead on its inherent musicality. R. Murray Schafer and the World Soundscape Project, working in the late 1960s and 1970s, countered with the observation that a great deal can be learned, not just for musicians and sound artists but also for society as a whole, from studying the social dimension of environmental sounds.

By the time that I completed my studies in electroacoustic music (1989–93), the gap between these positions had begun to close. The first step was Luc Ferrari's *Presque rien no. 1: Le lever du jour au bord de la mer*. The work was controversial at GRM during the year of its creation in 1970 because it consisted entirely of a time-compressed sound recording of day-long activities on a beach in Corsica. The emphasis on hearing sounds as they were, and not abstracting them into musical materials, made this piece a pivotal step in reconciling these different attitudes toward environmental sounds. Later on, Denis Smalley and Trevor Wishart in the United Kingdom developed theoretical texts that also helped to merge these different attitudes. Smalley's concept of spectro-morphology offered a listening model that incorporated the social dimension of environmental and other sounds along with an analysis of their basic acoustic structures. Wishart's book *On Sonic Art* also investigated the language of electroacoustic sounds that was inclusive of the sociological dimension.[2]

In focusing on environmental sounds in my work in the early 1990s, I thought a lot about the social dimension, or what I referred to as the associative properties, of environmental sounds.[3] By associative, I mean an inherent quality in sounds that can provoke images in the mind of the listener. My thinking was that I could compose works that would engage the listener's imagination on both a musical level and a social level. Composition with environmental sounds could then exist in a realm outside music, instead becoming part of a sound art discipline distinct from music. This can be compared with the way in which theatre, film, and video art are all distinct artistic disciplines despite their common characteristics.

I found this artistic ground to be rich and refreshingly new, but there was one problem. For my works that exclusively used environmental sounds, the audience responses varied considerably and often seemed to be dictated by personal experiences.[4] The degree of variance was so wide that responses often contradicted each other and even clashed with my intentions for the work. If music is an art of communication, then how is it that what I was expressing could not be shared by my listener? There was more at play than just the abstract nature of music, since many listeners made associations with experiences from the real world. For example, the sound of a train in

a piece might remind one person of a wedding or funeral or some other significant family event, but to another listener the same recording might evoke a scene from childhood. There were many different directions in which the mind of the listener could go.[5]

I tried to deal with this issue from the later part of the 1990s until around 2003 by creating works that combined environmental sounds with spoken text. I wanted to provide a context in which to focus the latent associations in the sounds, and thus guide the artist-listener discourse, while keeping the experience of the work entirely in the realm of sound. I have indeed found that the combination of text and environmental sounds is successful in focusing the listening experience. The text element provides a clearer context in which listeners can make associations tied more closely to the intentions of the work. Let us take a hypothetical example. If I use a recorded soundscape in a sound art work that features a child playing on a swing in a park, then it might evoke a variety of associations, such as playtime, childhood memories, youth, and so on. But if I speak the text "There is going to be a problem" over this soundscape, then the associations change altogether. They become more specific and are drawn into a larger pool of related associations based on the text and sounds from earlier in the work. Of course, the reader's imagination fills in his or her own associations of where the scene might go; however, a general sense or affect has been communicated.

My interest in the problem of communication in sound art is not that I wish to make works that are highly declamatory and leave little room for listeners to draw their own conclusions. Rather, I want to create better conditions for listeners to engage actively with what they are hearing and to do so on levels that are not only musical. *Lapse in Perception*, included on the DVD accompanying this book, is an example of my work with environmental sound and text. In it, I use my own reflections on the perception of environmental sounds to invite the listener to do the same, and I examine our habit of "tuning out" the acoustic environment. *Lapse in Perception* includes a text in which I refer to the incredible density of information in the contemporary public environment and ponder whether this is why people tune out. Yet, in retrospect, I think that we also simply lack the vocabulary to talk about sound from our social experience. In his study of sound art, Douglas Kahn observed that in the twentieth century, even as sound technologies developed, there was a lack of discourse for sound art (especially compared with the highly developed discourses of visual art). I wonder whether our limited vocabulary for talking about sound is one result.[6]

One advantage of the absence of the visual in a sound work is that the experience cannot be judged in an instant. Sound travels in time and negotiates with our critical faculties for some space for acceptance and engagement, and in this way sound can engage us on emotional and social levels at the

same time. Therefore, an art practice engaged entirely with environmental sound lies somewhere between music (affect) and language (symbol). Let us take the sound of a streetcar in Toronto as an example. It conjures up many associations for listeners who live there, have lived there in the past, or even know something about what it is like to live there. This presents the sound artist with a number of possible associations to consider. The streetcar might evoke early-twentieth-century technology; it might imply an event in the future as one disembarks from the streetcar; it might trigger a memory of crowded aisles during rush hour; or it might suggest the sound of a trolley or tram from another place and time. In my opinion, compositions for conventional instruments do not combine affect and symbolism in such a fluid manner. This added richness presents the sound artist with a set of creative challenges distinct from the musical traditions of all cultures.

These challenges are positive in that the discourse of sound art does not need to be constrained by the concerns of music. Visual artists, journalists, writers, poets, and media artists have picked up the cause of sound art along with musicians and audio artists to give sound art a diverse and interdisciplinary richness of perspective. I have done what I can in this regard by creating work that crosses over into drama, documentary, and installation forms and by curating programs that include non-musicians working with sound.[7] Sound artists need to recognize that artistic expression through sound is not the exclusive domain of musicians and audio artists, and the public needs to be educated about the importance of listening in everyday life. Linking education to the creative discovery latent in the processes of recording and editing environmental sounds is one way to do this. It is effective because it appeals to the creative side of the individual, which by implication requires a deeper level of mental investment in listening. I will return to this topic when I discuss the educational activities of New Adventures in Sound Art below.

Despite the satisfaction that I found in combining text and environmental sounds in my work, I did not want to handcuff my artistic output and limit myself to one approach. I still wanted to explore other artistic avenues, using what I learned from working with text as a point of departure for my creative process. I discovered that creating site-specific sound installations and introducing abstract pitched material into my work offered interesting alternatives for contextualizing environmental sounds. The social context of the installation site provides a framework for interpreting the meaning of a sound.

In my piece *Intersections*, recordings of a pedestrian bridge are played back in a manipulated form through a multichannel sound system located on the same bridge to create an ambiguous, dream-like relationship between context and listener.[8] Pitched elements such as drones, filtered resonant

tones, and melodic fragments help to create the emotional atmosphere of this fantastic world. People who pass over the bridge hear sounds familiar to this setting. The sounds are altered in some strange way, and they overlap with the actual soundscape of the bridge. Some might walk by without consciously noticing the transformation, but for those who do, discovery of the alteration certainly adds to the surreal quality of the experience.

Breath Control is an audio-video installation made for Gallery 1313 in the Parkdale region of Toronto. When entering the installation, the audience is confronted with a black-and-white video of a pair of lips breathing. The sound of the breathing is displaced spatially, heard up high in the distance through tower-like pillars with their tops sliced off like factory smokestacks. Surrounding the listener is an array of studio monitor loudspeakers, which play electroacoustic transformations of environmental sounds recorded inside and outside the gallery space. The breathing in a sense drinks in the environment, but the smokestacks and the transformed nature of the sounds colour both elements. In another area of the gallery, audience members are invited to breathe into a microphone, thereby controlling the amplitude of a recording of construction noise (their breath sounds are inaudible). The construction noise is from a number of renovation projects transforming the local Parkdale community. Is the breath of the individual obliterated by the commercial enterprise enveloping Parkdale? Or is the breath of the individual the silent/invisible puppeteer making this enterprise possible?

Direct personal feedback from visitors to my installations and performances in site-specific contexts has provided evidence of how sound communicates on levels beyond music. People often report back with biographical tidbits prompted by what they heard in the sound piece. *Breath Control* became the basis for discussing a number of topics with visitors to the installation: respiratory cancer, the environment, the death of a loved one, and changes to the neighbourhood. The piece was intended to be a vehicle for reflection on all of these topics, so feedback from the audience confirmed that the work successfully realized its communication goals without using any text.

CURATION

There are three intentions behind my work as artistic director of NAISA. The first is to gradually transcend the assumption that electroacoustic sound art in Canada starts and ends in Quebec, which historically has had a thriving scene.[9]

The second intention, related to the first, is to foster growth of the art form in Toronto by supporting all facets of electroacoustic sound art —including work derived from the many disciplines that meet sound art: music, new media (film, video, web art, etc.), visual art, theatre, performance art,

and radio journalism. The organization that I founded, New Adventures in Sound Art, has presented over 100 concerts and 50 installations since 1998 through its three festivals, Deep Wireless, Sound Travels, and SOUNDplay.

To anticipate a time when audiences are more equipped to engage in sound on aesthetic levels beyond music, it is necessary to cultivate quality listening environments for sound art presentations. This forms my third intention — to attract new audiences to the art form through high-quality productions. NAISA has focused on cultivating new audiences, and this focus has informed many of the activities and other objectives that it has taken on over the years. In this section, I address five facets of NAISA's work: spatialization, programming, Toronto, collaboration, and diversification.

Spatialization

Since its inception, NAISA has presented performances and installations using multichannel sound to place audiences in an immersive, life-like listening environment. By immersive, I mean the experience of hearing multiple sounds coming from multiple directions. At NAISA performances and installations, we strive for a polyphonic sound sensibility, so our preference is to place multiple layers of sound events in different locations of the listening space. We have done this without institutional resources or funding and despite coming onto the scene at a period when Canadian arts funding had just endured many debilitating budget cuts. NAISA decided to scale down the size of the loudspeaker systems used in concert performances from the 24 to 100-plus loudspeakers traditionally found in acousmatic performances to eight (or later on twelve) loudspeakers. Instead of apologizing for its limitations, NAISA used them to its advantage. Ignoring the acousmatic model of spatialization that, largely through real-time improvisation, projects a somewhat singular orchestral mass of sound, we developed a model closer to that of West Coast computer music composers John Chowning and Barry Truax, who advocate a polyphonic, chamber-like experience emphasizing precomposed computer automation of sound spatialization using smaller loudspeaker systems.

NAISA also departed from the conventional audience layout of a front-central proscenium arch and switched to a circular ("in the round") layout (see Figure 13.1).[10] This brought the performance focus to the middle of the room, with audiences sitting in concentric circles around that point. The advantage of this layout was that it removed the visual frustration of having to look at what was essentially an inactive front area. Positioning eight loudspeakers in a circle around the audience also made the best use of that limited arrangement. A higher number of "desirable" listening positions became available simply because the closest loudspeaker was located behind each audience member. This arrangement avoided the unfortunate situation

**PROSCENIUM SEATING
WITH ACOUSMATIC 24-SPEAKER ARRAY**

**CONCENTRIC CIRCLES SEATING
WITH CIRCULAR 12-SPEAKER ARRAY**

KEY:

- ☐ Performance Area-Unavailable Seats
- ■ Regrettable Seats
- ▧ Undesirable Seats
- ☐ Desirable Seats
- ○⇒ Ear-level Speakers and Orientation
- ●→ Overhead Speakers and Orientation

NOTE: Both examples assume a rectangular performance venue with flexible positioning for stage and audience on a flat ground floor as well as a full lighting grid for overhead mounting of speakers. Speaker positions and orientations may change from one context to another.

Figure 13.1 Comparison of proscenium and concentric circle speaker configurations.

common to proscenium seating arrangements, in which audiences at the front of the hall are seated with their backs to the majority of the speakers.

Composers had to be made aware of the audience layout in advance of preparing their spatializations because there were a number of limitations with which they had to work. First, there is no universal front or back for the audience; second, like the four parts of a string quartet, all loudspeakers are equally important; and third, with all eight loudspeakers at the same distance from the listener, it is more challenging for the composer to create illusions of distance. Later we adopted a twelve-channel model of spatialization to address this problem.

My focus on creating an immersive listening experience came from an artist residency that I did in Vancouver in 1996, hosted by Simon Fraser University. The artists participating in the residency had the opportunity to do automated eight-channel spatialization of their work with a prototype that

led to the Richmond Sound Design Audiobox. Prior to this, my experience with concert spatialization was very frustrating because in the acousmatic model all of the sounds move together en masse — a severe limitation when dealing with multiple layers of sound plus spoken voice. Instinctively, I wanted to hear each sound and each voice follow its own spatial trajectory, and that was not possible in the conventional acousmatic format, in which all of the sources are mixed to stereo before being spatialized to the loudspeaker array. Through this residency, I was helped immensely by software programmer and composer Chris Rolfe to turn my desire for polyphonic spatial distribution into reality. When the Audiobox and its control software ABControl were commercially available, they became the cornerstone of all of the presentations for NAISA, and my individual artistic practice, from 1998 to 2006. Sticking for that length of time to one piece of hardware and software certainly went against the current trend. Most people in the field were (and still are) acquiring and dropping software and hardware tools at such an alarming rate that it called into question the reason for using those tools in the first place. The Audiobox and ABControl software did what I needed, while the commercial platforms such as Pro Tools, Logic, and Nuendo were very limited in terms of their possibilities for surround sound spatialization.

Since 2006, I have tried to reconcile some of the strengths of acousmatic spatialization with this immersive soundscape approach. The weakness of what we were doing with the Audiobox was that it removed the performer from the concert experience. The composer had a tremendous degree of control both in preparation and in rehearsal, but when the audience came into the hall the performance side of the equation was reduced to the level of control and making sure that the automated spatialization was "performing" as expected. Although this was artistically satisfying and less stressful for the artist, it was a huge let down for any audience member seeking some kind of visual reinforcement during the concert experience.

So in 2006 I engaged Max/MSP programmer and composer Benjamin Thigpen (along with some consultation with Rolfe and electronic artist Jim Ruxton) in designing a new spatialization system that places the performer in the centre of the experience. The new system is performance driven in that it behaves more like an instrument with automation support than an instrument for automated control. Naturally, there are differences from performance to performance, and, more importantly, there is the implementation of a physical controller mapped to sound spatialization so that the audience's listening experience is mediated by the physical gestures of a performer. Currently, NAISA uses both this new system and the Audiobox to offer sound artists and composers two options for spatialization.

The main source of visual interest for the audience with the new system is that a sensor is attached to the left hand of the performer, whom we might

better refer to as a "spatializer." This sensor responds to information about its position in a virtual three-dimensional grid (x, y, and z) as well as information that corresponds to rolls of the wrist (roll), tilts of the hand that move upward or downward from the wrist (elevation), and direction that the sensor is facing (azimuth[11]). It is no accident that some of this terminology sounds similar to that used in aviation, for the sensor is a serial device called the Patriot made for pilot training by Polhemus in the United States.[12]

The Patriot has been adapted for sound spatialization by mapping its six control parameters to all of the control parameters of the Spit software written in Max/MSP by Thigpen. To give a simple example, the performer can manually move the sound in the room by tracing his or her hand around a three-dimensional zone and, at the same time, roll his or her wrist to change the width of the stereo channels that he or she is moving. However, mappings are often less straightforward than this example indicates (particularly when controlling eight or more channels of input) and can be modified over the course of a piece simply by changing presets with the keypad of the computer. The name Spit is a variation on the Spat system for spatialization developed at l'Institut de Recherche et Coordination Acoustique/Musique (IRCAM) in Paris. Thigpen worked and taught at IRCAM for six years and made a Max/MSP patch for spatialization that was a leaner alternative (from a CPU resource point of view) to Spat. He compromised a bit on the believability of the illusion of distance created by Spat by removing the reverberation parameter of the software, very demanding for a computer to execute. However, he implemented some features that were not in Spat, such as random and drunk distributions of distance, azimuth, and, for NAISA, a new elevation parameter that sends the signal to four speakers located above the audience in addition to the eight in a circle at ground level.

The result is a much more dynamic spatialization experience that offers the potential of a visual correlation for the audience between what they see and what they hear — "potential" because, depending on the preferences of the spatializer and the needs of the piece, this visual correspondence can be very subtle and even indirect. The experience is similar to how a conductor mediates the audience's listening experience of a symphony orchestra, and to me this is far more meaningful for an audience member than watching someone interact with a laptop. Electroacoustic performance becomes a real-time interpretive act similar to the French acousmatic method of spatialization, which favours real-time manual performance over automation.

NAISA has started to develop a core group of spatializers who are experienced users of the Spit software patch and the Patriot controller. If a composer is unable to attend a performance (or perhaps is already performing in it on another instrument), then a "spatialization interpreter"

can assist. The interpreter adapts the listening experience of the work to the particular loudspeaker system and acoustic conditions of the hall but also to the social and ideological influences of the audience and spatializer. A good or bad spatialization will certainly have a direct influence on the audience's reception of the work, but of course the risk of failure is always part of any live performance in front of an audience.

Programming

NAISA does more than just concert performances using spatialization. It presents an amazing array of year-round activities, including installations, public sound sculptures, workshops, youth education, as well as web, CD, and print publications, to provide a comprehensive and adventurous immersion in sound art for Toronto audiences.

When NAISA began in 1998, there was no audience for electroacoustic music in Toronto. A handful of people were following the tradition, but that is not enough on which to stake an organization's identity. Drawing on my experiences in other Canadian and European cities, our presentations were designed to attract a new public for whom we would create "new adventures in sound" (our original name). This concept of a new adventure has also dictated the relationships that we have forged with the artists whom we have programmed. No matter how established and experienced an artist is, we have always tried to make his or her visit to Toronto an occasion to try something different or new. In addition to offering our unique spatialization system, we have tried to engage artists in projects that stretch them creatively.

Over the years, NAISA has commissioned radiophonic and installation works from theatre and visual artists, and we have had acousmatic artists collaborate with producers of the CBC Radio program *Outfront* on spoken narrative works.[13] NAISA has initiated large-scale projects, such as the two permanent outdoor sound sculptures by Barry Prophet and the team of Kristi Allik and Robert Mulder commissioned for Toronto Island. Established acousmatic artists, including Francis Dhomont, have made works specifically for alternative live spatialization techniques. Dhomont's collaboration revolved around David Eagle's aXio controller, using a palm-rest joystick controller for live spatialization, and this first inspired me to develop the gestural real-time spatialization system for NAISA discussed above.

Our diverse activity marks our commitment to comprehensiveness. Sound art need not be limited to the concert hall. It can be encountered not only on CD, the web, and radio but also in less likely places such as a park on Toronto Island or a public washroom in Toronto's historic Gladstone Hotel (where we hosted the Radio Art Salon during our Deep Wireless festival in May 2008). Electroacoustic sound (as communication) envelops

us everywhere, so why not consider the entire spectrum of environments as potential platforms for artistic presentation?

Our open approach does create certain challenges. Cultural agencies and city officials are sometimes unduly concerned about mounting sound presentations in public spaces. Officials can underestimate the openness of the public, perceiving our proposals as potentially "harmful" or "annoying." One of our earlier site-specific presentations was at Metro Square in downtown Toronto for John Wynne's piece *Response Time*, an octophonic sound installation that places electronic alarm sounds in public parks.[14] City officials were initially very nervous about hosting an installation of alarm sounds over four days; however, by the conclusion of its short run, the public response was so encouraging that the individual managing Metro Square wanted the installation to continue longer. Unfortunately, the cost of running the installation was too high to fulfill this request, because we had to address other concerns of the City of Toronto over cables running through an outdoor square by using expensive wireless loudspeaker systems. Needless to say, this experience confirmed my suspicion that ordinary people are happy to engage with sound art, and we need to give them more credit than we normally do. If the work is good and aesthetically suitable for the context, then people will get it.

Indeed, the presence of technology in public installations provokes curiosity. In our society, people are comfortable with exploring technology since they do it all the time with the latest pocket-sized music gizmo or cell phone. At one time, I thought that it was necessary to hide technology from the audience, but now its presence is a selling point — an area of mutual interest between audience and artist. After all, sound artists are not the only ones conversant in contemporary technology: their preoccupation is shared across all areas of business, art, and science.

Toronto as an Immersive Environment for Sound Art
One could argue that NAISA has created an "immersive environment" for sound art out of a city (Toronto) that up to now has not offered much institutional support for electroacoustic music. NAISA has been able to reach new and more "general" audiences for sound art without compromising the work or its standards of presentation.

Historically, Toronto has been a city of isolated individuals and tightly knit groups. Despite its much-vaunted multiculturalism, there are few examples of city-wide community action that transcend both ethnicity and geography. The city is physically sprawling compared with most European cultural centres and perhaps even New York, Boston, or Montreal. When NAISA started, individual artists were active full time in electroacoustic music — Randall Smith, John Oswald, and Wende Bartley — but there was

no full-time presenting organization or academic institution for sound art in Toronto. There was no platform on which a community could be built, and thus activity in electroacoustic music and sound art was staked on the reputations of a few individuals.

The absence of a full-time Toronto presenter was a void that NAISA felt compelled to fill in order to help define a Toronto scene for sound art that matches the city's own diversity. Given the lack of full-time programs for electroacoustic sound art at the local universities, an independent, non-profit presenting organization seemed to be a viable solution. Fifteen years earlier we might have formed an artist-run production centre,[15] but the affordable cost of technology in the late 1990s suggested that the lack of participation in sound art was not about access to technology but simply about awareness. Building knowledge and awareness of sound art had to become the focus, and public presentation was one way to achieve that goal.

Even though NAISA has amassed a mailing list of over 1,000 subscribers to its electronic newsletter, the *NAISA Sound Channel*, I work from the assumption that the audience for electroacoustic music can be greatly expanded.[16] There are many entertainment and cultural choices for the 5 million people who live within one hour's drive of downtown Toronto, but NAISA looks at itself as offering an exceptional alternative to the cultural offerings available to residents. We are now developing new audiences with our move to the Artscape Wychwood Barns, situated in an artistic community that nevertheless has few local cultural events — something that NAISA aims to help correct. Therefore, newcomers are in our midst all the time — even in our own backyard.

NAISA first established itself in Toronto with the presentation of Sound Travels on Toronto Island, a traditional summertime haven for city dwellers that is a cool and affordable escape from the trappings of a big city in the hot summer weather. It is pleasant and quiet rather than noisy and annoying. It is car free rather than car obsessed. It is a place where people visit with an open mind rather than a judgmental attitude.

In this context, NAISA has brought sound art to the public both with permanent outdoor sound sculptures and with guerrilla-style experimental music performances whose small portable format we use to intersect with the walking paths of the island tourists — people from all cultures, ages, and levels of familiarity with sound art. These intersections serve to raise artistic awareness among the public, which is beneficial for NAISA but also for the island's arts-centred residential community. Sound art contains plenty of real-world references (whether from recorded sounds or from mechanical structures), and people from all walks of life can draw on personal experiences when they encounter sound art for the first time. Another attribute of the island is that its car-free soundscape reduces the negative impact of

acoustic masking on outdoor sound production. This allows subtler listening experiences to be better appreciated, for there is less competition for the attention of the audience member. The outdoor surroundings also provide an enhanced awareness of a physical, social, and environmental context that audiences new to the form can apply to their interpretations of sound art.

Sound Travels' eight-channel spatialization performances occurred outdoors annually from 2000 to 2002, but the high cost of outdoor event production made it difficult to sustain that experience over a longer period of time. Thankfully, there is a small, beautiful, wooden Anglican church on the island that has been very supportive of NAISA's activities. St. Andrew-by-the-Lake offers a wonderful acoustic and an intimate atmosphere to make the indoor electroacoustic experience no less of a treat than the previous outdoor productions. These presentations have occurred in conjunction with outdoor site-specific performances that generally do not use loudspeaker systems. Instead, these performances use acoustic or portable sound sources to create more one-to-one relationships with audiences and performers and to challenge the public's awareness of sound in the everyday soundscape.

Collaboration

Earlier I referred to a wider range of options available to me as an artist because of my curatorial activities. I do not just pick artists to present. I pick artists to work with and ultimately be influenced by. My role as artistic director at NAISA does not stop when the artist arrives in Toronto. I also serve as an audio technician, and in this capacity I work closely with the artist to make sure that what the audience experiences reflects the artist's intentions — while at the same time introducing the artist to spatialization practices that might be unfamiliar. Through this direct personal collaboration, and simply by hearing the work over and over, I get access to many aspects of a work and its creator. I learn ways of organizing ideas. I learn which technical issues are important to some artists yet unimportant to others. Being an artistic director is the greatest long-term education for me, for I prefer to learn by doing. From the point of view of furthering my personal compositional technique, I do not think that I could imagine a better environment for development.

Diversifying the Field

In 2003, I published a "state of the art" essay about audiences and funding for electroacoustic music. In the article, I proposed the following questions: "Will electroacoustic music flee its academic routes and assimilate itself into the alternative streams of mainstream westernized culture? Or will it remain steadfast to the avant garde cause, and maintain its artistic integrity continuing to subsist in cultural obscurity?"[17] I suggested that the future for

electroacoustic music lay in developing new, general, and especially young audiences. Enough has changed in the past decade among youth (with the ubiquity of mp3 listening, YouTube, Facebook, etc.) that the critical issues facing sound art might also have changed.

The project of finding new listeners for electroacoustic music and sound art is still at an early stage. NAISA has started a youth education initiative in which high school-aged youth get the opportunity to think about electronics and computers not just as tools of sonic consumption but also as tools for sonic expression. Arguably, although young people today listen to a wider quantity and variety of music than the generations of youth before them, they are also less active in the creation and performance of music in the "classical" conservatory context. However, youth (from turntablists to circuit benders to video game hackers) are often experts at subverting audio technology by developing new instruments of expression that were originally conceived as instruments for consumption. NAISA is capitalizing on this zeitgeist by teaching youth how to solder and assemble basic electronics. Consumer electronics gadgets can be demystified by building a NAISAtron, a small electronic synthesis instrument that uses three light sensors that control three square wave oscillators.[18] NAISA is also teaching young people to build radio transmitters and to record and edit sounds using inexpensive hardware devices and software tools that are compatible with their home computers. Our workshops are interconnected; for instance, the NAISAtron can be recorded and transformed using computer software to make radio art that uses micro-radio transmissions alongside the performance of live NAISAtrons — and that is just one of the many possible permutations that we offer to participants.

Digital audio is spawning a new generation of creative artists, but institutions are slow to catch up. I was fortunate to be the beneficiary of affordable consumer-level audio gear in the 1980s, and I learned at a formative point in my life how to express myself through technology before I began serious study and practice of music or sound art. With our educational program, we want to get serious young musicians and artists creating sound art before they get to university, partly so that the work they produce in university is of a higher standard, but also so that the idea of specializing in sound art is an option available to them when they apply for university studies. One reason that universities in the Toronto area do not offer full-time programs for sound art is a lack of critical mass. There is just not enough awareness or interest among the public to support it. Promoting exploration of the art form among young people might help to encourage universities to offer full-time programs not just for music technology but also for sound art.

And, of course, new listeners and practitioners are defined not only by age but also by other cultural factors. When I go to my local music store in Brampton to rent a piece of audio gear, the customer next to me is not

usually of European descent. Yet, when I look at the established roster of sound artists, they are almost invariably of European heritage. The same goes for the faces that I see in the audience at sound art performances (and for contemporary classical music in general). My experience at the music store tells me that access to technology is not the issue. In fact, high school-aged youth whom we have worked with at our workshops in higher-risk neighbourhoods of Toronto typically come with a high level of comfort with computers and audio gear. The question then becomes how to make sound art a relevant tool of expression for people of all cultures and socio-economic positions in a diverse city such as Toronto. What can sound art express socially that hip hop cannot? What is the bridge to a new sound art that is relevant to a contemporary social demographic?

CONCLUSION

Both my practice as a sound artist and my activities as a curator try to build access points for people from all walks of life to immerse themselves in sound art as much as they immerse themselves in the latest indie rock band, DJ artist, or classical performer. This can be achieved in a number of ways, as I have discussed in this chapter. I support a diverse and comprehensive range of activity as a curator and take great care as both a curator and a composer in shaping the presentation experience for both concerts and installations so that the works I present communicate to all listeners, not just a select few. I also work to create presentation sites for performances and installations that intersect with the public: one of the great things about these sorts of events is that they do not require much publicity — they just need to be well located and well signed.

My concern about audience accessibility might be a by-product of the fact that both NAISA and my individual professional activity in Toronto have operated without the assistance of academic institutions. A significant portion of funding for NAISA (and my individual practice) comes from government arts grants. This funding does not come with the kind of built-in infrastructure and marketing support available to major institutions, and it places a justifiable demand on the organization to reach a diverse audience with its public programming. Consequently, NAISA has had to devise cost-effective strategies for designing spatialization systems and reaching the public that would not necessarily have been the first options in an academic context.

It is important to underline that there are both artistic and social reasons for diversifying audiences. Let me return to my earlier comments on environmental sounds. The great thing about these sounds and the experience of sound in a physical space is that they relate to the most basic listening experiences of any hearing person and require no assumed musical train-

ing or experience to appreciate. The fact that one does not require musical training to appreciate environmental sounds and, I would even say, to start creating sound art should open the door to participation by a more diverse community. Consequently, further discussion might need to focus on the choices of sounds used by sound artists and the degree to which they open or close doors to those unfamiliar with the practice.

NOTES

1 The French composer Pierre Schaeffer was the founder of *musique concrète* in the late 1940s and early 1950s at the Groupe de Recherches Musicales at Radio France in Paris. His book *Traité des objets musicaux* (Paris: Le Seuil, 1966) is the seminal text for acousmatic art. R. Murray Schafer founded the World Soundscape Project in the late 1960s at Simon Fraser University in Burnaby, British Columbia, and authored *The Soundscape: Our Sonic Environment and the Tuning of the World* (Rochester, VT: Destiny Books, 1994), which continues to have a formative impact on soundscape artists and people active in the interdisciplinary field of acoustic ecology.

2 Luc Ferrari, *Presque rien* (CD: MUSIDISC 245172, INA-GRM, 2008); Denis Smalley, "Spectro-Morphology and Structuring Processes," in *The Language of Electroacoustic Music*, ed. Simon Emmerson (London: Macmillan, 1986): 61–93; Trevor Wishart, *On Sonic Art* (York, UK: Imagineering Press, 1985).

3 Darren Copeland, "Associative Listening," *Soundscape: The Journal of Acoustic Ecology* 1, 1 (2000): 23.

4 I am referring here to responses stated in personal conversations following concert performances, broadcasts, and CD listening. The range of responses is also evident in published reviews of my works from the 1990s, some of which are documented at http://electrocd.com/en/cat/imed_9841/critiques/.

5 Darren Copeland, "Cruising for a Fixing: In This Art of Fixed Sounds," *Musicworks* 61 (1995): 55. See also Copeland, "Associative Listening." Both articles are available at http://www.darrencopeland.net/essays.html.

6 Douglas Kahn, "Introduction: Histories of Sound Once Removed," in *Wireless Imagination: Sound, Radio, and the Avant Garde*, ed. Douglas Kahn and Gregory Whitehead (Cambridge, MA: MIT Press, 1994), 1.

7 Radio drama projects include adaptations of August Strindberg's *A Dream Play*, Gwendolyn MacEwen's *Terror and Erebus*, and Birger Sellin's autobiography *Ich will kein inmich mehr sein: Botschaften aus einem autistischen Kerker* (I Don't Want to Be Inside Me Any More: Messages from an Autistic Mind). Documentary projects include *Life Unseen* with Alex Bulmer and *The Toronto Sound Mosaic* with Richard Windeyer. Artists from outside music and sound art have been commissioned by New Adventures in Sound Art since 1998 to create radio art works for the Deep Wireless festival and installation works for Sound Travels and SOUNDplay.

8 The pedestrian bridge is located between the two buildings of the Metro Toronto Convention Centre. Passenger railway lines to Union Station run

underneath the covered bridge, and the trains are audible when they pass by. This installation was made in 2005 for the Toronto Art Fair as part of an exhibit of media art work called *Interactive '05*.

9 The Canadian Electroacoustic Community is a national organization founded in 1986 that provides outlets for communication and information exchange among its membership of professionals and people interested in electroacoustic music and sound art. From my understanding, more than half of the members have postal codes that start with the letter *H* for the Montreal area, which is a fair barometer for activity in Canada. See http://cec.sonus.ca/members/index.html.

10 In rectangular venues that prohibit circular seating, NAISA adopts an arena-style configuration with the audience on two sides facing the middle.

11 An azimuth is the angle from a reference vector in a reference plane to a second vector in the same plane, pointing toward (but not necessarily meeting) something of interest. For example, with the sea as the reference plane, the azimuth of the Sun might be the angle between due north and the point on the horizon that the Sun is currently over. An imaginary line drawn along the surface of the sea might point in the direction of the Sun but obviously would never meet it. See http://en.wikipedia.org/wiki/Azimuth.

12 Information on the Polhemus Patriot Sensor can be found at http://www.polhemus.com/?page=Motion_Patriot.

13 See http://www.cbc.ca/outfront/.

14 *Response Time* ran at Metro Square in August 2001 as part of the NAISA series Sound Travels. See http://www.naisa.ca/soundtravels/Older%20Pages/response.html.

15 One such example in Toronto is the Interaccess Electronic Media Arts Centre; see http://www.interaccess.org.

16 E-mail naisa@naisa.ca to receive the *NAISA Sound Channel* on a monthly basis.

17 Darren Copeland, "Survival Strategies for Electroacoustic Music," *Circuit* 13, 2 (2003): 59–65.

18 The NAISAtron was designed by media artist Robert Cruickshank. It is available for order at http://naisa.ca/NAISAtron.html.

CHAPTER FOURTEEN

Artist Presentation:
Journeys of the Human Spirit

Barry Truax

For my artist presentation at the 2007 Art of Immersive Sound-scapes conference, I invited the audience to join me on a series of four imaginary journeys provided by a set of octophonic works that I have collectively titled *Spirit Journies* and that have since been released on CD. This listening experience was intended to complement my keynote presentation on soundscape composition and what interdisciplinary knowledge is available about the perception of acoustic space.[1] Our current ability to document and re-create soundscapes, and to extend them with digital signal processing and multichannel playback systems, gives artists and researchers powerful tools to experiment with the creation of virtual acoustic spaces.[2] Moreover, audiences have responded enthusiastically to the experience of being immersed in a three-dimensional acoustic space that both re-creates and extends their experience of everyday soundscapes.

For many years, I have been interested in the challenge of creating large-scale musical works, something that the current situation of the marginalized art form of electroacoustic music does not encourage. The typical duration of works selected for concerts is from ten to fifteen minutes in North America

See DVD — Barry Truax — for fifteen sound examples and excerpts from Spirit Journies.

and somewhat longer in Europe. The pragmatic alternative for me has been to create works in pairs and larger sets that individually are self-contained but together allow me to explore various aspects of the central concept. I have also ventured into the field of opera with my *Powers of Two*, but the difficulty of securing a production (typically a ten-year process) unfortunately prevents this path from being viable. Over twenty years ago, when I created my own Cambridge Street Records (CSR) label and started producing my own discs, I was able to control the entire process of composing the disc and the pieces on it. My previous LPs (*Sonic Landscapes* and *Androgyne* from 1977 and 1980 respectively) had themes but were essentially collections of recent works. However, in 1985, with *Sequence of Earlier Heaven*, the first CSR publication and the last LP, I was able to present a set of four works, two per side, which included pieces inspired by the *I Ching* and one of its patterns of trigrams.[3] I even exploited the two sides of the LP in a yin-yang manner by placing the complementary works for instruments and tape on one side (*East Wind* and *Nightwatch*) and the two digitally synthesized pieces (*Wave Edge* and *Solar Ellipse*) on the other. Each piece was inspired by a particular hexagram, and its title reflected the imagery of the *I Ching* (wind, earth, water, fire) and the directions of the compass (north, east, south, west). Two decades earlier Morton Subotnick had been the first to compose electronic music specifically for disc (commissioned by Nonesuch and Columbia), but conventional practice by most composers has been to regard the compact disc as a means of distributing works rather than a format for composition.

My first CD, *Digital Soundscapes* (1987), was admittedly a collection of previous works loosely linked under the soundscape concept (including the analog studio work *The Blind Man*), but thereafter, in CDs such as *Pacific Rim* and *Song of Songs*, I developed a specific theme or brought together works related by their approach to sonic materials, such as text-based pieces (*Twin Souls*) and soundscape compositions (*Islands*). Therefore, around 2002, when I started thinking about some new compositional directions for my eight-channel pieces, the idea that they should work within a larger framework was firmly established in my mind. Four years later the set of pieces was complete and ready to be issued on a CD, along with an introductory work, *Steam*, for alto flute and tape, which had recently been remixed and could act as a kind of overture. The four works are *Temple* (2002), *Prospero's Voyage* (2004), *The Shaman Ascending* (2004–05), and *The Way of the Spirit* (2005–06), each of which represents a journey through acoustic space and time, based on different cultural contexts: spiritual, secular, Aboriginal, Asian. These then were the four octophonic pieces presented together at the Art of Immersive Soundscapes event in Regina, the first such occasion where they could be presented as a set.

In my introduction to the audience, I mentioned that the word *spirit* in the collective title referred to the human spirit, one aspect of which might be described as spiritual or religious. The manifestations of the human spirit through art and culture have been so varied over time and across cultures that any specific references are arbitrary, but the ones that I chose have resonated deeply with me. The first two pieces, *Temple* and *Prospero's Voyage*, are drawn from the European traditions of spirituality and humanistic thought respectively. *The Shaman Ascending* was inspired by Inuit throat singing and the shamanistic traditions of Canada's arctic region, and *The Way of the Spirit* was prompted by Zen Buddhist aesthetics from Japan.

Temple is composed of choral voices and appears to take place in the reverberant cathedral of San Bartolomeo in Busetto, Italy. See Figure 14.1. This effect is achieved by convolving the three studio-recorded voices (countertenor, alto, bass) with the impulse response of the cathedral, which makes the voices appear to have been recorded in that space.[4] Mixing and multitracking create the impression of a large choir at various points in the piece, often with movement around the listener. Because the original recordings were mainly of individual pitches and short phrases, the musical content is somewhat neutral (possibly reminiscent of a spare Medieval style), except for the third section, in which the bass voice's multiphonic singing might suggest Tibetan chanting. However, lacking any specific Christian reference other than the cathedral acoustics, the work might be heard as a spiritual voyage in an imaginary temple (the choice of title deliberately being the more general term) whose acoustic properties not only reverberate the choral voices but also reflect them back as ghostly after-images that suggest an inner space of vast dimensions. These after-images are created by convolving each voice with itself in order to bring out only the prominent frequencies in the voice and double their duration, hence creating an image somewhere between the embodied voice and the reverberation of the space.

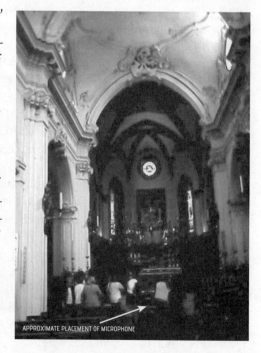

APPROXIMATE PLACEMENT OF MICROPHONE

Figure 14.1 San Bartolomeo Cathedral, Busetto, Italy

The presence of this disembodied element, as well as the complex spatial movements of the various sounds, extend the work from being merely a recording of a possible choral event to the realm of the imagination. To enhance this journey, each of the middle sections moves away from the realistic voice material via granular time stretching before returning to unaltered voices in the next section. By the end of the work, all of the voices are reduced to their most prominent harmonics to create an ethereal and timeless ending.[5]

Prospero's Voyage returns to the mythical island of my piece *Island* (2000) except that this time it is Prospero's island from Shakespeare's *The Tempest*. The work begins with a Shakespearean actor, Christopher Gaze, intoning Prospero's final speech from the play, "Now are my charms all o'erthrown ...," which culminates with the phrase "Let your indulgence set me free." Hence, the premise of the piece is what happens after Prospero leaves the island. Before he leaves, however, there is a rainstorm and a scene in which he circles the listener intoning a fragment of the speech from the play. In the next scene, he walks toward the beach, and with a final incantation he enters the water and is submerged by it. His underwater voyage is interrupted by several "surfacings," but eventually this underwater dream world leads to a very distant place where the piece concludes with Macbeth's speech that ends with "to the last syllable of recorded time."[6] In other words, the work can be interpreted as a voyage of the imagination in which Prospero, symbolizing the creative powers of the artist, leads us through the depths of the imagination to its furthest point. It is a lonely journey that is occasionally terrifying ("a tale told by an idiot ... signifying nothing") but ultimately one that accepts the human condition of what it means to be conscious in a vast universe.[7]

The Shaman Ascending and its title were inspired by a pair of Canadian Inuit sculptures (*The Shaman* and *Antler Face*) by John Terriak from Labrador with collectively the same title, as well as by Inuit throat singing. The sculptures depict a shaman's face that, as it ascends through the spaces in the antler, becomes more radiant, a progression that I interpreted as the shaman's ascent toward a state of spiritual ecstasy. In one of those moments of fortuitous synchronicity, my partner acquired the sculptures while I was about a third of the way through composing the piece, and the two works instantly became bonded in my mind. See Figure 14.2.

The aural effect of the eight-channel version of the piece is difficult to describe, but technically it is achieved by having the AudioBox, a digital signal processor that controls not only mixing levels but also the spatial trajectories of each of its sixteen input channels onto eight or sixteen output channels, spin all of the sound material around the listener at high rates. All of the sound in the piece is derived from two samples sung by the

same bass voice that I used in *Temple* (Vancouver bass Derrick Christian). As the piece starts, small phonemic segments of his voice (100 millisecond [ms] duration followed by a 50 ms pause) are heard rotating around the eight speakers, one segment per speaker with no cross-fade between them, such that after 1.2 seconds the pattern has completed a full rotation around the listener. However, as more of the eight tracks are added (in a pattern such that each speaker has only one phonemic segment at any one instant), the listener can no longer follow individual rotations but instead experiences a vibrating sound mass. Other rotational

Figure 14.2 *The Shaman* and *Antler Face*, John Terriak sculptures.

speeds are used with shorter phonemes (50 ms), the fastest being 100 ms per speaker (producing a complete rotation every 0.8 second) as well as 200 ms. The patterns can proceed clockwise or counterclockwise, either advancing by a single speaker or skipping two speakers (e.g., the speaker sequence 1 4 7 2 5 8 3 6 1 ...). Other processes used to treat the voice are granular time stretching at the original pitch and down an octave, along with convolution that brings out the voice's inner harmonics, particularly with the multiphonic singing. In several sections, hearing these pure harmonics emerge out of the vibrating vocal sound mass symbolizes the "ascent" referred to in the title. As with *Temple*, at the end of the piece, only the harmonics are left. At the premiere at ZKM Centre for Art and Media in Karlsruhe, Germany (which commissioned the work), the harmonics were projected onto a high ring of speakers above the audience, greatly adding to the effect.[8]

The final piece in the sequence, *The Way of the Spirit*, is my second collaboration with Asian music specialist and improvising composer-performer Randy Raine-Reusch. Our first collaboration, *Bamboo, Silk, & Stone* (1994), established the practice in which I would compose the tape part of the piece from recordings of instruments in his extensive collection and he would

then create an improvised live part to interact with the prerecorded and processed material. The lack of a fixed score for the piece allowed him, and later his partner, Mei Han, who specializes in performing on the Chinese *zheng* (a type of zither), to create alternative versions of the piece, such as solo and duo *zheng* performances. In 2005, Randy suggested that we explore his long experience with Japanese instruments associated with Zen Buddhist traditions to create a new work. As a result, all sounds in the piece are derived from the two live instruments: the deeply philosophical Japanese one-string *ichigenkin* and the *shakuhachi* end-blown flute, both associated with Zen for their expressions of the duality of life and spirit, simplicity and complexity, materiality and immateriality. The inherently disembodied quality of the processed sounds seemed to be a perfect representation of the Zen concepts. In an era of globalization, it is tempting for composers to borrow from (or some would say "dabble in") cross-cultural traditions, and there have been some thoughtful criticisms and proposed guidelines on the subject.[9] However, despite my misgivings about my ability to understand and be respectful of these Japanese traditions, I felt that I was in good hands working with Randy, who had studied them in Japan with the masters of the instruments for several decades. Although Zen concepts such as *mah* are notoriously difficult to translate into English, I felt guided by the emphasis on asymmetry, the importance of silence and spacing of events, the lack of repetition, and even a tolerance for the unintended or "irrational" gesture. The compositional techniques followed a pattern similar to those in the previous pieces, such as time stretching, and the repeated use of convolution on a single sound that progressively removed noise from the source material (the breathiness of the *shakuhachi* and the hard attack of the *ichigenkin* string) until only the fundamental vibration of the tube or string remained.

Given that *The Way of the Spirit* is the only piece of the set to involve a live performer, its realization in a performance of the entire cycle, as well as the manner of its recording, present interesting challenges. The piece is the last in the cycle, not simply because it was the last to be realized, but also because I thought that this deeply introspective piece presented the most challenging of the "journeys" in terms of the subtle and possibly unfamiliar concepts involved. Randy was unable to be present in Regina to perform the piece live, but fortunately we had just completed a studio recording of the live part, so it could be projected onto the front speakers as a kind of virtual presence of the performer. Given the sensitive interaction of the live performer with the tape, I abandoned my usual studio practice of piecing together on multitrack tape the "best" version of each section of a piece, down to individual phrases. Instead, we recorded the piece all the way through three times, each inherently different in improvisational details, and then selected a minimum number of switches among preferred versions,

in essence the *ichigenkin* parts from one take and the *shakuhachi* parts from another complete performance (where the two instruments alternate). On the *Spirit Journies* CD, the ending with Randy's *shakuhachi* performance nicely complements the opening track with the breathy alto flute in *Steam*.[10]

In conclusion, I thought that this unique opportunity to present a set of four works lasting a little over an hour was one of the best concert experiences that I have ever participated in as a composer. The balanced ring of speakers set up by Charlie Fox provided a clear, well-defined, omnipresent, and omnidirectional experience for the audience in the intimate space of the black box theatre. I introduced each piece before it began and responded to any comments or questions from the previous performance, and perhaps because most of the audience had spent the previous few days together at the conference the entire atmosphere was informal, intimate, and felt more like a family get-together than an impersonal public concert. The sustained mood over the four pieces seemed to encourage a deeper, more thoughtful, and more sensitive reaction than might be expected in the more usual smorgasbord approach of even an expertly programmed concert. The feedback from the audience was tremendously encouraging, particularly the positive comments about *The Way of the Spirit*, which I worried might be the most difficult work in the set to appreciate. However, I am convinced that its positive reception (many said that it was their favourite piece) can be attributed in part to the context of the entire presentation that led up to its inclusion.

Later that year the CD version with the stereo reduction of all the pieces was issued. The CD has the advantage of repetition and choice of listening environment, along with short program notes, but of course it lacks the intensity of the octophonic experience and the presence of the live performer and real-time diffusion control. These are essentially two different presentation formats, and it might be a personal preference which is more effective. Personally, I find both formats far more satisfying than the "disposable mp3 download" practices that are the norm today, though clearly my music will not reach as wide an audience since there are few means to create that kind of audience and little external support beyond our own efforts as a community. Still, I find optimism in the possibility that an alternative experience is possible for an audience, and there is a reason for them to come to a live presentation, one that clearly surpasses even a 5.1 home theatre format. But even if we can attract such an audience, what "content" can we provide? Clearly, the almost tactile immediacy of the immersive aural experience is extremely convincing, but what I also hope to provide is the kind of sustained artistic stimulation that can engage the listener, not just aurally, but also in terms of larger cultural issues. Soundscape composition is a powerful way to do this, and I find it satisfying that digital technology can be used to extend traditional discourses, such as the four referenced here.[11]

1 See Barry Truax, "Techniques and Genres of Soundscape Composition as Developed at Simon Fraser University," *Organised Sound* 7, 1 (2002): 5–14; and Barry Truax, "Soundscape Composition as Global Music: Electro-acoustic Music as Soundscape," *Organised Sound* 13, 2 (2008): 103–09.

2 Barry Truax, "Composition and Diffusion: Space in Sound in Space," *Organised Sound* 3, 2 (1998): 141–46.

3 Barry Truax, "*Sequence of Earlier Heaven*: The Record as a Medium for the Electroacoustic Composer," *Leonardo* 20, 1 (1988): 25–28.

4 See Barry Truax on the accompanying DVD. The first four audio examples demonstrate how vocal recordings and resonance combine to virtually place the voice in the acoustic of San Bartolomeo Cathedral, Busetto, Italy: 1. Vocal-ize (Sue McGowan, alto, recorded in the Sonic Research Studio, Simon Fraser University); 2. Impulse response (recorded in San Bartolomeo Cathedral); 3. Convolution of vocalize with San Bartolomeo impulse response; 4. Convolu-tion of vocalize with itself and San Bartolomeo impulse response.

5 This progression can be heard on three excerpts included on the DVD under *Journeys of the Human Spirit*: *Temple*, opening, *Temple*, section 3 opening (Derrick Christian, bass), *Temple*, ending.

6 My choice of Macbeth's speech might seem strange, but I have always found this particular speech more philosophical and Prospero-like than someone capable of regicide!

7 See Barry Truax on the accompanying DVD for two excerpts from *Prospero's Voyage*: the opening and the final section.

8 See Barry Truax on the accompanying DVD for excerpts from the opening and the ending of *The Shaman Ascending*.

9 See Robert Gluck, "Between, Within, and Across Cultures," *Organised Sound* 13, 2 (2008): 141–52.

10 See Barry Truax on the accompanying DVD for excerpts from *The Way of the Spirit* featuring Randy Raine-Reusch playing *ichigenkin* and *shakuhachi*.

11 More information on all of the CDs, works, and technical concepts referred to here can be found at www.sfu.ca/~truax.

Works Cited

Altena, Arie, ed. *Unsorted: Thoughts on the Information Arts: An A to Z for Sonic Acts X.* Amsterdam: Sonic Acts/De Balie, 2004.

Benjamin, Walter. *Selected Writings.* Translated by Edmund Jephcott et al., edited by Howard Eiland, and Michael W. Jennings. Vol. 4, 1938–40. Cambridge, MA: Harvard University Press.

Blesser, Barry and Linda-Ruth Salter. *Spaces Speak, Are You Listening?* Cambridge, MA: MIT Press, 2007.

Braun, Marta. *Picturing Time: The Work of Etienne-Jules Marey 1830–1904.* Chicago: University of Chicago Press, 1995.

Brett, Philip, Elizabeth Wood, and Gary C. Thomas, eds. *Queering the Pitch: The New Gay and Lesbian Musicology.* New York: Routledge, 1994.

Busch-Vishniac, Ilene J. "Noise Levels in Johns Hopkins Hospital." *Journal of the Acoustical Society of America* 118, no. 6 (2005): 3629–3645.

Calvino, Italo. *Invisible Cities.* Translated by William Weaver. London: Vintage, 1972.

Cascone, Kim. "Laptop Music: Counterfeiting Aura in the Age of Infinite Reproduction," *Parachute* 107 (2002): 52–67.

Carlyle, Angus, ed. *Autumn Leaves: Sound and the Environment in Artistic Practice.* Paris: Association Double-Entendre in association with CRISAP, 2007.

Cecchinato, Manuel. "Il Suono Mobile. La Mobilità Interna Ed Esterna Dei Suoni." In *La Nuova Ricerca sull'opera Di Luigi Nono*, edited by Borio, Gianmario, Giovanni Morelli and Veniero Rizzardi. Firenze: Leo S. Olschki, 1999.

Connell, John. *Soundtracks: Popular Music, Identity, and Place.* New York: Routledge, 2002.

Cope, David. *Computers and Musical Style.* Madison: A-R Editions, 1991.

Copeland, Darren. "Associative Listening." *Soundscape: The Journal of Acoustic Ecology* 1, no. 1 (2000): 23–25.

———. "Cruising for a Fixing: In this Art of Fixed Sounds." *Musicworks Magazine* 61 (1995): 51–53.

———. "Survival Strategies for Electroacoustic Music." *Circuit* 13, no. 2 (2003): 59–65.

Corringham, Viv. "Vocal Strolls." *Musicworks Magazine* 86 (2003): 22–27.

Cowell, Henry. "The Joys of Noise." *The New Republic,* 1929.

Cox, Christoph and Daniel Warner, eds. *Audio Culture: Readings in Modern Music.* New York: Continuum International Publishing Group, 2005.

Cubitt, Sean. *Ecomedia.* Amsterdam: Rodopi Press, 2005.

Cummings, Jim and Steven M. Miller. "Editorial." *Soundscape: The Journal of Acoustic Ecology* 7, no. 1 (2007): 1.

Suzanne Cusick, "On a Lesbian Relationship with Music: A Serious Effort Not to Think Straight." In *Queering the Pitch: The New Gay and Lesbian Musicology,* ed. Philip Brett, Elizabeth Wood, and Gary C. Thomas. New York: Routledge, 1994.

Dalziel, Kate. "A Patient's Perspective." In *Transplant,* edited by Victoria Hume. London: rb&hArts, 2008.

DeBord, Guy. *The Society of the Spectacle.* Cambridge, MA: Zone Books, 1995.

Desjardins, Gregory, ed. *Sound Works. Volume I: Inscription.* Ostfildern: Cantz Verlag, 1994.

Dillard, Annie. *Pilgrim at Tinker Creek.* New York: Harper's Magazine Press, 1974.

Drobnick, Jim, ed. *Aural Cultures.* Toronto: YYZ Books/Walter Phillips Gallery Editions, 2004.

Emmerson, Simon, ed. *the Language of Electroacoustic Music.* London: Macmillan, 1986.

Fabbriciani, Roberto. "Walking with Gigi." *Contemporary Music Review* 18, no. 1 (1999): 7–15.

Fanstone, J. "Sound and Touch: A Campus GIS for the Visually Impaired." *GIS Europe* (1995): 44–45.

Feld, Steven. "Lift-Up-Over-Sounding." In *The Book of Music and Nature,* edited by David Rothenberg and Marta Ulvaeus. Middletown, CT: Wesleyan University Press, 2001.

———. "Waterfalls of Song." In *Senses of Place,* edited by Steven Feld and Keith H. Basso. Santa Fe: School of American Research Press, 1996.

Feld, Steven and Keith H. Basso, eds. *Senses of Place*. Santa Fe: School of American Research Press, 1996.

Forsyth, Michael. *Buildings for Music*. Cambridge, MA: MIT Press, 1985.

Gardner, Howard. *Frames of Mind*. New York: Basic Books, 1985.

Geertz, Clifford. "Afterword." In *Senses of Place*, edited by Steven Feld and Keith H. Basso. Santa Fe: School of American Research Press, 1996.

Ginsborg, Paul. *Storia d'Italia Dal Dopoguerra a Oggi: Società e Politica 1943–1988*. Milan: Einaudi, 1989.

Gluck, Robert. "Between, Within, and Across Cultures." *Organised Sound* 13, no. 2 (2008): 141–152.

Golledge, Reginald G., Jack M. Loomis, Roberta L. Klatzky, Andrea Flury, and Xiao Li Yang. "Designing a Personal Guidance System to Aid Navigation without Sight: Progress on the GIS Component." *International Journal of Geographical Information Systems* 5, no. 4 (1991): 373–379.

Haller, Hans Peter. *Das Experimentalstudio Der Heinrich-Strobel-Stiftung Des Südwestfunks Freiburg 1971–1989: Die Erforschung Der Elektronischen Klangformung Und Ihre Geschichte*. Baden-Baden: Nomos, 1995.

Harding, Anna, ed. *Curating: The Contemporary Art Museum and Beyond*. London: Academy Group, 1997.

Hayles, N. Katherine. "The Materiality of Informatics." *Issues in Integrative Studies* 10 (1992): 121–144.

Hellman, Stephen. *Italian Communism in Transition: The Rise and Fall of the Historic Compromise in Turin, 1975–1980*. Oxford: Oxford University Press, 1988.

Hume, Victoria, ed. *Transplant*. London: rb&hArts, 2008.

Jacobson, R. Daniel. "Talking Tactile Maps and Environmental Audio Beacons: An Orientation and Mobility Development Tool for Visually Impaired People." In *Proceedings of the International Cartographic Association Commission on Maps and Graphics for Blind and Visually Impaired People*." Ljubljana, Slovenia, 21–25 October, 1996. http://www.immerse.ucalgary.ca/publications/llub1.pdf.

Kahn, Douglas. "Introduction: Histories of Sound Once Removed." In *Wireless Imagination: Sound, Radio, and the Avant Garde*, edited by Douglas Kahn and Gregory Whitehead. Cambridge, MA: MIT Press, 1994.

———. *Noise, Water, Meat: A History of Sound in the Arts*. Cambridge, MA: MIT Press, 2001.

Kahn, Douglas and Gregory Whitehead, eds. *Wireless Imagination: Sound, Radio, and the Avant Garde*. Cambridge, MA: MIT Press, 1994.

Kam, P., A. Kam, and J. Thompson. "Noise Pollution in the Anaesthetic and Intensive Care Environment." *Anaesthesia* 49 (1994): 982–986.

Keidan, Lois. "Showtime: Curating Live Art in the 1990s." In *Curating: The Contemporary Art Museum and Beyond*, edited by Harding, Anna. London: Academy Group, 1997.

Kelman, Ari. "Rethinking the Soundscape: A Critical Genealogy of a Key Term in Soundscape Studies." *The Senses and Society* 5 (2010): 212–34.

Kepler, Johannes. *Epitome of Copernican Astronomy and Harmonies of the World.* Translated by Charles Glenn Wallis. New York: Prometheus Books, 1939; reprint, 1995.

Kiyooka, Roy. *Mothertalk: Life Stories of Mary Kiyoshi Kiyooka,* edited by Daphne Marlatt. Edmonton: NeWest Press, 1997.

———. *Pacific Rim Letter,* edited by Smaro Kamboureli. Edmonton: NeWest Press, 2005.

———. *Transcanada Letters.* Edmonton: NeWest Press, 2005.

Kramer, Gregory et al. "The Sonification Report: Status of the Field and Research Agenda." National Science Foundation, 1997. http://www.icad.org/websiteV2.0/References/nsf.html.

Landy, Leigh. *Understanding the Art of Sound Organization.* Cambridge, MA: MIT Press, 2007.

Lefebvre, Henri. *Critique of Everyday Life.* 3 vols. London: Verso, 2002.

———. *The Production of Space.* Translated by Donald Nicholson-Smith. Oxford: Blackwell, 2000.

Licht, Alan. *Sound Art: Beyond Music, between Categories.* New York: Rizzoli International Publications, 2007.

Lilles, Thomas M., Ralph W. Kiefer, and Jonathan W. Chipman. *Remote Sensing and Image Interpretation.* New York: John Wiley and Sons, 2008.

Lippard, Lucy. *The Lure of the Local: Senses of Place in a Multicentered Society.* New York: New Press, 1997.

Lynch, Kevin. *City Sense and City Design: Writings and Projects of Kevin Lynch.* Cambridge, MA: MIT Press, 1995.

———. *The Image of the City.* Cambridge, MA: MIT Press, 1960.

———. *What Time is this Place?* Cambridge, MA: MIT Press, 2001.

Marcuse, Herbert. *The Aesthetic Dimension: Towards a Critique of Marxist Aesthetics.* Boston: Beacon Press, 1979.

Mazer, Susan E. "Sound Advice: Seven Steps for Abating Hospital Noise Problems." *Health Facilities Management,* May 2002. http://www.healinghealth.com/d-resources/seven_steps.php.

Mockus, Martha. *Sounding Out: Pauline Oliveros and Lesbian Musicality.* London: Routledge, 2008.

Nash, P. H. and George O. Carney. "The Seven Themes of Music Geography." *Canadian Geographer* 40, no. 1 (1995): 69–74.

Nielinger, Carola. "'The Song Unsung': Luigi Nono's *Il Canto Sospeso.*" *Journal of the Royal Musical Association* 131, no. 1 (2006): 83–150.

Nightingale, Florence. *Notes on Nursing: What It Is and What It Is Not*. New York: D. Appleton, 1860.

Nono, Luigi. *Scritti e Colloqui. 2 Vols*, edited by De Benedictis, Angela Ida, Veniero Rizzardi. Milan: Ricordi, 2001.

———. "Le Sue Parole e Le Sue Grandi Drammatiche solitudini." *L'unità*, June 16, 1984.

O'Sullivan, Simon. "The Aesthetics of Affect: Thinking Art Beyond Representation." *Angelaki: Journal of the Theoretical Humanities* 6, no. 3 (2001).

Oliveros, Pauline. *Sonic Meditations*. Baltimore: Smith Publications, 1974.

———. "Tripping on Wires: The Wireless Body: Who Is Improvising?" *Critical Studies in Improvisation/Études critiques en improvisation* 1, 1 (2004): n. pag. http://journal.lib.uoguelph.ca/index.php/csieci/article/view/9/32.

Ouzounian, Gascia. "Embodied Sound: Aural Architectures and the Body." *Contemporary Music Review* 25, no. 1–2 (2006): 69–79.

Patterson, R. D. "Auditory Warning Sounds in the Work Environment." *Philosophical Transactions of the Royal Society of London*. Series B, Biological Sciences 327, no. 1241 (1990): 485–492.

Quinn, Martin. "The Climate Symphony: Rhythmic Techniques Applied to the Sonification of Ice Core Data." In *4th Annual Conference of the International Environment Forum*." Orlando, FL, December, 2000. http://www.bcca.org/ief/dquinooc.htm.

Rebelo, Pedro. "Haptic Sensation and Instrumental Transgression." *Contemporary Music Review* 25, no. 1–2 (2006): 27–35.

Reston, Maeve. "Storm Over Weather Service Initiatives." *Pittsburgh Post-Gazette National Bureau*, 26 April 2005.

Rice, Tom. "Soundselves: An Acoustemology of Sound and Self in the Edinburgh Royal Infirmary." *Anthropology Today* 19, no. 4 (2003): 4–9.

———. "Sound and the Boundless Body." In *Transplant*, edited by Victoria Hume. London: rb&hArts, 2008.

Riviere, Georges Henri et al. "Problems of the Museum of Contemporary Art in the West: Exchange of Views of a Group of Experts." *UNESDOC Museum* 24, 1 (1972). http://unesdoc.unesco.org/Ulis/cgibin/ulis.pl?catno=2576&set=493E742F_o_270&gp=o&lin=1.

Rizzardi, Veniero. "Notation, Oral Tradition, and Performance Practice in the Works with Tape and Live Electronics by Luigi Nono." *Contemporary Music Review* 18, no. 1 (1999): 47–56.

Robinson, Greg. *A Tragedy of Democracy: Japanese Confinement in North America*. New York: Columbia University Press, 2009.

Rossolo, Luigi. *The Art of Noises. Translated and with an Introduction by Barclay Brown*. [*L'arte dei rumori*]. Pennington: Pendragon Press, 1986, reprinted 2005.

———. *L'Arte Dei Rumori*. Milan: Edizioni futuriste di "Poesia," 1916.

Rothenberg, David and Marta Ulvaeus, eds. *The Book of Music and Nature*. Middletown, CT: Wesleyan University Press, 2001.

Ruscoe, James. *On the Threshold of Government: The Italian Communist Party, 1976–81*. New York: St. Martin's Press, 1982.

Sadler, Simon. *The Situationist City*. Cambridge, MA: MIT Press, 1998.

San Martín, Diputación Foral de Guipúzcoa, ed. *La Mirada Nerviosa: Manifiestos y Textos Futuristas*. Guipúzcoa: Arteleku, 1992.

Sandford, Mariellen R. *Happenings and Other Acts*. New York: Routledge, 1995.

Schaeffer, Pierre. *Traite Des Objets Musicaux*. Paris: Éditions du Seuil, 1966.

Schafer, R. Murray. *Our Sonic Environment and the Soundscape: The Tuning of the World*. Originally published as *The Tuning of the World* (New York: Knopf, 1977). Rochester, VT: Destiny Books, 1994.

———. *Patria: The Complete Cycle*. Toronto: Coach House Books, 2002.

Serfaty, Simon and Lawrence Gray. *The Italian Communist Party: Yesterday, Today, and Tomorrow*. Westport, CT: Greenwood Publishing Group, 1980.

Shixiang, Wang. "Pigeon Whistles make Aerial Orchestra." *China Reconstructs* 12, no. 11 (1963): 42–43.

Sinclair, Iain. *London Orbital*. London: Granta Books, 2002.

Skoltz, Dominique, and Herman Kolgen. *Silent Room*. DVD boxed set. Liner notes by Lucinda Catchlove. Montreal: SK Faktory, 2007.

Small, Christopher. *Musicking: The Meanings of Performing and Listening*. Middletown, CT: Wesleyan University Press, 1998.

Smalley, Denis. "Spectro-Morphology and Structuring Processes." In *The Language of Electroacoustic Music*, edited by Simon Emmerson, 61-93. London: Macmillan, 1986.

Stockhausen, Karlheinz. "…wie die Zeit vergeht…." *Der Reihe* 3 (1959): 13–42.

Strogatz, Steven H., Daniel M. Abrams, Allan McRobie, Bruno Eckhardt, and Edward Ott. "Theoretical Mechanics: Crowd Synchrony on the Millennium Bridge." *Nature* 438 (3 November 2005): 43–44.

Sturm, Bob L. "Sonification of Particle Systems Via De Broglie's Hypothesis." In *Proceedings of the International Conference on Auditory Display*." Georgia Institute of Technology, Atlanta, 2–5 April 2000. http://www.icad.org/websiteV2.0/Conferences/ICAD2000/PDFs/BobSturmICAD.pdf.

Taber, Christine, ed. *Sound, Space*. New York: Cantz Verlag, 1998.

Thoreau, Henry David. *Wild Fruits: Thoreau's Rediscovered Last Manuscript*, edited by Bradley P. Dean. New York: W. W. Norton, 1999.

Tittel, Claudia. "Sound Art as Sonification, and the Artistic Treatment of Features in our Surroundings." *Organised Sound* 14, no. 1 (2009): 57–64.

Toop, David. "The Art of Noise," *Tate etc* 3 (2005). http://www.tate.org.uk/context-comment/articles/art-noise.

———. "Depths and Clamour; Inside and Outside." In *Transplant*, edited by Victoria Hume. London: rb&hArts, 2008.

Truax, Barry. *Acoustic Communiication*. 2nd ed. Portsmouth, NH: Greenwood Press, 2001.

———. "Composition and Diffusion: Space in Sound in Space." *Organised Sound* 3, no. 2 (1998): 141–146.

———. *Handbook for Acoustic Ecology*. CD-ROM edition, v. 1.1. Vancouver: Cambridge Street Publishing, 1999.

———. "*Sequence of Earlier Heaven*: The Record as a Medium for the Electroacoustic Composer." *Leonardo* 20, no. 1 (1988): 25–28.

———. "Soundscape Composition as Global Music: Electroacoustic Music as Soundscape." *Organised Sound* 13, no. 2 (2008): 103–109.

———. "Techniques and Genres of Soundscape Composition as Developed at Simon Fraser University." *Organised Sound* 7, no. 1 (2002): 5–14.

Tufnell, Ben and Andrew Wilson. *Hamish Fulton: Walking Journey*. London: Tate Publishing, 2002.

Vaidhyanathan, Sive. *The Anarchist in the Library*. New York: Basic Books, 2004.

Walker, Curtis. "The Disappearing Artist: The Creative Act of Listening to Microsound and Glitch." MA thesis, Trent University, 2004.

Waterman, Ellen. "Revisiting Haraway's Cyborg: The Non-Innocent Music of Ellen Waterman." *Vague Terrain* Fall (2006). http://vagueterrain.net/vt-journal.

Welsch, Wolfgang. *Undoing Aesthetics*. London: Sage, 1997.

Westerkamp, Hildegard. "Linking Soundcape Compositions and Acoustic Ecology." *Organised Sound* 7.1 (2002): 51–56.

Wishart, Trevor. *On Sonic Art*. York, UK: Imagineering Press, 1985.

Wyman, Max. *The Defiant Imagination*. Vancouver: Douglas and McIntyre, 2004.

Zhao, Haixia, Catherine Plaisant, Ben Shneiderman, and Ramani Duraiswami. "Sonification of Geo-Referenced Data for Auditory Information Seeking: Design Principle and Pilot Study." In *Proceedings of ICAD 04: Tenth Meeting of the International Conference on Auditory Display*. Sydney, Australia, 6–9 July 2004. http://www.icad.org/websiteV2.0/Conferences/ICAD2004/papers/zhao_etal.pdf.

Contributors

María Andueza Olmedo is a Spanish independent researcher and sound artist. She holds a PhD in urban sound installations from the Universidad Complutense of Madrid. She is currently an associate professor of interactive art and design at the Universidad Europea of Madrid. She is part of the team of the Radio of the Reina Sofía Museum. Additionally, in collaboration with Abelardo Gil-Fournier, she designs and conducts workshops of interactive creation in Latin America and Spain. The works of Andueza have been presented in several venues in Europe, including the project of public art LunaKrea and the Noche en Blanco. She has lectured and published several papers in different media. For more details, check out her own website at http://mariaandueza.wordpress.com/.

Craig A. Coburn received a PhD in geography from Simon Fraser University in 2002, specializing in remote sensing. He is currently an associate professor of geography at the University of Lethbridge and teaches a wide variety of courses in remote sensing, geographical information systems, statistical techniques, and physical geography. His current research involves understanding the directional differences in surface features of the Earth when viewed from different angles. Coburn has had a long-standing collaborative effort with A. William Smith (Department of New Media, University of Lethbridge) in which they have been investigating new ways of understanding Earth observation imagery through sonification.

As well as being a sound artist and composer, **Darren Copeland** is the artistic director of New Adventures in Sound Art (NAISA), which produces electroacoustic and experimental sound art events in Toronto. With NAISA, he has also toured Europe and Canada, performing in concerts, facilitating workshops, and giving lectures with a focus on octophonic spatialization. Copeland is an associate member of the Canadian Music Centre. He also serves on the board of directors for the Canadian Association for Sound Ecology (CASE) and previously did so for the Canadian Electroacoustic Community (CEC), Vancouver Pro Musica, and Rumble Productions.

Viv Corringham is a British sound artist, vocalist, and composer, currently based in New York, who has worked internationally since the 1980s. Articles about her work have appeared in *Organised Sound* (UK), *Musicworks* (Canada), and *For Those Who Have Ears* (Ireland). Her work usually involves walking as a method of investigating people's relationships with place. The experiences and materials gathered on these walks find their way into installations, headphone works, and concert pieces. Corringham has received many awards, including a McKnight Composer Fellowship in 2006. Her work has been commissioned by arts centres and festivals in Ireland, Portugal, Turkey, Australia, the United States, and Britain.

As Associate Professor, Media Production and Studies, Faculty of Fine Arts, University of Regina, **Charlie Fox** co-developed and co-presented both *The Art of Immersive Soundscapes* (2004) and the symposium *AIS2* (2007) in collaboration with his colleague Dr. Pauline Minevich. Since the early 1970s, Fox has presented audio art, experimental film, video art and multimedia installation artworks in Canada and abroad. He has collaborated with arts collectives and advocacy groups throughout his career and was central to the founding of a number of media arts centres and arts organisations in Canada. He has developed curriculum for university programs across the country and has created state-of-the art facilities for sound that have been utilized by faculty, graduate and undergraduate students and featured residencies with artists as Ellen Moffat (2006), Gordon Monahan (2007-8), David Ogborn (2008), Eric Powell (2008-9) and Erin Gee (2010).

James Harley is a Canadian composer and researcher who teaches at the University of Guelph. He obtained his doctorate at McGill University in 1994 after spending six years in Europe. His music has been performed and broadcast around the world. He composes music for acoustic forces as well as electroacoustic media, with a particular interest in multichannel audio. Harley has published numerous articles and reviews on various aspects of new music, and his book *Xenakis: His Life in Music* was published in 2004 by Routledge. With Ellen Waterman, he is a member of ~spin~ duo for flutes and electronics.

The compositions of composer and artistic director **Peter Hatch** are in many genres, from orchestral and chamber music to instrumental theatre, performance art, electroacoustics, and installations. Some of his work incorporates theatrical and multimedia elements, reflecting his interest in extending traditional concert music performance practices. The founder of NUMUS Concerts (Waterloo), Hatch was the composer-in-residence with the Kitchener-Waterloo Symphony from 1999 to 2003 and the founder and artistic director of the Open Ears Festival of Music and Sound from 1998 to 2013. He is currently Arts and Culture Consultant at the Perimeter Institute of Theoretical Physics and is a professor at Wilfrid Laurier University, where he was the University Research Professor for 2006–07.

Pauline Minevich is an associate professor in the Department of Music, Faculty of Fine Arts, at the University of Regina. She holds a Master of Music degree in clarinet performance and literature, and a PhD in systematic musicology, both from Western University. In 2004 and 2007, in collaboration with Charles Fox, she initiated The Art of Immersive Soundscapes, two SSHRC-funded workshops and a conference held at the University of Regina. Minevich and Fox presented the results of this workshop at the Institut de Recherche et Coordination Acoustique/Musique (IRCAM) in 2004 and the international conference of the World Forum for Acoustic Ecology in Hirosaki, Japan, in 2006.

Freely traversing borders and genres, **David Ogborn** is an artist-researcher whose work frequently combines traditional performance arts with new media. A doctoral graduate of the Faculty of Music, University of Toronto, and the president of the Canadian Electroacoustic Community from 2008 until 2013, Ogborn teaches audio and computational media in the Department of Communication Studies & Multimedia at McMaster University, where he also directs the Cybernetic Orchestra. He is active in the live coding movement as d0kt0r0 and with the ensembles extramuros and armada de lindo. See http://d0kt0r0.net

Andrea Polli is an associate professor of art and ecology with appointments in the College of Fine Arts and School of Engineering at the University of New Mexico. She holds the Mesa Del Sol Endowed Chair of Digital Media and directs the Social Media Workgroup, a lab at the university's Center for Advanced Research Computing (socialmedia.carc.unm.edu). Polli is also an artist working at the intersection of art, science, and technology. She has been creating media and technology artworks related to environmental science issues since 1999, when she first began collaborating with atmospheric scientists on sound and data sonification projects. Among other organizations, she has worked with the NASA/Goddard Institute Climate Research Group in New York City, the National Center for Atmospheric Research, and AirNow. Polli is the co-author of *Far Field: Digital Culture, Climate Change, and the Poles* (Intellect Press).

Gabriele Proy is a leading Austrian composer and pioneer in the field of soundscape composition. Many renowned ensembles such as the Koehne Quartet, the Munich Philharmonic Choir, the ORF Vienna Radio Symphony Orchestra, the Ensemble die reihe, and the Salzburg Mozarte Quintet have performed her music. Among many distinctions and commissions, she won the Austrian commission in the EU-Japan-Year-2005, in the Austria-Japan-Year-2009 and for the European Capital of Culture Marseille-Provence-2013. In 2013, she was highly honoured by the City of Vienna Music Prize. Her compositions are performed with great success in Europe, Australia, Iran, Japan, Turkey, Canada, Latin America, and the United States. She teaches composition and sound design at the ARD.ZDF Media Academy in Nuremberg and lectures internationally. Since 2011, she has taught composition at the Vienna Institute for the International Education of Students. From 2001 on, she has been the president of the European Forum Klanglandschaft (FKL). See http://www.gabrieleproy.at.

A. William Smith has a music theory and composition degree as well as five others (including one in mathematics). As a founder of the New Media Department in 1999 at the University of Lethbridge, he has explored many types of animation, including motion-captured aesthetic movement in 3-D environments. His soundscape for Ottawa with drumming features this type of animation. Currently, Smith applies his sonification techniques to gallery-size digital artworks that he has created and performs real-time interactive visuals based on that imagery.

Barry Truax is a professor in the School of Communication and formerly in the School for the Contemporary Arts at Simon Fraser University. He has worked with the World Soundscape Project, and his book *Acoustic Communication* deals with all aspects of sound and technology. As a composer, Truax is best known for his work with the PODX computer music system, which he has used for tape solo works and those that combine tape with live performers or computer graphics. In 1991, his work *Riverrun* was awarded the Magisterium at the International Competition of Electroacoustic Music in Bourges, France, a category open only to electroacoustic composers of twenty or more years of experience.

The practice of **Tim Wainwright** represents the interaction of the present moment with something timeless as he reflects or intuits how such moments show the interplay between psychological and material aspects of our reality. His residency at Harefield Hospital with John Wynne continues a fifteen-year exploration of the four essential elements of being human — mind, body, heart, and soul. Throughout this time, Wainwright has used photography, film, and sound to investigate the nature of transformation while working with concepts of witness and voyeurism. He lives and works in London, England.

Ellen Waterman conducts research at the intersections of sound studies, ethnomusicology, improvisation studies, and performance studies. Her work can be found in *Sonic Geographies Imagined and Remembered* (Penumbra, 2002) and a special issue of the journal *Intersections* on women and sound (with Andra McCartney, 2006). She is a founding co-editor of the journal *Critical Studies in Improvisation* (http://www.criticalimprov.com) and an executive member of the International Institute for Critical Studies in Improvisation, funded by a SSHRC Partnership Grant. Waterman is the dean of the School of Music at Memorial University. With James Harley, she is a member of ~spin~ duo for flutes and electronics.

Hildegard Westerkamp is a composer who focuses on listening, environmental sound, and acoustic ecology. She is on the board of the World Forum for Acoustic Ecology (WFAE) and until 2012 was the editor-in-chief of its journal *Soundscape: The Journal of Acoustic Ecology* (see http://www.wfae. net). She has taught courses in acoustic communication at Simon Fraser University, has worked with writers Norbert Ruebsaat and Sharon Thesen and photographer Florence Debeugny, and conducts soundscape workshops and gives concerts and lectures internationally. Some of Westerkamp's compositional work appears in US filmmaker Gus van Sants's films *Elephant* and *Last Days*. For more details, see http://www.sfu.ca/~westerka.

Sound artist **John Wynne** has a PhD from Goldsmiths College, University of London. His award-winning work, which is often research led, is made for museums, galleries, public spaces, as well as radio: it ranges from massive installations to delicate sculptural works and from architectural sound drawings to flying radios and "composed documentaries." Major projects have included work with speakers of endangered languages in Botswana and Canada and with heart and lung transplant patients in the United Kingdom. His *Installation for 300 speakers, player piano and vacuum cleaner* became the first work of sound art in the Saatchi collection in 2010. He is a Reader in Sound Arts at the University of the Arts London and a core member of the CRiSAP research centre.

Index

A

F

G

H

I

Art of Immersive Soundscapes DVD

The accompanying DVD includes audio and video excerpts and complete works to accompany many of the chapters in *Art of Immersive Soundscapes*. The DVD is formatted in 5.1 audio, which means that it will play on compatible home entertainment systems. You can also listen to it in stereo sound on any device that plays DVDs.

DVD Track Listing

TRACK	CHAPTER	TITLE OF WORK
Charlie Fox	Prologue	*Wildurban*
David Ogborn	Chapter 3	Field Recording: *Bells of Venice*
Andrea Polli	Chapter 4	*Heat and the Heartbeat of the City* (excerpt)
Craig A. Coburn and A. William Smith	Chapter 5	*Recording Regina from Eta Carinae*: "Shapes in Different Directions"
Gabriele Proy	Chapter 6	*Waldviertel*
James Harley and Ellen Waterman	Chapter 7	*Wild Fruits 2: Like a Ragged Flock, like Pulverized Jade*
John Wynne and Tim Wainwright	Chapter 9	*ITU*
Hildegard Westerkamp	Chapter 10	*MotherVoiceTalk*
Viv Corringham	Chapter 11	*Shadow-walk: Cal State University, Fullerton*
Peter Hatch	Chapter 12	*Guerrilla Sound Events:* "Car(r)ying Play"
Darren Copeland	Chapter 13	*Lapse in Perception*
Barry Truax	Chapter 14	*Journeys of the Human Spirit* (examples and excerpts)